The Ultimate Guide to Painting From Photographs

The Ultimate Guide to
Painting from
PHOTOGRAPHS

40 step by step projects

Edited by James Markle and Layne Vanover

NORTH LIGHT BOOKS
CINCINNATI, OHIO
www.artistsnetwork.com

The Ultimate Guide to Painting From Photographs. Copyright © 2005 by North Light Books. Manufactured in China. All rights reserved. No part of this book may be reproduced in any form or by any electronic or mechanical means including information storage and retrieval systems without permission in writing from the publisher, except by a reviewer who may quote brief passages in a review. Published by North Light Books, an imprint of F+W Publications, Inc., 4700 East Galbraith Road, Cincinnati, Ohio, 45236. (800) 289-0963. First Edition.

fw
F+W PUBLICATIONS, INC.

Other fine North Light Books are available from your local bookstore, art supply store or direct from the publisher.

09 08 07 06 05 5 4 3 2 1

DISTRIBUTED IN CANADA BY FRASER DIRECT
100 Armstrong Avenue
Georgetown, ON, Canada L7G 5S4
Tel: (905) 877-4411

DISTRIBUTED IN THE U.K. AND EUROPE BY DAVID & CHARLES
Brunel House, Newton Abbot, Devon, TQ12 4PU, England
Tel: (+44) 1626 323200, Fax: (+44) 1626 323319
Email: mail@davidandcharles.co.uk

DISTRIBUTED IN AUSTRALIA BY CAPRICORN LINK
P.O. Box 704, S. Windsor NSW, 2756 Australia
Tel: (02) 4577-3555

Library of Congress Cataloging in Publication Data
Markle, James.
 The ultimate guide to painting from photographs / James Markle and Layne Vanover.-- 1st ed.
 p. cm
 Includes index.
 ISBN 1-58180-717-1 (pbk. : alk. paper)
 1. Painting from photographs--Technique. 2. Drawing from photographs--Technique. I. Vanover, Layne. II. Title

ND1505.M37 2005
751.4--dc22 2004065472

Content edited by Layne Vanover
Production edited by Jennifer Ziegler
Designed by Wendy Dunning
Interior Layout by Jessica Schultz
Production coordinated by Mark Griffin

Adobe® and Photoshop® are either registered trademarks or trademarks of Adobe Systems Incorporated in the United States and/or other countries.

Metric Conversion Chart

To convert	to	multiply by
Inches	Centimeters	2.54
Centimeters	Inches	0.4
Feet	Centimeters	30.5
Centimeters	Feet	0.03
Yards	Meters	0.9
Meters	Yards	1.1
Sq. Inches	Sq. Centimeters	6.45
Sq. Centimeters	Sq. Inches	0.16
Sq. Feet	Sq. Meters	0.09
Sq. Meters	Sq. Feet	10.8
Sq. Yards	Sq. Meters	0.8
Sq. Meters	Sq. Yards	1.2
Pounds	Kilograms	0.45
Kilograms	Pounds	2.2
Ounces	Grams	28.3
Grams	Ounces	0.035

The following artwork originally appeared in previously published titles from North Light Books (the initial page numbers given refer to pages in the original book; page numbers in parentheses refer to pages in this book):

Artist's Photo Reference:
Birds © 1999.
Nelson, Sherry C. Pages 137–140 (112–115)
Rulon, Bart. Pages 34–37 (116–119)

Artist's Photo Reference:
Boats & Nautical Scenes © 2003.
Adams, Norma Auer. Pages 124–127 (88, 108–111)
Greene, Gary. Pages 38, 112–115 (62, 84–87)
Nicoll, Ross. Pages 72–75 (76–79)
Pankowski, Ted. Pages 66–69 (80–83)
Shyne, Dianna. Pages 132–135 (62, 68–71)

Artist's Photo Reference:
Buildings & Barns © 2001.
Cooper, Michele. Pages 108–111 (156–160)
Greene, Gary. Pages 21, 52, 80–83 (144, 198–201)
Jenkins, Barbara Krans. Pages 134–137 (144, 168–171)
Tompkin, Linda. Pages 117–123 (144, 161–167)
Weston, Larry. Pages 36–41 (146–151)
Zuccarelli, Frank E. Pages 67–69 (144, 152–155)

Artist's Photo Reference:
Flowers © 1998.
Adams, Norma Auer. Pages 38–41 (16–19)
Greene, Gary. Pages 3, 6, 9, 100–103 (14, 22–25)
Jackoboice, Sandy. Pages 52–53 (20–21)
Jenkins, Barbara Krans. Pages 132–135 (26–29)

Artist's Photo Reference:
Landscapes © 2000.
Braeutigam, Peggy. Pages 124–127 (46–49)
Greene, Gary. Pages 58–61 (32–35)
Lewis, Carolyn E. Pages 36–39 (64–67)
Lytle, Nancy Pfister. Pages 138–141 (30, 50–53)
Sweet, Mary. Pages 92–95 (30, 36–39)
Weston, Larry. Pages 108–113 (30, 40–45)

Artist's Photo Reference:
Reflections, Textures & Backgrounds © 2004.
Bennett, Liana. Pages 62–65 (184–187)
Fotheringham, Beverly. Pages 38–43 (174–179)
Greene, Gary. Pages 6, 9–11, 14–15, 21– 22, 31, 49, 128, 102–105, 130 (8–13, 144, 172, 194–197)
Messina, Pia. Pages 52–55 (180–183)
Whitney, Steve. Pages 92–97 (188–193)

Artist's Photo Reference:
Songbirds & Other Favorite Birds © 2004.
Boyle, Mark. Pages 96–99 (99–102)
Ross, Sueellen. Pages 16–19 (90–93)
Rulon, Bart. Pages 6, 15, 34, 36–40, 91, 119–123 (8, 88, 94–98, 103–107)

Artist's Photo Reference:
Water & Skies © 2002.
Boyle, Mark. Pages 66–69 (30, 54–57)
Carey, June. Pages 28–31 (72–75)
Rulon, Bart. Pages 27, 39, 112, 114–115, (58, 60–62)

Artist's Photo Reference:
Wildlife © 2003.
Baughan, Kalon. Pages 58–63 (126–131)
Ross, Sueellen. Pages 76–79 (132–135)
Rulon, Bart. Pages 2, 26–29, 56, 74, 94–97, 126–129 (120, 122–125, 136–143)

CONTENTS

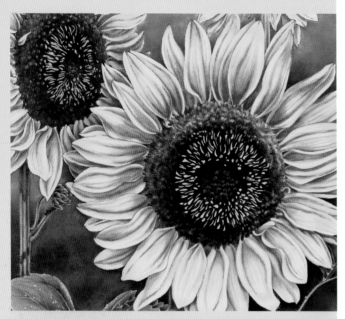

1 | Flowers 14

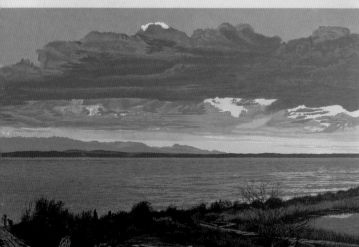

2 | Landscapes 30

3 | Seascapes and Nautical Scenes 62

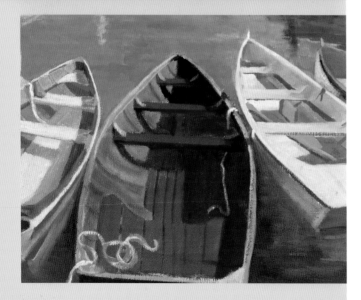

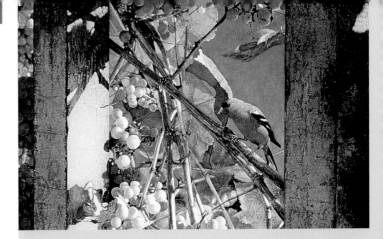

4 | Birds 88

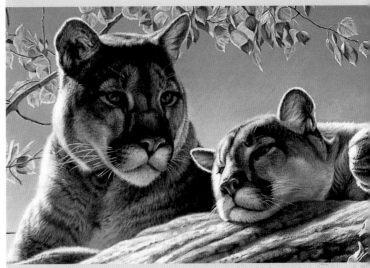

5 | Wildlife 120

6 | Buildings and Barns 144

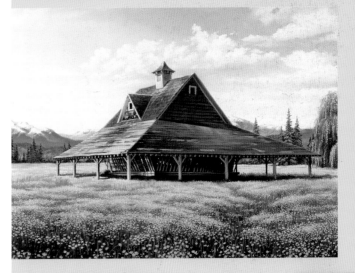

7 | Reflective and Textured Surfaces 172

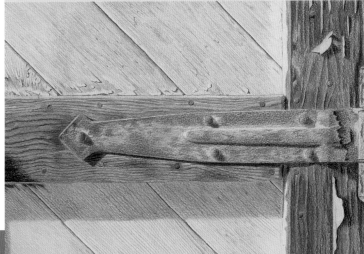

INTRODUCTION

Good models for reference photographs are found just about everywhere you look—the secret is being able to identify them. For instance, a trip to the grocery store offers a variety of fruits and vegetables to shoot for your next still life, while a walk along the beach provides breathtaking views of endless water and dramatic skies perfect for a seascape. Likewise, a drive through the countryside presents you with a treasure chest of old buildings and barns waiting to be captured, and a stroll through the garden supplies you with a plethora of material for a landscape. As you can see, references for paintings exist virtually everywhere you go. All you have to do is open your eyes to discover them. *The Ultimate Guide to Painting From Photographs* will help you recognize the abundance of reference materials that surround you, getting you started along the journey to creating successful paintings.

Whether you're most interested in painting nautical scenes or wildlife, *The Ultimate Guide to Painting From Photographs* has something for every artist. Forty step-by-step demonstrations completed by professional artists cover everything from flowers to barns and illustrate how to create finished paintings using reference photographs as your guide. Each demonstration showcases the artist's own unique interpretation of reference materials and presents you with the chance to experiment with a number of painting styles. What's more, *The Ultimate Guide to Painting From Photographs* provides you with the opportunity to work with a wide variety of mediums, including acrylic, colored pencil, mixed media, oil, pastel and watercolor. With so many options available, you're guaranteed to find the perfect subject, style and medium to suit your tastes.

Taking Your Own Reference Photos

Unless you specialize in nonrepresentational art, having your own original photographs to work from should be a major part of your repertory. Shooting reference photos can be just as exciting and creative as actually painting.

Different subject matter may require a different method of shooting and a few pieces of specialized equipment. Let's cover the basics first.

Cameras—Film vs. Digital

The digital camera is the most revolutionary product to impact photography since Kodak's Brownie over seventy-five years ago. Digital cameras offer the convenience of no film, no processing and, depending on the size of the memory card, hundreds of shots in your camera. Some of the newer high-end Single Lens Reflex (SLR) digital cameras produce images that rival and even surpass 35mm film in sharpness and color accuracy.

Should you use a digital camera for reference photography? The answer is a qualified "yes." All reference photos must be sharp, especially texture studies. In order to get the level of detail required for this kind of work, a digital camera with a resolution of at least six megapixels is required. A digital camera must be set to the highest resolution in order to obtain acceptably sharp prints. This greatly reduces the number of shots available, resulting in either frequent downloading (not convenient without a computer nearby) or the expense of additional or larger memory cards. High-resolution images result in larger files that make a very large dent in an older computer's hard drive, therefore you might need a new hard drive, an additional external hard drive, a CD or DVD burner or a new computer.

You will also need prints of your digital images. Should you send your digital images to a photo lab or copy center and pay for prints that may not be satisfactory or should you buy a printer and print them yourself? Satisfactory ink-jet photo printers start at around $350. Don't forget that you'll have to replace paper and ink cartridges regularly. It is cumulative expenses like these that make digital photography a "qualified" choice. The decision you need to make is, "Is the expense worth the convenience of digital imaging?"

Although not as convenient, film is still a better choice over digital photography because initial investments cost less, and more importantly, film usually produces sharper images.

Suggested Photo Equipment

- 35mm SLR camera
- 100mm Macro Lens
- 28–200mm wide angle to telephoto zoom lens
- 400–800mm focal lens
- Protective filter: 81A
- 1.4x or 2x teleconverter
- Tripod with ball head and quick release

A 35mm SLR camera is a must for reference photography. It offers the interchangeability of a wide variety of lenses of different focal lengths and permits exposure choices, plus many other options that improve your chances of successful photography.

Reliance on autoexposure, even with sophisticated cameras, usually results in improperly exposed photos. Most modern SLR cameras have autofocus, which may not always be useful for these subjects.

In choosing cameras and lenses, you will find that equipment produced by major manufacturers is of excellent quality with a wide range of prices based on the number of features.

It's best not to use point-and-shoot cameras to capture most subjects, as they usually have less efficient optics and versatility. Most point-and-shoot cameras do not offer important features like manual exposure or external flash capabilities.

Electronic Flash

Almost all indoor subjects require flash because of insufficient light, and a tripod may not be practical because of limited space. Choose a flash unit dedicated to your camera, one that automatically adjusts its output based on the camera's settings. A wireless remote control is very useful but not a necessity.

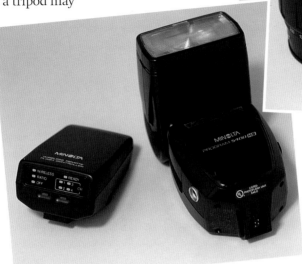

Electronic flash

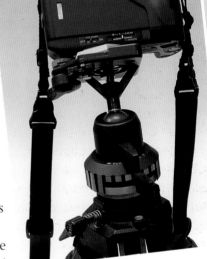

Filters

Tripod

Tripod

A sturdy tripod is sometimes necessary to get sharp, detailed pictures in low lighting situations, particularly when photographing landscape backgrounds. Instead of the standard pan head that most tripods come equipped with, refit the tripod with a ball head and quick release. Ball heads allow easy camera positioning, and a quick release has a small plate that attaches to the bottom of the camera that locks it onto the tripod without any fumbling with a screw mount. You can easily release the camera from the tripod by merely flipping a lever.

Filters

Attach a filter to the front of your lenses to protect the front element from dust and scratches. Many photographers use a clear Ultraviolet (UV) or Skylight filter, but an 81A filter is a better choice. Its pale orange color "warms up" photos without drastically altering them, which is particularly useful on overcast days.

What Film Should You Use?

Slides are preferable to prints because they produce sharper photos and more accurate color. Some artists paint directly from slides viewed through an inexpensive photographer's loupe. A slide is placed in a clear acetate sleeve and taped to a 10× loupe, and when it is held up to a light source, the slide is magnified to an equivalent of an 8 × 10-inch (20cm × 25cm) print, only with considerably more detail. This method is particularly useful when painting textured surfaces. Slides are less costly than prints and easier to store. Prints made from slides (called "R prints") are equal in quality to prints from negatives.

Print film is more "forgiving" than slide film, because you can miss the correct exposure by a greater margin and still have a usable photo. However, print film is more vulnerable to printing errors in the lab, resulting in poor color, incorrect exposure or both.

A film's speed (ISO) determines how sensitive it is to light. The faster the film, the higher ISO number, the more light sensitive it is. Light-sensitive films enable the photographer to shoot at higher shutter speeds, sometimes making a tripod or electronic flash unnecessary. However, faster films also have larger light-gathering particles in their emulsion and produce grainier, less sharp photos.

Suggested slide films are Fujichrome Velvia (ISO 50) and Provia F (ISO 100). These films are among the sharpest films available and produce brilliant colors, even on overcast days. They are professional films available only at camera stores or photo labs.

Shooting Successful Reference Photos

Taking photographs is as much fun as painting and drawing when you're taking photos that you'll use as subjects. *The Ultimate Guide to Painting From Photographs* offers such a large field of material, you can find subjects anywhere and anytime. Because these subjects are usually used for either reference or as an ingredient in a painting, attention to composition, lighting and precise color is not as critical as when shooting specific subjects.

The most important consideration in photographing natural subjects such as flowers, or textured objects such as weathered wood, is detail, so it is important to shoot with fine-grain film and the smallest possible f-stop to be sure everything is in sharp focus. This requires using either electronic flash or a tripod.

Reflections also require small f-stops, especially when trying to capture reflections in the subject you are shooting. Reflections in water may require fast shutter speeds in order to freeze the water's movement. When photographing intense reflections, such as the sun shining on windows, take care to expose a similar area without the reflection to avoid severe underexposure.

Photos of animals and birds usually require large focal lenses in the range of 400mm to 800mm. In addition, having a 1.4× or 2× teleconverter can add length to your lens when you need it. You might also consider stabilization tools to reduce camera shake. These are particularly useful when shooting photos from a car or boat.

Compose landscape backgrounds such as mountains, rivers, lakes and clouds from a variety of vantage points and with a variety of exposures. Silhouettes make good backgrounds and good backlit subjects on sunny days; just be sure to give your exposure one to two extra f-stops to prevent underexposure. Overcast conditions also offer an excellent opportunity for silhouettes. Overexpose the scene so the gray overcast background results in clear areas on your slides. Long exposures of colorful reflections on moving water make great backgrounds.

You can easily make interesting backgrounds by overexposing scenes that have strong contrasts in value or color, such as gardens, fall foliage, crowds of people or neon signs. Simply throw your camera out of focus by zooming or intentionally moving the camera while making long exposures or multiple exposures, if your camera has the capability. Combine these tricks or invent your own. Who knows, photography might be so much fun you'll be tempted to throw your brushes away!

Creating Composite Photos

Consider combining reference photos to create exciting new images. You can also do so using traditional methods, such as physically cutting and pasting photos or by using a computer and image-editing software such as Adobe® Photoshop®. As personal computers become more commonplace, artists are becoming more proficient with them. Not long ago, image-editing programs were a mystery to everyone except experienced designers, illustrators and photographers. Today, many artists use such software to alter or enhance photos.

Most subjects lend themselves to composite reference photos. If slide film is used, it's possible to "sandwich" composite photos from two or more slides. For example, a silhouetted scene with a clear background can be sandwiched with another background, texture or reflection to produce an interesting composition.

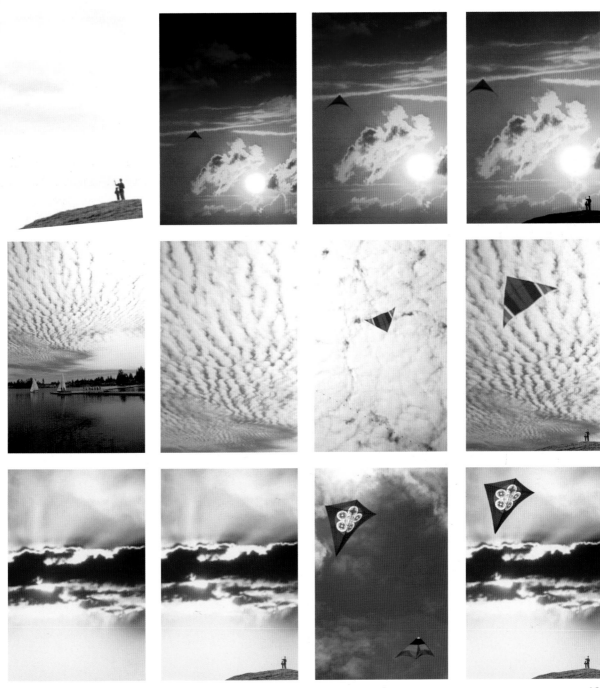

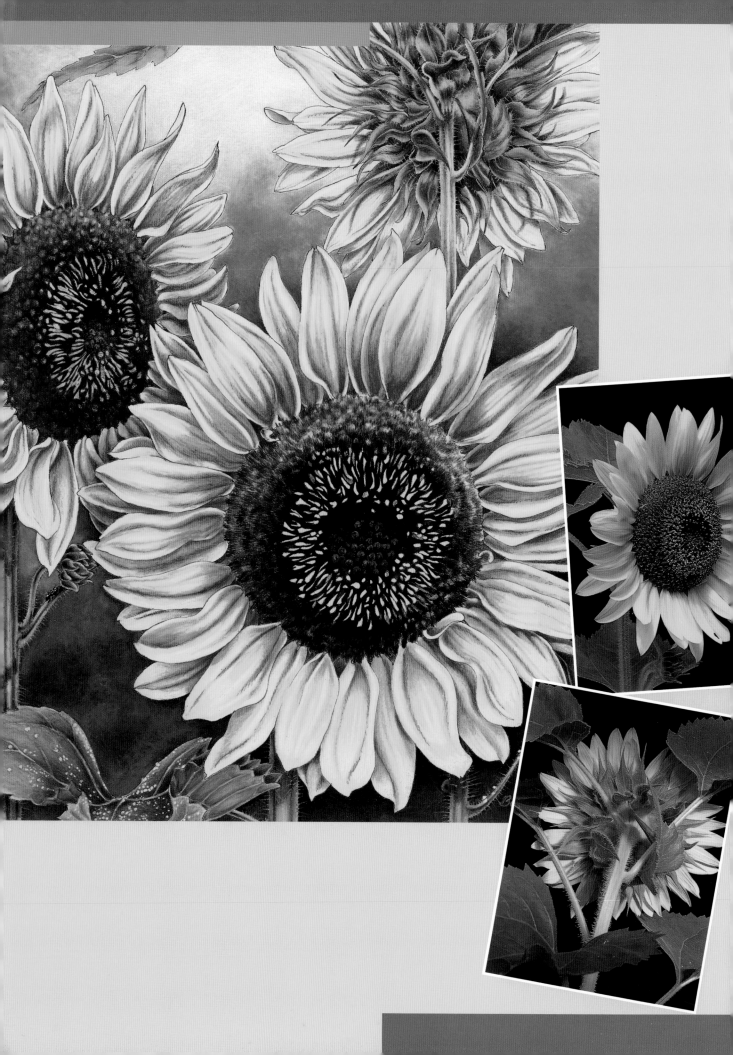

FLOWERS

Have you ever wanted to paint radiant tulips in October but couldn't travel to Australia, where they bloom at that time of year? Or perhaps you've had an impulse to capture the brilliant yellow hue of sunflowers in the middle of winter, knowing full well that they won't show up until the summer? With such astounding beauty, it's no wonder flowers are popular subjects for paintings. However, their seasonal nature can present a problem for the artist who desires to paint them year round. In such instances, reference photographs serve as the perfect solution.

Though fresh flowers are good for accurate color rendition and detail, the advantages of using photo references far outweigh live models. For example, photos free you from rushing to complete your artwork before your subject begins to wilt or die. In addition, flowers undergo rapid change on a daily basis, so a particular blossom or leaf may completely transform from one day to the next. Working from photographs, on the other hand, helps you capture the flower exactly as you see it, giving you time to study and observe your subject before you begin painting.

In this chapter, you'll have the opportunity to create finished paintings of several popular flowers. You'll notice that each painting is the artist's personal interpretation of his or her references rather than an exact replica of a photograph. When creating your own paintings from photographs, feel free to take the same liberties; exercise your artistic license. Use numerous photos taken from various points of view and in different lighting conditions. This provides you with the freedom to choose desired elements from each reference, creating your own unique floral composition.

Chrysanthemums in Acrylic

BY NORMA AUER ADAMS Norma Auer Adams has always been drawn to nature. When she paints, she immerses herself in the images and tries to create works that radiate the peace, stillness and sense of awe in the natural world. Originally an abstract artist, now a realist, Norma works with airbrush and acrylic paint on paper and canvas.

MATERIALS

Surface

Arches 140-lb. cold-press watercolor paper stretched as for watercolor painting

Palette

Liquid acrylic paint in colors shown for mixing

Brushes

Gesso brush for priming paper

Iwata HP-C double-action airbrush(es)

No. 1 sable

No. 8 white nylon sable

Other

2B drawing pencils

Acrylic gloss medium thinned with equal
 parts water

Airbrush solvent to clean airbrush(es)

Black thread

Compressor for airbrush(es)

Face mask to prevent spray inhalation

Frisket film

Masking tape

Pint-size glass jars with lids

Tracing paper

White acrylic gesso for priming paper

X-Acto knife with no. 11 blades

REFERENCE PHOTO

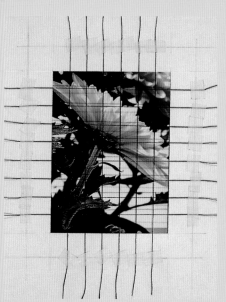

1 Lay Out the Composition

Crop the reference photograph to create a strong design. Tape down a grid of black thread to divide the photograph into equal-size blocks.

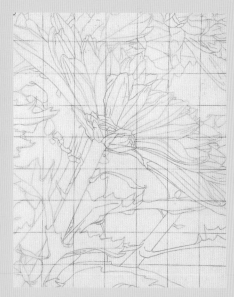

2 Make the Drawing

Place a full-size piece of tracing paper over the primed painting surface, then tape down a grid of black thread to create the same number and proportion of blocks as on the photograph. Do the drawing on the tracing paper using the photo as a guide. When finished, remove the grid lines and redraw the pencil lines on the back of the tracing paper, then rub to transfer to the gessoed surface.

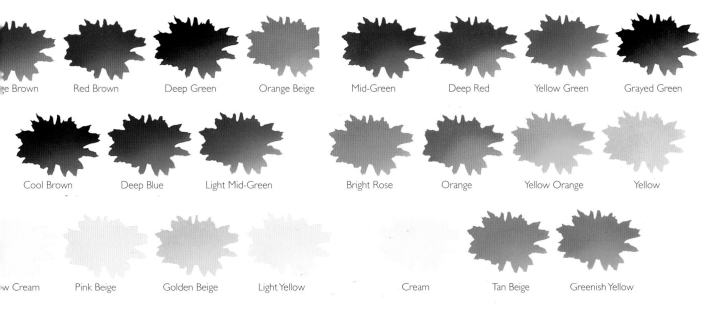

e Brown	Red Brown	Deep Green	Orange Beige	Mid-Green	Deep Red	Yellow Green	Grayed Green

Cool Brown	Deep Blue	Light Mid-Green	Bright Rose	Orange	Yellow Orange	Yellow

w Cream	Pink Beige	Golden Beige	Light Yellow	Cream	Tan Beige	Greenish Yellow

3 Mix Colors

Colors are based on the photo as well as personal memories. Premix a quantity of each color using jar acrylics. Thin them to the consistency of slightly thickened milk with equal parts water and acrylic gloss medium, then strain and pour into pint-size glass jars.

4 Mask and Begin Painting

Frisket film is a low-tack adhesive-backed transparent plastic film designed for airbrush work. A frisket film mask is used to cover some areas of the paper before painting is begun. Cut the frisket film around the shapes to be painted with an X-Acto knife. Remove each section as the painting around it is completed, beginning with the background. Paint the darkest areas first, working from dark to light, establishing the relationship between values in each area. After the initial frisket film mask, alternate freehand airbrushing with film masking, increasing the amount of freehand work as the painting progresses.

Spray the darkest areas of the partial flower with Orange Brown, followed by a lighter spray of Red Brown. Spray lightly with Deep Green in the shadowed area, then lightly with Orange Beige over areas in sunlight.

For the background foliage, spray a medium-dense layer of Deep Green. Follow with a lighter layer of Cool Brown, then a light layer of Deep Blue. Spray with Light Mid-Green to intensify and unify color.

5 Soften Edges

Respray the painted areas to soften edges and create a more realistic effect. Lightly blend the partial flower with sprays of thinned white gesso, Yellow Cream and Pink Beige to unify. Repaint using the same color palette as in step 4 (Orange Brown, Red Brown and Orange Beige), spraying lightly. Spray midtones with Golden Beige. Spray lights and highlights with Yellow Cream, Pink Beige and Light Yellow.

Spray light areas of the background foliage with Yellow Cream and thinned white gesso to bring up highlights. Deepen and define dark areas with Mid-Green. Follow with lightly sprayed layers of Deep Red and Deep Blue. Spray Yellow Green over areas highlighted by Yellow Cream and thinned white gesso.

6 Underpaint the Central Flower

Underpaint the central flower with Grayed Green, Bright Rose, Orange and Yellow Orange. Protect areas from overspray with frisket film and pieces of tracing paper.

7 Unify Underpainting and Develop Highlights

Unify the underpainting by spraying with Light Yellow, Yellow Cream and thinned white gesso; details of the underpainting should be visible through this layer. Dust with a light spray of Yellow and Cream, especially at the tops of the petals.

Develop highlights and color by spraying with Tan Beige, Light Yellow, Golden Beige and Bright Rose. Compare the illustrations for steps 6 and 7. Step 7 shows the petals at the underpainting stage, covered with light-colored overspray and ready for repainting.

Alternate Masking and Freehand

After the initial frisket film mask, alternate freehand airbrushing with film masking, increasing the amount of freehand work as the painting progresses.

Mix Colors With Layers

Paint is thinly applied with each layer of spray, making it easy to mix colors on the painting surface itself. This layered paint application creates color that is luminous and vibrant.

8 Paint Foreground Foliage, Stem and Partial Flower

Mask the calyx and stem with frisket film, then underpaint the leaves. Underpaint the leaves at the left center edge of the painting and the two leaves attached to the stem by putting frisket film over the existing leaves and using the same colors as in the step 4 background foliage: Deep Green, Cool Brown, Deep Blue and Light Mid-Green.

For the leaves at the left center edge of the painting, spray with Yellow Cream overall to blend and lift the value of leaves to a lighter tone. Spatter with Deep Green, Deep Blue, Orange Beige and Yellow Cream to create texture. To put in veins and other details, airbrush freehand with Mid-Green, Cool Brown and Deep Blue. Paint linear details and highlights with Yellow Cream and Light Yellow using a no. 1 paintbrush. Soften the edges of the lines with a slightly wet no. 8 paintbrush.

Complete the leaves attached to the stem by unifying their tone with an overall spray of Mid-Green. Airbrush light veins freehand with Light Yellow and Yellow Cream. Airbrush dark areas using Cool Brown, Red Brown and Mid-Green. Dust highlights and edges of leaves with Greenish Yellow. With the no. 1 and no. 8 paintbrushes, paint light accents on the tips of the leaves with Yellow Cream, Greenish Yellow and Orange Beige.

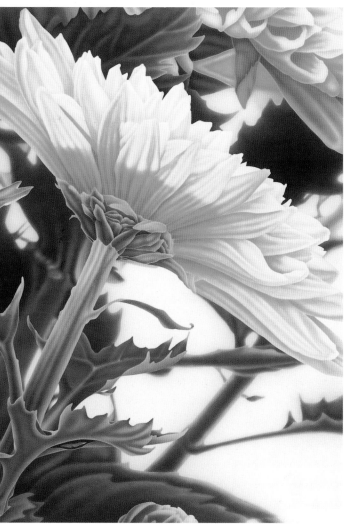

9 Paint Stem, Remaining Leaves and Finishing Touches

Remove the frisket film applied in step 8, then airbrush the stem using the same colors used for underpainting in step 8, leaving the upper left part of the stem light in tone. Spray the stem lightly with Yellow Cream, then spatter with Cool Brown, Grayed Green, Orange Beige and Yellow Cream. Airbrush darker lines freehand, then highlight the edges of the stem near the top with a no. 1 paintbrush. Hand paint light accents of Yellow Green and paint the remaining leaves.

Keep the sepals (nearest base of flower petals) light. Cover the underpainting on the calyx with a coat of Golden Beige and a dusting of Grayed Green. Repaint the dark areas of the calyx with the same colors used in the underpainting. Sharpen the details with a no. 1 brush using Golden Beige, Yellow Cream and Greenish Yellow, keeping the feeling of shade on the calyx.

To match the color intensity of the central flower, lightly spray the partial flower at the upper right with Yellow Cream and Pink Beige. Spray dark areas with Bright Rose, Orange Beige and Red Brown again. Use Grayed Green on lowest leaves for shade.

CHRYSANTHEMUM PROFILE
Norma Auer Adams
27½" × 21¼" (70cm × 54cm)

Dahlias in Pastel

BY SANDRA JACKOBOICE Sandy works at an easel, mostly while standing, so she can move back and forth to see how the whole image is developing. She places the work straight, not slanted on the easel, so pastel particles can fall off easily.

MATERIALS

Surface
8½ × 11-inch (22cm × 28cm) layout or sketch paper

Palette
Because most pastels are identified by numbers instead of color names, hues are accompanied by numbers except where the manufacturer has no hue name.

PRISMACOLOR NUPASTEL SEMI-HARD PASTELS: 244 Blue Violet; 298 Bottle Green; 365 Ceylon Blue; 227 Corn Yellow; 228 Hooker's Green; 254 Hyacinth Violet; 277 Ivory; 304 Orchid; 266 Pale Vermilion; 376 Peach

REMBRANDT MEDIUM SOFT PASTELS: 640 Bluish Green; 331 Madder Lake Deep

SENNELIER SOFT PASTELS: 346 Bright Yellow; 602 Lemon Yellow; 384 Madder Carmine; 310 Madder Violet; 272 and 274 Pink; 484 Purplish Blue Grey; 407 Van Dyck Violet; 281 Violet; 525 White; 66 Yellow

UNISON SOFT PASTELS: BG6 Blue Green; A37 and A39 Dark Neutral; SC13 Gold; G1, G4, G5, G9, G13 and G14 Green; A25 and A29 Light Neutral; R18 Red

Other
2B drawing pencil

Cloths and paper tissues for blending

Colored pencils

Krylon Crystal Clear protective coating

Krylon workable fixative

Vine charcoal

REFERENCE PHOTO

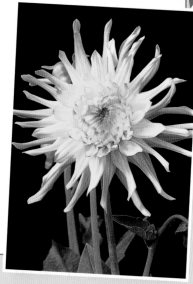

Safety Notes
- Some pastels are toxic, so using fingers to blend them can be hazardous. Be sure to wash your hands frequently.
- Do not have food or beverages in your work area.
- Use sprays in a well-ventilated area.

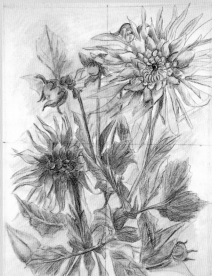

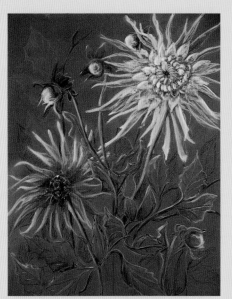

1 Lay Out the Composition
Sandy finds a pleasing composition by first laying out a preliminary sketch. Using reference photographs, sketch leaves, buds and flowers on 8½ × 11-inch (22cm × 28cm) layout paper with a 2B drawing pencil, followed by colored pencils to block in hints of desired color. Divide the page into quarters.

2 Transfer the Composition
Drawing lightly, divide your paper into quarters and sketch the subject. Block in the buds, leaves and flowers with Nupastel 376 Peach, 304 Orchid, 254 Hyacinth Violet, 228 Hooker's Green, 298 Bottle Green, 365 Ceylon Blue, 227 Corn Yellow, 244 Blue Violet, 277 Ivory and 266 Pale Vermilion. Spray with Krylon workable fixative.

Tip
Loosen excess pastel dust, which can clog the tooth (texture) of the paper, by hitting the back of the paper a few times while tilting it slightly forward.

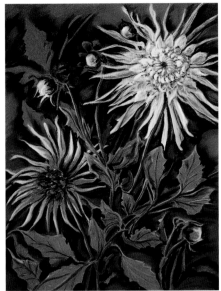

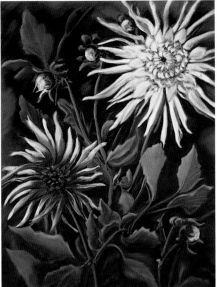

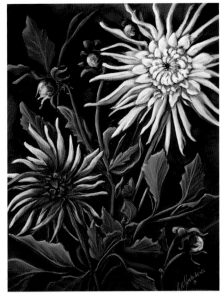

3 Add Darker Values

With softer pastels, add darker background values to emphasize middle values in step 2. Use hints of dark, cool shades in the background with Unison pastels: G9, G14, G1 and G13 Greens; A37 and A39 Dark Neutrals and BG6 Blue Green. Make small additions or composition changes as necessary by defining negative space with warmer Sennelier 281 Violet in the foreground.

4 Strengthen Middle Values

Enhance middle values and colors by using and blending varied shades of pastels for petals, buds and leaves: Rembrandt pastels 640 Bluish Green and 331 Madder Lake Deep; Sennelier 384 Madder Carmine and 407 Van Dyck Violet; Unison pastels G4 Green, R18 Red, SC13 Gold, G5 Green, A25 and A29 Light Neutral. Spray with Krylon workable fixative.

5 Add Lights, Define Foreground and Blend Background

Add light values to emphasize highlights with Sennelier soft pastels 66 Yellow, 484 Purplish Blue Grey, 274 Pink, 272 Pink, 602 Lemon Yellow, 310 Madder Violet, 525 White and 346 Bright Yellow. Using vine charcoal, define foreground shapes by sharpening darker areas around the petals and leaves, and cleaning up smeared edges. Using cloths or paper tissues, lightly fade background petals and leaves by blending the edges into background colors. Spray with Krylon workable fixative.

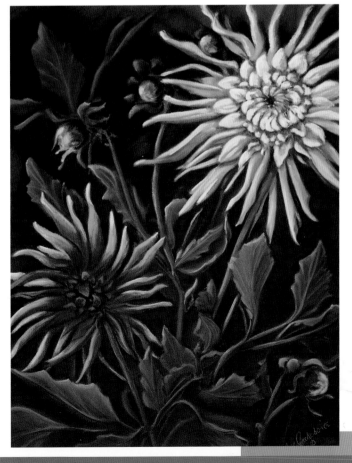

6 Make Final Adjustments

Make last-minute changes, if necessary, then spray with Krylon Crystal Clear.

DAHLIA
Sandra Jackoboice
8½" × 11" (22cm × 28cm)

Orchids in Colored Pencil

BY GARY GREENE Gary uses the following terms to describe the techniques employed in this colored pencil demonstration. *Layering* is a light application of desired colors on top of each other, usually starting with the darkest value of any given area.

Burnishing involves layering, then blending the layers together with a colorless blender pencil or a white or very light-colored pencil. The lighter areas of color are completed first to prevent darker colors in adjacent areas from being "dragged" into lighter areas. The process is repeated until the entire paper surface is covered.

Wash or *underpainting* is achieved when layered colored pencil is dissolved with a solvent to create a smooth ground which shows through subsequent layers of colored pencil.

MATERIALS

Surface
Strathmore four-ply museum board

Palette
CARAN D'ACHE PABLO COLORED PENCILS: Green Ochre, Khaki Green, Olive Black, Olive Yellow

FABER-CASTELL POLYCHROMOS COLORED PENCILS: Burnt Carmine, Chrome Yellow Light (was Light Chrome), Cream, Golden Ochre, Indian Red, Lemon, Light Ochre, Ochre

PRISMACOLOR COLORED PENCILS: Apple Green, Black Grape, Cream, Deco Yellow, French Grey (10%, 20%, 30%, 50%, 70%), Goldenrod, Indigo Blue, Jasmine, Lime Peel, Marine Green, Orange, Pumpkin Orange, Scarlet Lake, Sunburst Yellow, Terra Cotta, Tuscan Red, White

PRISMACOLOR VERITHIN PENCILS: Light Gray, Light Green, Olive Green

Other
2B or B graphite pencil

Bestine solvent and thinner

Colorless blender, such as Lyra Splender

Cotton swabs

Electric pencil sharpener

Kneaded eraser

Koh-I-Noor #285 imbibed eraser strip in electric eraser

Krylon workable fixative

REFERENCE PHOTO

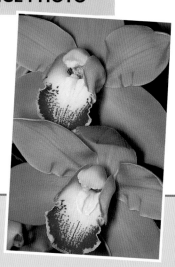

Lay Out the Composition and Underpaint Shadows

With a medium-soft graphite pencil, such as a 2B or B, sketch out basic shapes using very little pressure (too much pressure will impress lines into the paper). After the initial layout is complete, make adjustments with the graphite pencil.

Draw lines next to (not on top of) the graphite lines with a hard colored pencil, such as a Verithin, using colors that correspond to the area to be painted so the outlines disappear when the area is completed. In this case they are Light Green, Golden Ochre and Light Gray.

Erase the graphite with a kneaded eraser so only the colored pencil lines remain (they may need to be touched up). Don't lay out red variegations until the surrounding light yellow area is complete, to avoid unwanted color contamination.

Layer French Grey 70%, 50% and 30% to cast shadow areas as shown. Wash with Bestine solvent and a cotton swab.

Don't Press Too Hard

Be careful not to press too hard when using Verithin pencils, to avoid unwanted impressed lines.

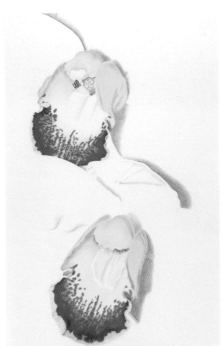

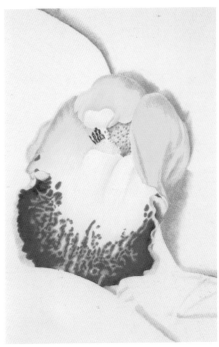

2 Paint the Centers

Layer the center petal shadow areas with French Grey 20% or 10%, depending on the value of the shadow. Wash with Bestine solvent and a cotton swab.

Layer the left and right center petals with Green Ochre, Olive Yellow, Goldenrod, Golden Ochre, Ochre and Light Ochre. Layer the upper center petal with Ochre, Green Ochre, Olive Yellow, Jasmine, Lemon, Chrome Yellow Light, Deco Yellow, Cream (Polychromos) and Cream (Prismacolor).

Layer the lower center petal with French Grey 10% in the shadow areas. Wash with Bestine and a cotton swab. Then layer with Golden Ochre and Ochre. Wash with Bestine and a cotton swab again. Layer the remainder of the petal with a gradation of Jasmine, Deco Yellow, Cream (Polychromos) and Cream (Prismacolor).

Wash the lower center petal with Bestine and a cotton swab. Lightly burnish the remainder of the area with a white pencil. Layer the stamen (lower flower only) with Pumpkin Orange, Orange and Sunburst Yellow, then lightly burnish it with a colorless blender or white pencil.

3 Continue the Centers and Paint Red Variegations

Lightly burnish the left, right and upper center petals with a colorless blender or white pencil. Repeat the following until the surface is covered: Layer the left and right center petals with Green Ochre, Olive Yellow, Goldenrod, Golden Ochre, Ochre and Light Ochre; layer the upper center petal with Ochre, Green Ochre, Olive Yellow, Jasmine, Lemon, Chrome Yellow Light, Deco Yellow, Cream (Polychromos) and Cream (Prismacolor); and lightly burnish the left, right and upper center petals with a colorless blender or white pencil.

Layer red variegations with a gradation of Black Grape (darkest values only), Tuscan Red, Indian Red, Burnt Carmine and Scarlet Lake. Layer the lower open areas with Jasmine, and burnish with a colorless blender or white pencil.

4 Stay With the Centers

Layer the center with French Grey 30% and 20%. Wash with Bestine and a cotton swab. Then layer with Cream (Prismacolor), and wash with Bestine and a cotton swab. Stipple speckled variegations with Black Grape (darkest only) and Tuscan Red.

5 Complete the Petals

Layer the green variegations with Apple Green, then layer selected variegations with Terra Cotta. Wash with Bestine and a cotton swab.

Layer the shadows with Olive Black, Lime Peel and Green Ochre. Wash with Bestine and a cotton swab. Then layer the petal with Apple Green, Lime Peel, Khaki Green, Olive Yellow and Jasmine. Burnish the shadows with a colorless blender. Burnish the remainder of the petal with White. Repeat this process until the paper surface is completely covered.

6 Color the Background

Layer Indigo Blue and Marine Green until approximately two-thirds of the background area is covered with pigment, then lightly burnish with a colorless blender pencil. Layer Indigo Blue and Marine Green until the entire paper surface is covered. Sharpen edges with Verithin Olive Green, then spray with three or four light coats of Krylon workable fixative.

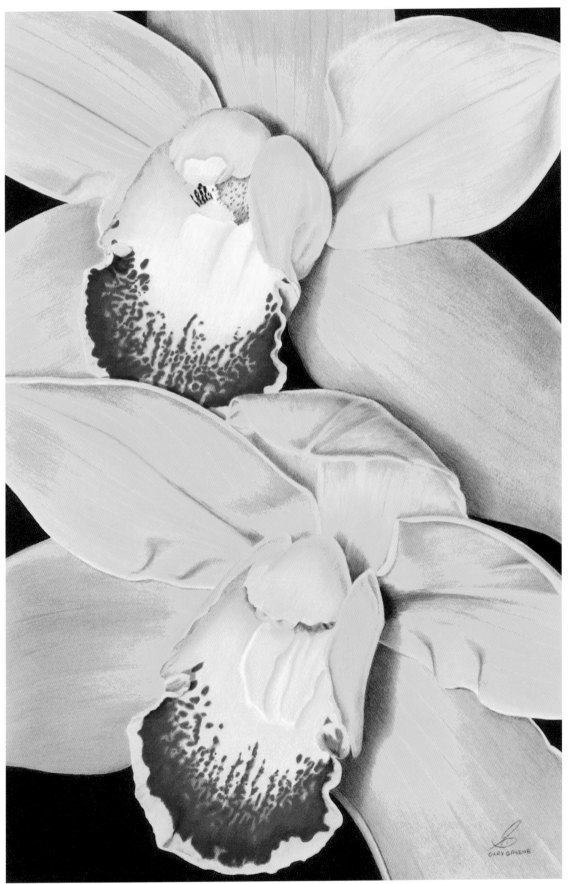

GREEN ORCHIDS
Gary Greene
19" × 12" (48cm × 30cm)

Sunflowers in Ink and Colored Pencil

BY BARBARA KRANS JENKINS A reverence for the woodlands and their Creator and a deep concern for the delicate ecological balance of the environment provide the motivation for Barbara Krans Jenkins's choice of subject. Through her art she tries to stir a sharper awareness and appreciation of beauty so often taken for granted.

Barbara starts with an ink underpainting. She lightly applies several layers of colored pencil, then lighter hues of color with more pressure, until the desired effect is achieved.

MATERIALS

Surface

14 × 11-inch (36cm × 28cm) Crescent 100% rag hot-press watercolor board

Palette

PRISMACOLOR COLORED PENCILS: Apple Green, Beige, Black, Burnt Ochre, Canary Yellow, Chartreuse, Cool Gray 90%, Copenhagen Blue, Cream, Crimson Red, Dark Brown, Dark Green, Dark Purple, Dark Umber, Deco Yellow, French Grey (10%, 30%, 70%), Goldenrod, Grass Green, Grayed Lavender, Indigo Blue, Light Cerulean Blue, Light Umber, Lime Peel, Magenta, Mediterranean Blue, Metallic Green, Mineral Orange, Olive Green, Pale Vermilion, Parma Violet, Peacock Blue, Scarlet Lake, Sienna Brown, Spanish Orange, Sunburst Yellow, True Blue, Tuscan Red, Violet, White, Yellow Ochre

Other

Electric pencil sharpener

Krylon workable fixative

Mechanical pencil with 5mm 2B lead

Staedtler Mars magno 2 4x0

Vinyl eraser strip in electric eraser

REFERENCE PHOTOS

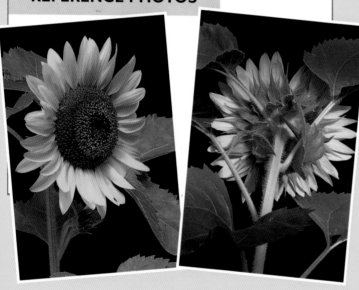

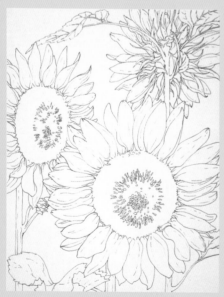

Draw the Composition
With a mechanical pencil, carefully create a contour line drawing on the board surface.

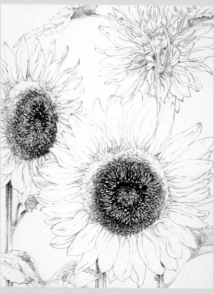

2 Crosshatch Details
Crosshatch detail on flower heads and greenery with a 4x0 mechanical pen.

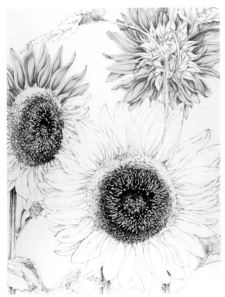 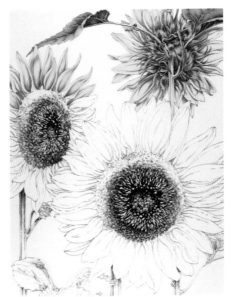 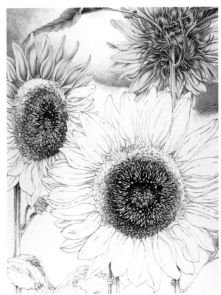

3 Paint Petals

Layer petals of the top flower and the top of the middle flower with French Grey 70% and Parma Violet in the receding and shadow areas, then burnish with Cream. Deepen with Violet, layer with Deco Yellow and burnish with White. Layer with Goldenrod and Yellow Ochre. Burnish with French Grey 30%, and adjust colors as necessary.

4 Paint Stems and Leaves on Back of Flower

Layer stems and leaves on the back of the flower and ladybug at the top with Magenta, Violet, Indigo Blue and Dark Green. Layer in the shadows and folds of the leaves with Olive Green and Grass Green. Burnish with White, Chartreuse and Metallic Green, adjusting colors as necessary. Layer stems with Lime Peel, Olive Green, Dark Green and Apple Green. Burnish with White. Leave the highlights on the ladybug free of color, allowing white paper to show through. Layer Tuscan Red and Crimson Red in the dark areas. Burnish with Scarlet Lake and Pale Vermilion. Complete the fuzz on the stems and bracts with a sharp White pencil. Apply strokes at the point of origin for each hair, pressing firmly, then quickly drawing the pencil up and out in different directions as the hairs would grow.

5 Paint Sky

Layer Light Cerulean Blue, True Blue, Mediterranean Blue and Copenhagen Blue, then burnish with White, adjusting colors as necessary.

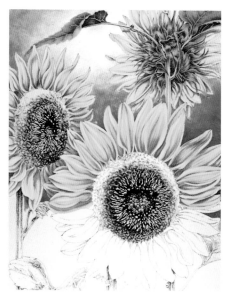 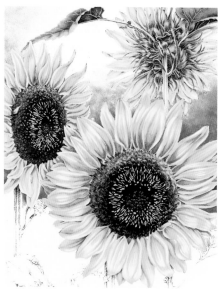 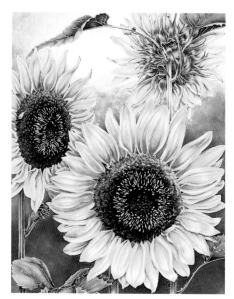

6 Complete Middle Petals and Paint Sky

Finish the middle petals with the same colors and technique used in step 3. Layer the petals at the top of the foreground flower with Parma Violet, French Grey 70%, Violet and Grayed Lavender. Layer folds with Canary Yellow, Spanish Orange and Yellow Ochre. Burnish with Beige and Deco Yellow. Bring the sky down with the same colors used in step 5. Add layers of Peacock Blue and Indigo Blue.

7 Complete Foreground Petals, Paint Sepals and Punch Up Foreground Flower

Follow step 6 to finish the foreground petals. Layer the heads with Canary Yellow, Light Umber and Yellow Ochre. Burnish with Beige. Layer the unopened buds in the middle of the heads with Olive Green. Burnish with French Grey 10%. Layer the heads with Burnt Ochre and Sienna Brown. Burnish with Dark Brown. Layer Dark Umber, Cool Gray 90% and Black. Adjust the colors as necessary. Punch up foreground petals by burnishing with layers of Mineral Orange, Burnt Ochre, Sienna Brown, Light Umber and Sunburst Yellow.

8 Emboss for Pollen; Complete Leaves, Ladybug and Sky

Complete the pollen on the leaves with Canary Yellow, then emboss the surface with a stylus to create dots of yellow. Finish the bottom leaves and stems using the colors in step 4. The pollen remains because the color is pressed into the board.

Complete the ladybug with the colors used in step 4, omitting the white highlight. Bring the sky down with more Copenhagen Blue, Peacock Blue and Indigo Blue, then burnish with White.

9 Final Adjustments

Adjust the colors over the entire painting with Violet, Blue Violet and Copenhagen Blue to accent the middle and back flowers. Intensify the background with Peacock Blue, Copenhagen Blue, Olive Green, Indigo Blue, Tuscan Red and Dark Purple. Burnish with White and French Grey 10% as needed.

Adjust the colors in the foreground leaf with the greens described in step 4. Burnish with White and Chartreuse. Accentuate pollen with a very sharp Canary Yellow pencil, using Yellow Ochre in darker areas. Apply Krylon workable fixative when complete.

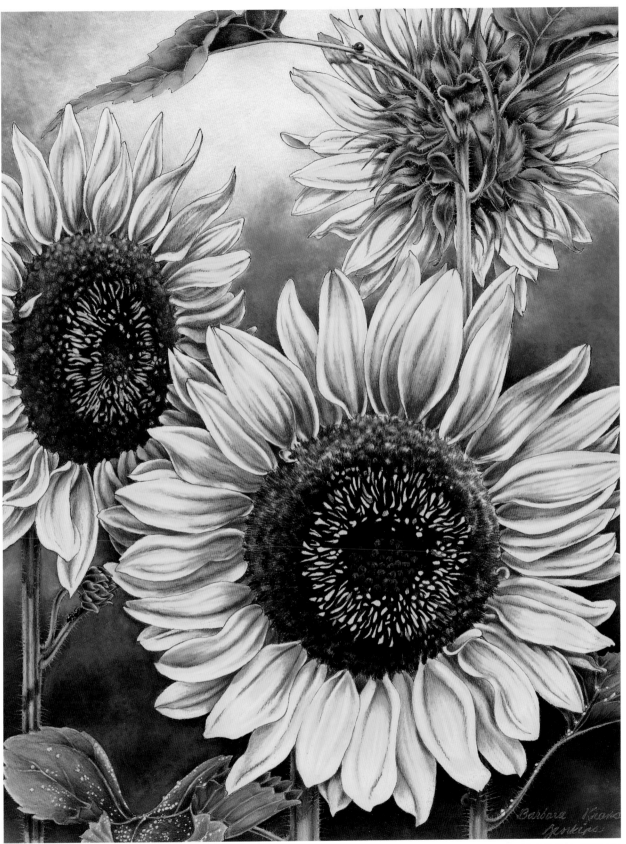

THREE'S A CROWD
Barbara Krans Jenkins
14" × 11" (36cm × 28cm)

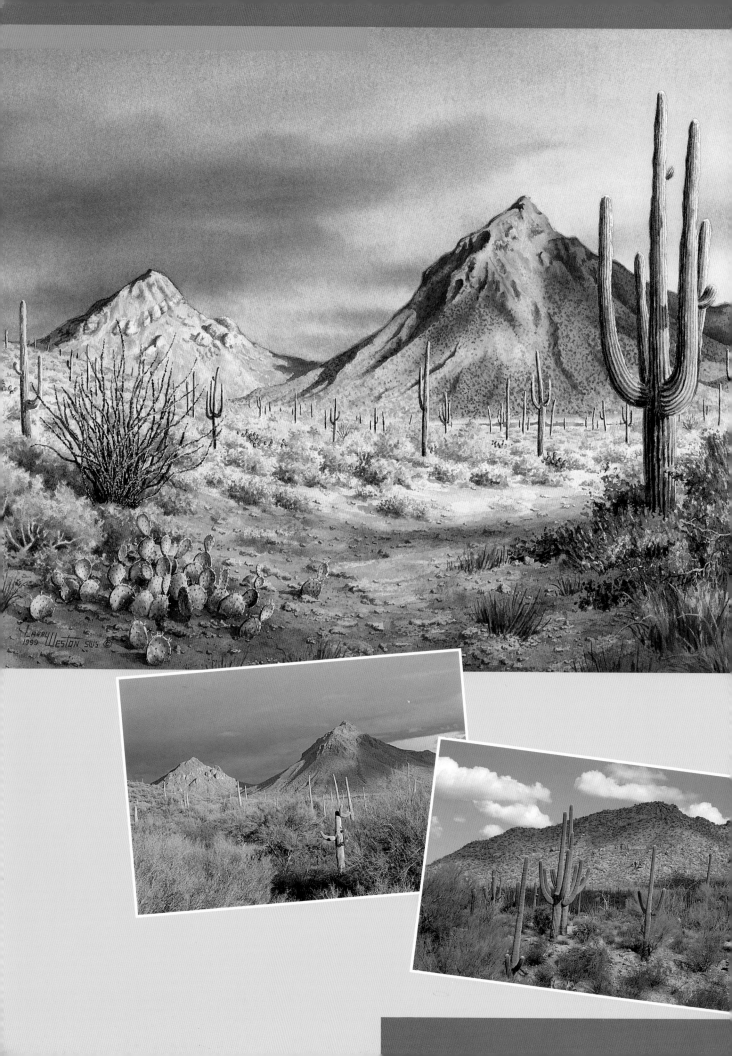

2 LANDSCAPES

Do you ever have an overwhelming desire to paint a desert scene, though you live several hundred or even thousands of miles away from the nearest desert? Most artists simply don't have the time or money to travel to faraway locations on a moment's notice. Instead, they wrack their brains for a mental image to re-create on their painting supports. Turning to reference photos for inspiration and ideas is a great way to save yourself the mental anguish that comes along with "winging it." Photographs allow you to experience a wide variety of landscapes without ever leaving your backyard.

Even if you have the time and resources to work on location, there are still benefits to painting from reference photos. No one can dispute the exhilaration one feels when viewing his or her subject first hand—it's nothing short

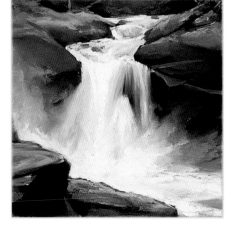

of thrilling to be an integral part of the scene you're capturing. But painting on location requires a great deal of planning and preparation. The unpredictable nature of weather and ever-changing lighting conditions can create conflict, and dragging your supplies to and from the painting site can get tiresome. Painting from photos frees you from such concerns, and you'll never have to leave the comfort of your own studio.

In this chapter, you'll encounter numerous landscapes that boast a wide variety of geographic and climatological features. You'll paint everything from lush forests to arid deserts, rugged, snow-capped peaks to beaches laden with miles of driftwood, and deep canyons to colorful cliffs. Enjoy the demonstrations, then try painting one of your favorite places from an old photo in your album.

Rocky Stream in Colored Pencil

BY GARY GREENE In this painting, Gary Greene demonstrates how selective cropping enhances a composition. Although he cropped out many interesting elements in the reference photo, the finished painting offers a stronger composition. Gary took the reference photo in the Mount Baker National Forest in the state of Washington. He used a slow shutter speed to depict the water's flow through the terra cotta rocks.

Gary used water-soluble colored pencils, wrapping up with oil-based pencils in the final step.

MATERIALS

Surface
Half sheet of Arches 300-lb. (640gsm) rough watercolor paper

Palette
DERWENT WATERCOLOR PENCILS: Brown Ochre, Raw Sienna, Silver Grey

FABER-CASTELL ALBRECHT DÜRER WATERCOLOR PENCILS: Brown Ochre, Burnt Carmine, Cream, Dark Cadmium Orange, Dark Sepia, Grey Green, Indian Red, Ivory, Raw Umber, Terracotta, True Green, Van Dyke Brown, Venetian Red, Warm Gray I, II, III and IV

FABER-CASTELL POLYCHROMOS COLORED PENCILS: Brown Ochre, Burnt Carmine, Dark Sepia, Grey Green, Indian Red, Light Phthalo Green, Terracotta, Van Dyke Brown, Venetian Red, Warm Gray I, II and III, White

Brushes
Nos. 6 and 8 rounds

Other
2B graphite pencil

Container for water

Cotton swabs

Electric eraser with Koh-I-Noor imbibed eraser strips

Electric pencil sharpener

Hair dryer (optional)

Kneaded eraser

Paper towels

Small piece of sandpaper

REFERENCE PHOTO

Lay Out the Composition
Lay out the painting on your watercolor paper with a 2B graphite pencil. When the composition is finalized, retrace it next to the graphite lines with the Silver Grey and Venetian Red water-soluble colored pencils. Then erase all the graphite lines with a kneaded eraser. The colored pencil lines will remain after erasing.

2 Underpaint the Fungi

Apply Raw Sienna, Cream and Ivory with a sharp pencil point to depict the light yellow fungi. Apply water with a medium-dry no. 8 round brush. Allow to dry thoroughly or dry with a hair dryer. Repeat the process with Terra-cotta, Dark Cadmium Orange and Ivory to depict the orange fungi.

3 Paint the Rocks

Apply Warm Gray IV, Dark Sepia or Van Dyke Brown with a sharp pencil point to depict the dark and shadow areas. Apply water with a medium-dry no. 8 round brush. Allow to dry thoroughly or use a hair dryer. Then apply various combinations of Indian Red, Venetian Red, Burnt Carmine, Brown Ochre (Faber-Castell Albrecht Dürer Watercolor Pencils) and Raw Umber to depict the rocks. Leave some areas clear of pigment for water or highlights.

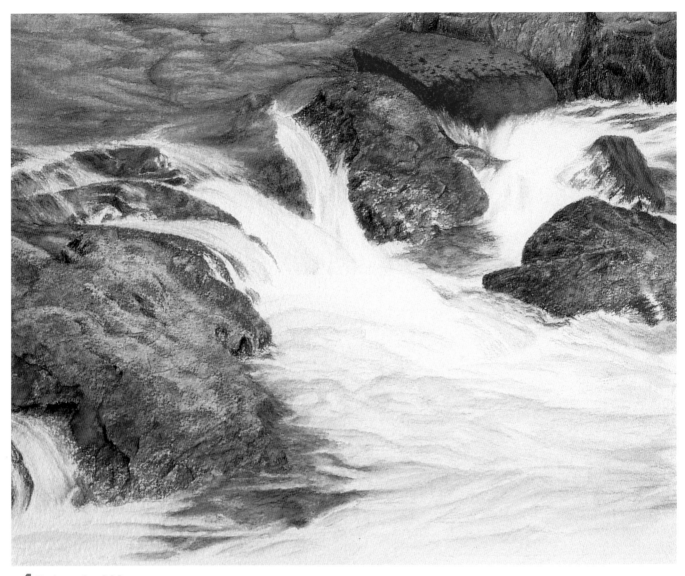

4 Paint the Water

Underpaint the still water areas with light applications of Grey Green and True Green. Apply water with a medium-dry no. 8 round brush. Allow to dry thoroughly or use a hair dryer.

Next, paint the submerged rocks and other underwater features on top of the green underpainting by applying various combinations of Dark Sepia, Van Dyke Brown, Raw Umber, Raw Sienna and Brown Ochre (Derwent). Apply water with a medium-dry no. 6 or no. 8 round brush. Dry thoroughly with a hair dryer or allow to air dry.

To depict the rapid water, lightly apply Grey Green, True Green and Warm Gray I, II or III. Apply water with a medium-dry no. 8 round brush. Dry thoroughly with a hair dryer or allow to air dry.

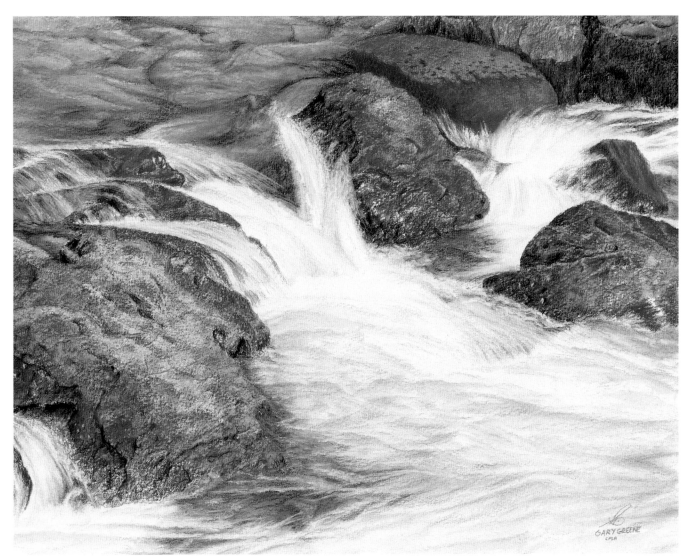

WATER ON THE ROCKS
Gary Greene
10½" × 14½" (27cm × 37cm)

5 Tie Rocks and Water Together

Using medium pencil pressure, add details to areas with the darkest values with Polychromos oil-based pencils Dark Sepia and Van Dyke Brown. Tighten areas where the water contacts the rocks by adding applicable rock and water colors, including Polychromos Light Phthalo Green, Brown Ochre, Burnt Carmine and Terracotta. Enhance the rapid water by lightly adding Polychromos Grey Green and Warm Gray I, II or III, then blending with a dry cotton swab. Repeat as necessary.

Using very light pencil pressure, add half-immersed rocks with various combinations of Polychromos Indian Red, Venetian Red, Dark Sepia and Van Dyke Brown. Sharpen the end of a vinyl electric eraser strip to a point with a small piece of sandpaper. Lightly erase areas where the water meets the base of the rocks and waterfalls to create a fine-mist effect. (Frequently sharpen the eraser point.) Lightly reapply applicable rock colors (Brown Ochre, Burnt Carmine and Terracotta). Add strokes of Polychromos White to depict waterfall details over the rocks.

Keep Pencils Sharp

The "dry" colored pencils in the final step must be kept extremely sharp at all times. Due to the rough texture of the paper, the point dulls quickly, requiring frequent sharpening.

Sandstone Rock Structures in Acrylic

BY MARY SWEET Mary Sweet, an accomplished Southwestern artist, is intimately familiar with the remarkable terrain of this area. Her unique stylistic rendition of sandstone structures, referred to as "hoodoos," evokes an ethereal feeling all its own.

Mary took the primary reference photograph (bottom) at Red Rock Canyon State Park, just a few miles from spectacular Bryce Canyon National Park in Utah. She used a polarizing filter to enhance the colors in the scene, then further enhanced the painting by adding fleecy cirrus clouds that were photographed an entire region away, in the Pacific Northwest (photo directly below).

MATERIALS

Surface
18 × 24-inch (46cm × 61cm) 300-lb. (640gsm) hot-press watercolor paper

Palette
LIQUITEX MEDIUM VISCOSITY ACRYLIC ARTIST COLORS: Acra Violet, Burnt Sienna, Burnt Umber, Cadmium Orange, Cadmium Yellow Medium, Cerulean Blue, Chromium Oxide Green, Dioxazine Purple, Hooker's Green Hue Permanent, Hooker's Green Deep Hue Permanent, Mars Black, Payne's Gray, Phthalo Blue, Raw Sienna, Red Oxide, Titanium White, Ultramarine Blue, Unbleached Titanium, Yellow Orange Azo, Yellow Oxide

Brushes
No. 18 Langnickel round

Nos. 1, 2, 4, 6 and 8 watercolor brushes

Old splayed no. 8 brushes (for mixing)

Other
Empty cans (to mix/store large quantities of paint)

Enamel trays (to cover palettes)

No. 2 graphite pencil

Paper palettes

Spray bottle (to keep paint moist)

REFERENCE PHOTOS

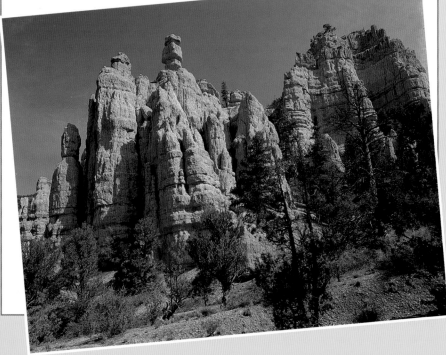

Make Your Line Drawing

Very lightly draw the main shapes of the rocks and clouds with a no. 2 graphite pencil on untreated water-color paper. The drawing shown here is actually darker than yours should be; it was done this way so you could see the lines more clearly.

2 Paint the Sky and Upper Trees and Start the Hoodoos

On a paper palette, mix Titanium White from the tube with enough water so it will spread. With the no. 18 round brush, cover the entire sky area with Titanium White. Be sure to cover any pencil lines. Mix Phthalo Blue, Ultra-marine Blue and Titanium White for the blue sky patches. Use the no. 8 brush to mix and fill in the big areas and a no. 4 brush for the tighter ones. (You may have to mix paint more than once to achieve the right color, smooth-ness and texture.) Directly on the can-vas, paint a mixture of Titanium White, Cerulean Blue and Payne's Gray for the few grayer shapes on the cirrus clouds. Keep the paint even and smooth.

Mix a large amount of Cadmium Yellow Medium, Titanium White, Yellow Oxide and Yellow Orange Azo and paint the main cliffs of the hoodoos. (Use a washed, empty peanut can to store the paint so you can go back to it later.)

Paint the trees on top of the hoodoos using Hooker's Green Hue Permanent, Burnt Umber and Dioxazine Purple with the no. 4 and no. 2 brushes. (Use the smaller brushes for second coats.) Add highlights with a mixture of the greens and Yellow Oxide using a no. 1 brush. Use Payne's Gray for the branches.

Turn Paper for Easier Painting

When painting freehand, turn the paper as needed to work from the angles that are easiest for you.

3 Shape the Rocks

Begin shaping the rock formations by painting the large rock shapes with the yellow mixture from the peanut can, using the no. 18 round brush for the large areas and the nos. 8, 4 and 2 brushes for the smaller areas. Mix Cadmium Orange and Titanium White and paint in patches on the lighter rocks. Detail areas as you go. For instance, at the top right of the rocks, mix Titanium White, Dioxazine Purple, Red Oxide and Burnt Umber (start the foreground with these colors, too). Use variations created with Payne's Gray for some patches and add detail using Raw Sienna and Titanium White, Red Oxide, Cadmium Orange and Burnt Umber.

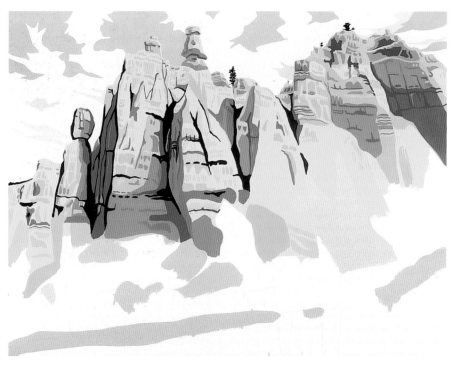

4 Shade and Detail the Rocks

Add subtle color differences to the orange in the rocks. Use Dioxazine Purple and Burnt Umber for the darkest darks in the cracks and to help define form. For slightly lighter darks, add Burnt Sienna and a bit of Titanium White. The hoodoos are very complex; work from left to right across the paper; defining form with dark color variations and adding details as you go. Mix Acra Violet and Titanium White with the dark residue on your brush. Add some of this color in areas where the spires have eroded to the ground and in a few small patches higher on the rocks. For the hoodoos on the right, use oranges, Unbleached Titanium and mixtures of Burnt Sienna, Burnt Umber, Red Oxide and Titanium White. Use the no. 2 brush for the small details and nos. 4 and 6 for the larger ones.

Painting With Acrylics

When painting with acrylics, you may need to paint an area more than once as some colors are translucent and do not cover completely.

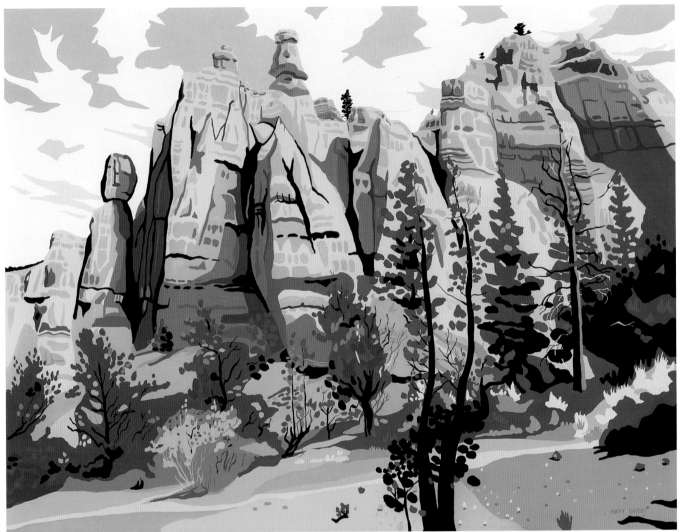

5 Add Lower Trees and Complete the Foreground

Mix Chromium Oxide Green with Mars Black, Unbleached Titanium and Titanium White in various combinations to create lighter and darker variations of greens to paint some of the trees and bushes. Use brush nos. 6 and 8.

The rock walls have been painted in behind the tree areas. You will have to work back and forth between the greens and the oranges to show the cliffs through the leaves. In the foreground, put in oranges and grayed purples interspersed with green and gray-green bushes and grasses, using the no. 2 and no. 4 brushes. Use Payne's Gray, Titanium White and a tiny bit of Chromium Oxide Green for the light gray-green areas. The brighter greens are Chromium Oxide Green mixed with Yellow Oxide and Titanium White.

Add the darker green shadow areas in the trees using Hooker's Green Hue Permanent and Hooker's Green Deep Hue Permanent. Finally, add the tree trunks and branches using a no. 1 brush. Most are Mars Black, but some trunks are mixtures of Burnt Umber, Titanium White and Burnt Sienna.

To finish, look carefully at the painting to see if anything is needed or if anything is out of balance.

Desert Cacti in Watercolor

BY LARRY WESTON Larry Weston uses a variety of reference photos in this demonstration to capture the essence of the desert, from the overcast sky to the prickly cacti.

MATERIALS

Surface

22 × 30-inch (56cm × 76cm) 300-lb. (640gsm) cold-press watercolor paper

Palette

WINSOR & NEWTON ARTISTS' WATERCOLORS: Aureolin, Burnt Sienna, Cerulean Blue, Cobalt Blue, New Gamboge, Payne's Gray, Ultramarine Blue, Winsor Blue, Winsor Red, Yellow Ochre

DANIEL SMITH EXTRA FINE WATERCOLORS: Quinacridone Gold, Quinacridone Red, Quinacridone Violet

Brushes

1-inch (25mm) and 2-inch (51mm) flats

Nos. 0, 3, 6 and 16 rounds

Other

¼-inch-thick (6mm) marine plywood board

Cosmetic sponge with small holes

Daler-Rowney Pro White

Drafting tape

Magic Rub eraser

Masking fluid

Masking tape

Natural sea sponge

No. 2 soft lead pencil

Stapler

REFERENCE PHOTOS

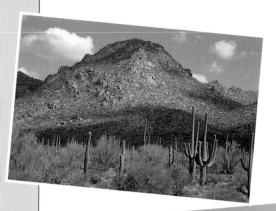
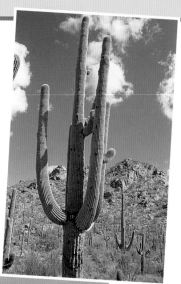
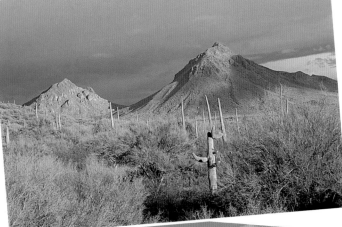
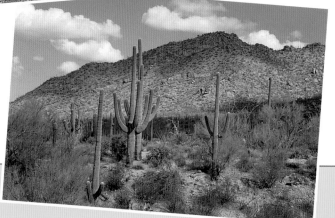

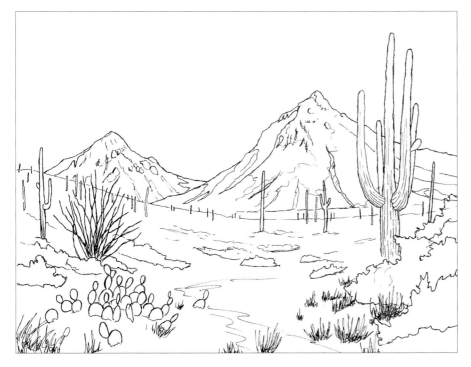

Prepare the Paper and Make Your Drawing

Cut the paper to the approximate size desired. Staple the dry paper onto a ¼-inch-thick (6mm) marine plywood board that is about 1 inch (2.5cm) larger than the paper. Wet the paper with a sponge; lightly rub four to five times in all directions to remove any excess sizing. Allow the paper to shrink and dry. Use drafting tape on each edge of the paper to establish the exact finished size of the painting. Use a no. 2 soft lead pencil to compose your sketch and a Magic Rub eraser to remove any unwanted lines.

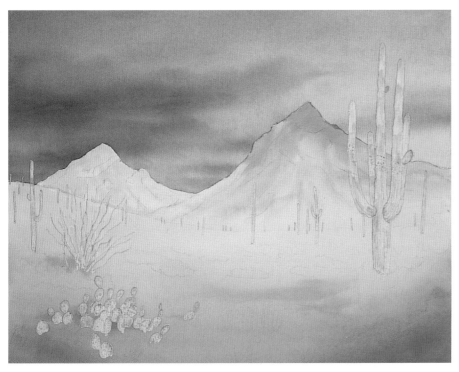

2 Paint the Sky and Begin the Mountains and Foreground

Brush masking fluid over the various cacti. To duplicate the warm glow behind the stormy sky, apply clear water while avoiding the mountains. While wet, paint a light wash of Winsor Red over the entire sky with a 2-inch (51mm) flat sky brush. Let this dry. Apply more clear water. Using a 1-inch (25mm) flat brush, add the stormy clouds using various mixtures of Payne's Gray and Winsor Blue. Air dry completely.

Brush two coats of clear water onto the mountains and the entire foreground (try not to overlap into the sky). Quickly brush a light coat of Burnt Sienna with a touch of Quinacridone Gold over the entire wet area with the 2-inch (51mm) flat sky brush. Keep the base of the mountain the lightest.

While the paint is still wet, add Burnt Sienna with a touch of Quinacridone Violet to the top portion of the large mountain and to the lower foreground. Add Winsor Red to the center portion of the lower foreground. Darken the lower corners of the painting with a mixture of Burnt Sienna and Winsor Blue. Let dry completely.

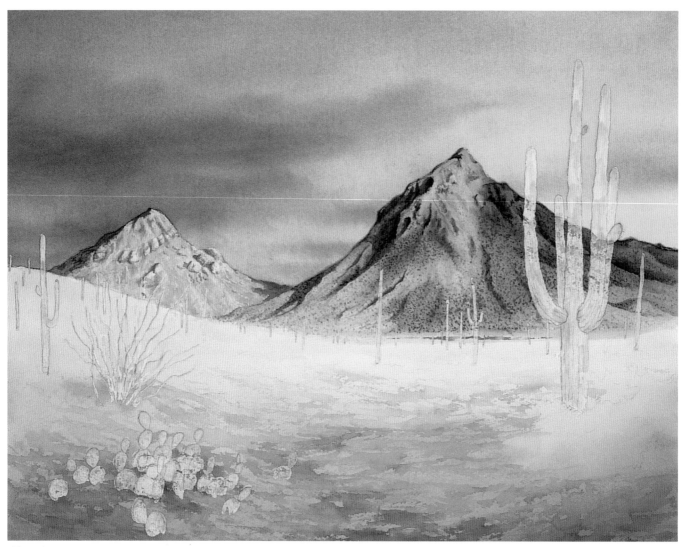

3 Paint the Mountains and Foreground Texture

Using your 2-inch (51mm) flat sky brush, apply clear water to the larger mountain followed by a light coat of Quinacridone Violet. Add Winsor Blue to the Quinacridone Violet and brush onto the upper half of the mountain. This glaze cools down the warmth of the mountain while maintaining its glow. Let dry.

Use a no. 6 round brush to apply a lighter version of the same colors directly onto the dry paper for the smaller mountain. While it's still wet, soften some of the edges with water. Apply clear water again to the larger mountain, then brush on a mixture of Quinacridone Violet and Winsor Blue with a no. 16 round brush to create the shadows. Allow the edges to bleed on their own and the painting to dry.

Lightly define the cracks, crevasses and shadow areas of both mountains with a light mixture of Quinacridone Violet and Winsor Blue with nos. 6 and 3 round brushes. While it's still wet, soft-

en some of the edges with water. Use the same color mixture to slowly go over each area several times until the desired darkness is achieved. Allow the layers to dry between applications.

With the tip of a no. 3 round brush, add small dots of the same color mixture to the lower portion of the larger mountain to suggest bushes. Soften some with water. Use a mixture of Aureolin, Cobalt Blue and Quinacridone Violet and dot onto the base of the mountain. Lastly, blend the edges of the mountain with the sky using a no. 3 round brush.

Using a no. 6 round brush loaded with Burnt Sienna, gently drybrush the foreground of the painting. Try to hit some of the little peaks on the paper's surface while leaving many unpainted holes. While it's still wet, soften some of the edges with water and drybrush a mixture of Burnt Sienna and Quinacridone Red over the same damp area. Work on small areas at a time to avoid hard edges.

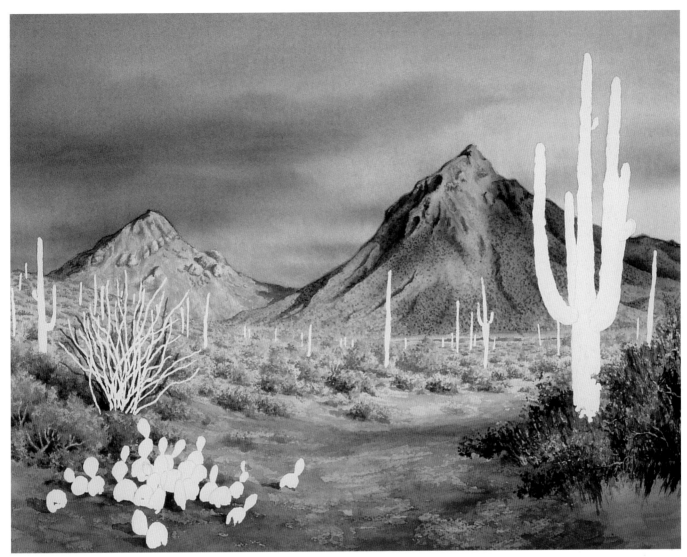

4 Add the Bushes and Intensify the Foreground Colors

Use Aureolin, Cobalt Blue and Quinacridone Gold to suggest the distant and middle-ground shrubbery. Subdue these pale greens with a slight trace of Burnt Sienna applied with a piece of a cosmetic sponge and let it dry. With the same sponge, lightly apply Quinacridone Red on some of the bushes. Darken the base of the shrubs using the same colors with a no. 3 round brush.

Intensify colors and values toward the foreground. Use negative painting to suggest a few branches in the shrubs near the bottom corners of the painting. Apply the same colors with a

piece of sea sponge for the dark bushes on the right. Deepen these with Burnt Sienna, Winsor Blue and New Gamboge. Darken the foreground with Burnt Sienna, Quinacridone Violet and Winsor Red. Drybrush the colors into place in small areas at a time while still damp, then soften with water.

After the painting is completely dry, remove the masking fluid from the cacti by dragging a piece of masking tape, in one direction only, across the dried masking. (Or you may use a rubber cement pickup.)

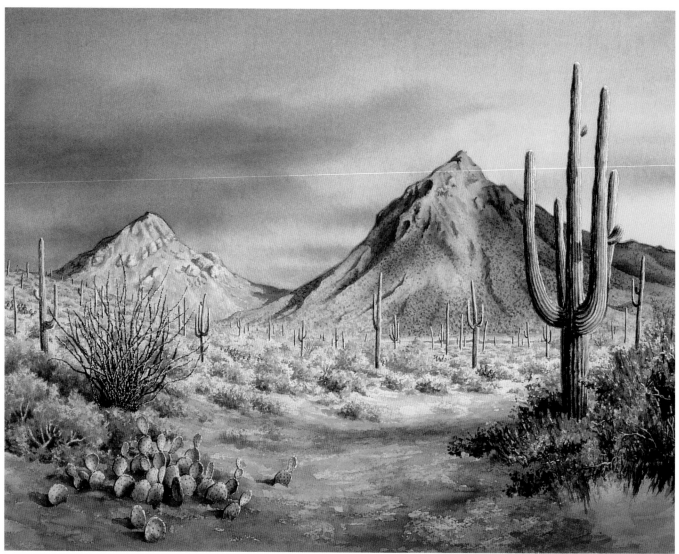

5 Paint the Cacti

Use nos. 6 and 3 round brushes with light mixtures of Cerulean Blue, New Gamboge and Burnt Sienna to establish the basic coloring and shape of the tall saguaro cacti. Let dry. Slowly add the rib details, shadows and darker values using combinations of Burnt Sienna, New Gamboge and Ultramarine Blue. Let this dry. Apply a little Quinacridone Red to the lower portions of the saguaros. Use a no. 3 round brush to apply the same colors used for the saguaro to the spindly ocotillo cactus on the left—light mixtures on the right side toward the light source, and darker values on the left.

Make small dots using darker values along the shady side of each stalk to suggest very small leaves (later, the leaves on the sunny side will be added using a little opaque color).

Using nos. 6 and 3 round brushes, separately paint each pad of the prickly pear cacti in the foreground with New Gamboge, Burnt Sienna and Quinacridone Violet. Leave a thin line between each pad. After the pads are dry, use both the lighter and darker colors from the saguaro and ocotillo to give the pads shape and form. When the pads are complete, glaze the white lines between them with New Gamboge and the dark green mixtures respectively.

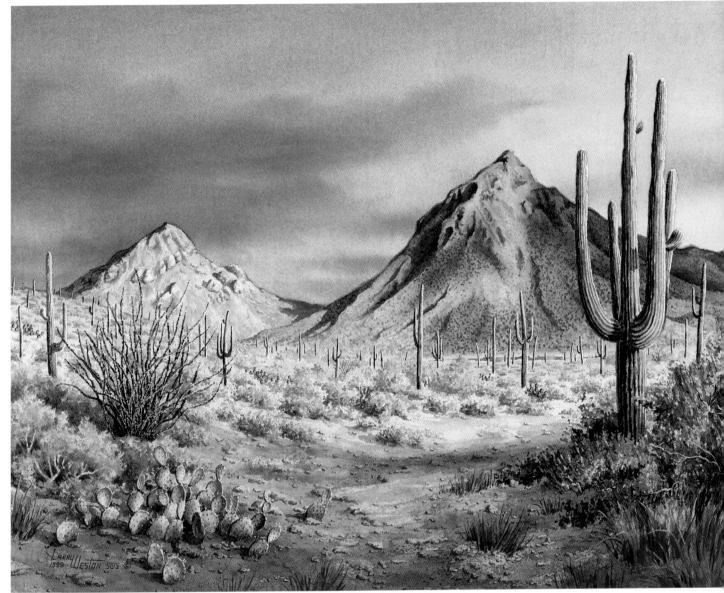

6 Paint the Rocks and Grasses

All light areas in the foreground had the potential to become rocks. In most cases, all a light area needs is a shadow side and a base to suggest a rock. Use the ground colors—Burnt Sienna, Quinacridone Red and Quinacridone Violet—to paint the rocks by creating a shadow below the light areas and up the left side. Use a hard edge to maintain the shadow where the rock touches the ground. Deepen these by adding a little Winsor Blue to the mixtures and dropping it into the wet color.

Use a small piece of sea sponge to create the foreground grasses. Load the wet sponge with Yellow Ochre and lightly touch the paper using both downward and upward strokes to suggest

NATURE'S PERFECTION
Larry Weston
16" × 21" (41cm × 53cm)

grass. Apply three values and colors while the first coat is still wet. Allow the grass to dry, then add several combinations of Yellow Ochre, Burnt Sienna and Quinacridone Red. Deepen with Quinacridone Violet and Winsor Blue.

Use Quinacridone Gold, Yellow Ochre and a small amount of Pro White to add small leaves to the ocotillo on the sunny side, the sharp spines to the prickly pear and to highlight a few blades of grass, using a no. 0 round brush.

Beach With Flowers in Pastel and Acrylic

BY PEGGY BRAEUTIGAM Peggy Braeutigam's pastel rendition of this beach in La Jolla, California, shows how the artist improves a photograph by deleting unwanted detail. The fence, light posts and other distracting elements on the background cliff and the dead branches in the foreground were omitted from the painting. Ice plant from an adjacent beach was tastefully added to the cliff and foreground, creating a serene, natural look.

MATERIALS

Surface

18 × 24-inch (46cm × 61cm) pastel board

Palette

Acrylics
GOLDEN LIQUID ACRYLICS: Dioxazine Purple; Hansa Yellow Light; Permanent Violet Dark; Quinacridone Burnt Orange; Turquoise; Ultramarine Blue

Pastels
ART SPECTRUM MEDIUM SOFT PASTELS: 580V Australian Leaf Green Light; 548T Burnt Sienna; 552V Burnt Umber; 520D Flinders Blue Violet; 574T Green Grey; 524T Spectrum Blue

GREAT AMERICAN SOFT PASTELS: 575.3 Havana; 275, 275.1 and 275.2 Merlot; 740, 740.1 and 740.3 Perry Winkle; 299 White

REMBRANDT MEDIUM SOFT PASTELS: 538.5 Mars Violet; 506.3 Ultramarine Deep

SENNELIER SOFT PASTELS: 57 Bistre; 412 and 415 Cassel Earth; 211 Reseda Grey Green

UNISON SOFT PASTELS: BV1 and BV18 Blue Violet; A43 Green; SC18 Green Earth; RE6 Red Earth; A27 and A34 Violet

Pastel Pencils
DERWENT PASTEL PENCILS: 78B Green Umber; 67B Ivory Black; 48B and 48D May Green; 53B Sepia; 1D Zinc Yellow

Brushes

No. 8 round

Other

Lascaux spray fixative

Paper towels

Vertical easel (for working with pastel)

REFERENCE PHOTOS

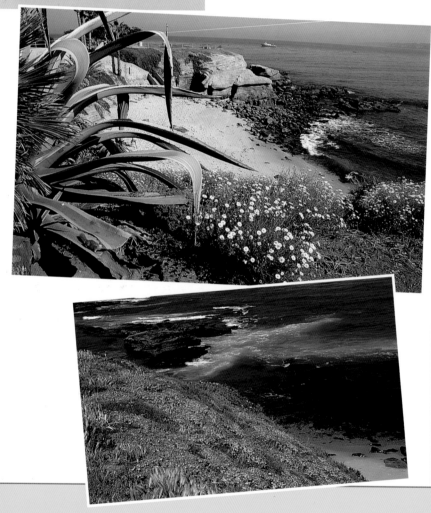

Draw the Layout

Draw the layout on the pastelboard with a 67B Ivory Black pencil, allowing ¼ inch (.6cm) all around for framing. Use the no. 8 round watercolor brush to carefully retrace the lines with water, dissolving and setting the pastel. Lightly dab any excess water around the lines with a paper towel as you work.

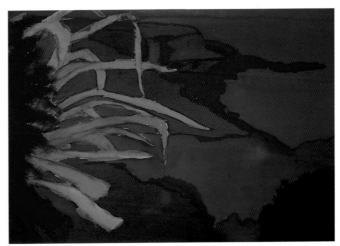

2 Begin Underpainting With Acrylics

Working on a flat surface, start at the top and apply a wash of Ultramarine Blue for the sky and ocean. Pick up excess color with a paper towel. Use Dioxazine Purple for the shoreline and shadow areas on the distant bluff and Quinacridone Burnt Orange for the bluffs, beach and foreground. Underpaint the floral bushes with Turquoise and the palm leaves on the left with Permanent Violet Dark. Allow to dry before using Hansa Yellow Light for the long, thin leaves. (This will help prevent bleeding at the edges.)

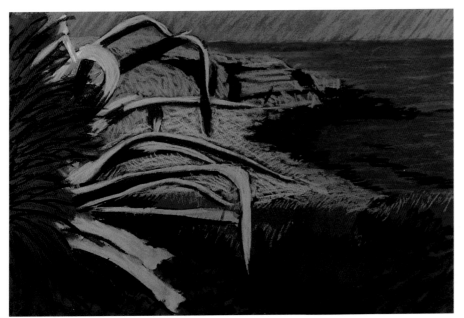

3 Block In First Pastel Layer

Always work pastels on a vertical easel. Starting at the top, keep all strokes loose, allowing the underpainting of acrylic to show through. Do not use your fingers anywhere at this stage. When finished, smack the back of the board to loosen any dust.

Use the following pastels for the different elements.

524T Spectrum Blue—sky area
BV18 Blue Violet—ocean
520D Flinders Blue Violet—shoreline and
 shadow area of bluffs
548T Burnt Sienna and A34 Violet—bluffs
548T Burnt Sienna—beach
A34 Violet and RE6 Red Earth—shoreline
574T Green Grey and A27 Violet—long,
 thin leaves
520D Flinders Blue Violet and SC18 Green Earth—palm leaves
520D Flinders Blue Violet and A34 Violet—shadows of floral
 bushes
RE6 Red Earth—foreground

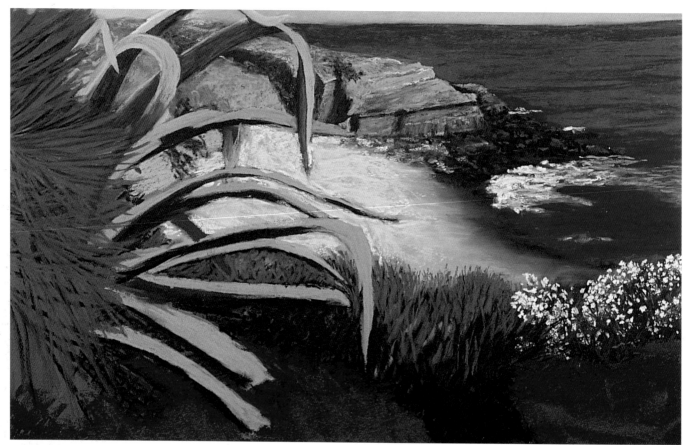

4 Refine With Second Pastel Layer

Many different combinations of colors are used to create the depth of the painting. Proceed with the following sections, using the colors listed.

A Sky. Use the broad side of BV1 Blue Violet to cover the sky area. Blend with your fingers.

B Ocean. At the horizon and throughout the ocean, apply BV18 Blue Violet, 524T Spectrum Blue, 506.3 Ultramarine Deep, 520D Flinders Blue Violet and BV1 Blue Violet. Lightly cover the area with Lascaux spray fixative to somewhat seal the existing pigments. Then use 299 White and BV1 Blue Violet for the waves.

C Bluffs. Start with the darkest values to create form. Use 520D Flinders Blue Violet; 552V Burnt Umber; 548T Burnt Sienna; 275, 275.1 and 275.2 Merlot; 538.5 Mars Violet; 415 Cassel Earth and 57 Bistre.

D Rocks along the shoreline. Use 520D Flinders Blue Violet, 57 Bistre and 275 Merlot. Define the shapes with 275.1 and 275.2 Merlot, 538.5 Mars Violet and 415 Cassel Earth.

E Beach and shoreline. Use 552V Burnt Umber, then 412 and 415 Cassel Earth. Work over with 520D Flinders Blue Violet and 275.1 Merlot.

F Long, thin leaves. Use 580V Australian Leaf Green Light, 520D Flinders Blue Violet, SC18 Green Earth and 275.1 Merlot.

G Palm fronds. Randomly place strokes of SC18 Green Earth over the 520D Flinders Blue Violet. Lightly spray entire painting with Lascaux spray fixative.

H White flower bushes. Use A43 Green and 520D Flinders Blue Violet for the stems. Do not blend with fingers anywhere. Apply 211 Reseda Grey Green, SC18 Green Earth and 580V Australian Leaf Green Light randomly throughout.

I Specks of flowers. Scrape a fingernail along the edge of the pastel stick using BV1 Blue Violet, 575.3 Havana and 299 White. Firmly apply pressure to the specks, press and lift; do not smear.

J Whole flowers. Use 299 White, 575.3 Havana and 740 and 740.1 Perry Winkle.

K Foreground dirt. Redefine shadows with 520D Flinders Blue Violet and 275 Merlot.

L Flower bush shadows and foreground. Use 520D Flinders Blue Violet. Finish the foreground with 275.1 and 275.2 Merlot.

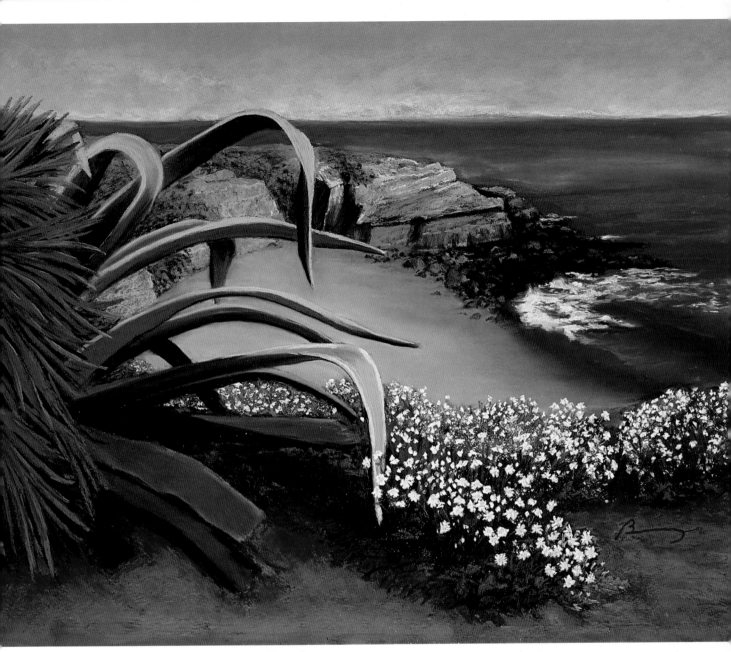

5 Finger-Blend and Add Finishing Touches

Use your fingers to blend various areas—the foreground dirt, ocean, plant leaves, beach and shoreline—taking care not to smudge. Spray periodically with Lascaux spray fixative. To finish the sky, use the broad side of the pastels to mix 524T Spectrum Blue and 740.3 Perry Winkle into the BV1 Blue Violet at the horizon line, then blend.

Using Derwent pencils 67B Ivory Black and 53B Sepia, redefine the shadow areas on the long, thin leaves. Draw in yellow lines on these leaves with 1D Zinc Yellow and 48B and 48D May Green. Highlight with 48B May Green. (You'll notice that the thin leaf above the horizon line was removed. The leaf was brushed out and the area washed with water and allowed to dry before repainting.)

Highlight the tips of the palm leaves with 48B May Green and 275.1 Merlot. Redefine some shadowed areas with 520D Flinders

Blue Violet. Finish the foreground flowers with the pastels used in step 4. For the flowers and grass on top of the background cliffs, use SC18 Green Earth, A43 Green and 740 and 740.1 Perry Winkle. Only use fingers to lightly tap the top of the flowers and grass. Mute the values as necessary. Draw the strokes in the direction that you want the eye to follow.

Redefine crevices in the bluffs with 67B Ivory Black and 78B Green Umber. Highlight areas of the flower bushes with 48B and 48D May Green. Don't finish with spray fixative at this point because all of the light values will darken too much.

SECLUDED BEACH
Peggy Braeutigam
17" × 23" (43cm × 58cm)

Autumn Mountain Scene in Mixed Media

BY NANCY PFISTER LYTLE You may have seen this vista before. That's because it's one of the most photographed spots in North America: Artist Point in the Mount Baker National Forest, about sixty miles east of Bellingham, Washington. On a beautiful autumn day like the one shown in these photographs, the most difficult problem in photographing this scene is keeping the other photographers out of the picture!

Nancy Pfister Lytle has captured the overwhelming beauty of Mount Shucksan reflected in Picture Lake by painting the best features of two reference photos in acrylic, ink and pastel.

MATERIALS

Surface

Strathmore 500 series hot-press illustration board

Palette

Acrylics
LIQUITEX HIGH VISCOSITY ACRYLICS:
Burnt Sienna, Burnt Umber, Deep Brilliant Red, Mars Black, Napthol Crimson, Phthalo Blue, Prussian Blue, Raw Sienna, Raw Umber, Titanium White, Viridian Hue Permanent

Pastels
PRISMACOLOR SEMI HARD NUPASTELS:
298 Bottle Green, 236 Carmine Madder, 256 Crimson, 228 Hooker's Green, 234 Red Violet, 226 Scarlet, 293 Sepia

Brushes

1-inch (25mm) wash brush
Nos. 1 and 10 rounds

Other

100% rag drafting paper

2B graphite pencil

Crow quill pen

Graphite transfer paper

Grumbacher Miskit liquid frisket

Higgins India ink

Magic Rub eraser

Pencil sharpener

White colored pencil

REFERENCE PHOTOS

Secondary reference photo

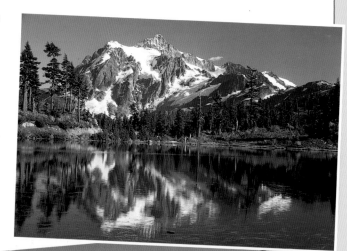

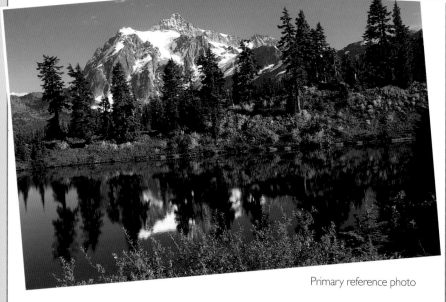

Primary reference photo

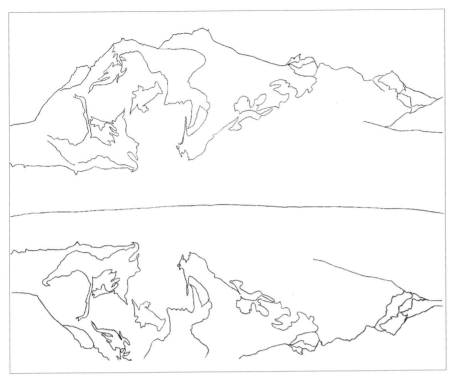

Make the Line Drawing

Make a photocopy of your main reference photo and draw a grid on the photocopy with a white colored pencil. Draw another grid in proportion for the finished size using your 2B graphite pencil on 100-percent rag drafting paper. With graphite transfer paper, transfer your drawing onto a sheet of Strathmore 500-series hot-pressed illustration board.

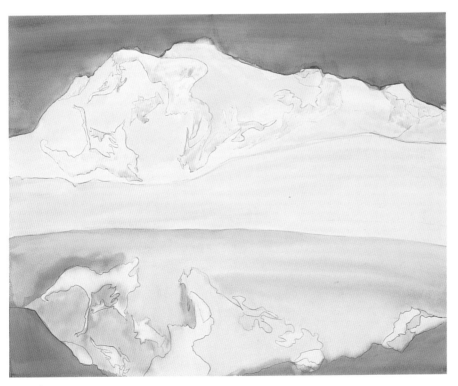

Begin the Painting

With a 1-inch (25mm) wash brush, wet your board with water. Next, lay in a wash of Phthalo Blue for the sky. With Miskit and an old brush, mask in the white snowy areas of the mountains and the area where the foliage will be placed. Let the masking dry. Wet your paper again and lay in a wash with a watery solution of Phthalo Blue, Burnt Sienna and Titanium White over the mountains. For the water, mix Prussian Blue, Burnt Umber and Mars Black and lay in a wash with a 1-inch (25mm) wash brush. Paint around the snowy areas of the mountains in the reflection. Paint the sky reflection in the two lower corners of the painting with Phthalo Blue. Let the painting dry.

3 Paint Darkest Masses of Mountains and Begin Trees and Foliage

Lay a mound of Mars Black on your palette straight from the tube. Use a no. 10 round brush for the darker masses of the mountains. Dip your brush into a mixture of Phthalo Blue, Burnt Sienna and Titanium White first, then dip your brush into the Mars Black. Vary the amount of Mars Black, depending on the darkness of the area you are painting. (Squinting your eyes will help you see the darkest areas of your reference photos.)

With a 1-inch (25mm) wash brush, lay in a wash of Raw Sienna for the foliage area. Allow your paper to dry, then remove the Miskit. Ink in the middleground trees with a crow quill pen and India ink. Let the ink dry for at least 24 hours. Next, mask out the trees. Wet the area of foliage reflection and wash in a mixture of Deep Brilliant Red and Napthol Crimson. Let the paints flow to add some texture.

Lay in another wash of the mixture of Prussian Blue, Burnt Umber and Mars Black for the water, adding a touch more Mars Black to darken.

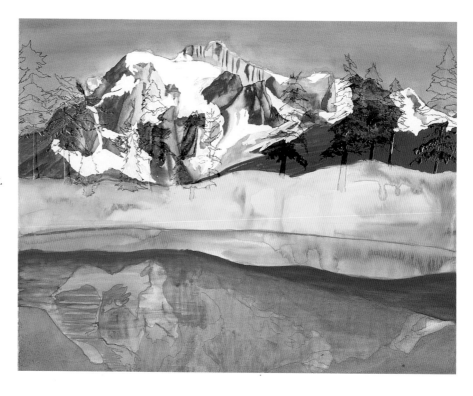

4 Add Some Foliage and Paint the Reflections

With your no. 1 round, paint in light patches of Viridian Hue Permanent for some of the foliage. With a thicker Viridian Hue Permanent, paint in more foliage around the trees. Let this dry, then remove the masking. With Raw Umber, paint the tree trunks. For the light areas where the sun hits them, paint in Raw Sienna. Wet your paper and paint in the tree reflections with a thick mixture of Viridian Hue Permanent and Mars Black using your no. 1 round. Paint the mountain reflections with a mixture of Prussian Blue, Napthol Crimson and Mars Black using your no. 10 round. Use your no. 10 round brush with Titanium White to paint in the white reflections.

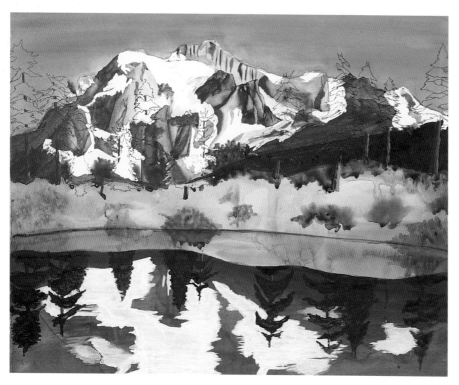

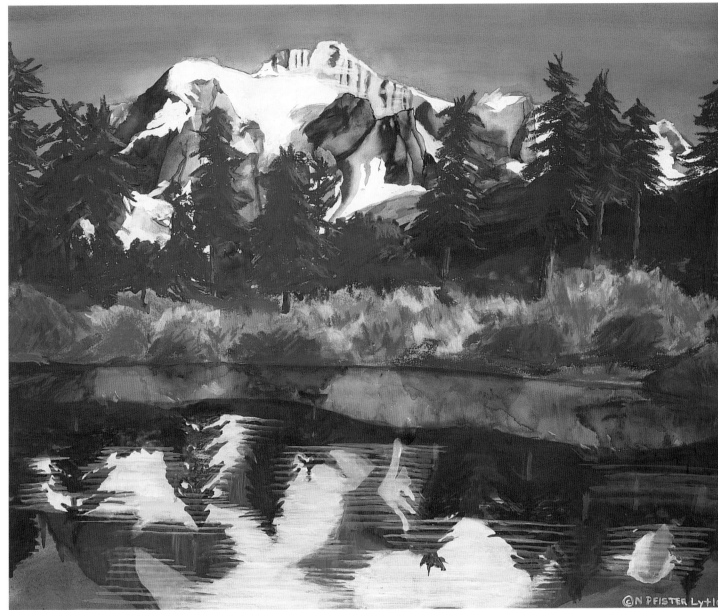

5 Finish the Trees and Foliage and Add Finishing Touches

For the trees and foliage, work from dark to light using Nupastel 228 Hooker's Green (light) and 298 Bottle Green (dark); 226 Scarlet, 256 Crimson, 234 Red Violet, 236 Carmine Madder and 293 Sepia. Lay in the dark green under-painting for the trees and foliage with 298 Bottle Green, and add highlights with 228 Hooker's Green.

Use Raw Umber and Burnt Sienna to paint the tree trunks reflected in the water. Use a no. 1 round brush with Titanium White to stroke across the snow reflections for ripples in the water.

PICTURE LAKE
Nancy Pfister Lytle
16" × 20¼" (41cm × 51cm)

Waterfall in Pastel

BY MARK BOYLE Mark Boyle took the photographs for this scene at Silver Falls in Washington, located on the Ohanapecosh River near the Stevens Canyon entrance to Mount Rainier National Park. Snowmelt and glacier runoff create a beautiful turquoise blue water virtually year round on this river. Silver Falls is surrounded by an evergreen rain forest. Lush mosses and vine maple adorn its banks. The river flows through a steep, narrow gorge below the falls.

Mark has visited Silver Falls several times for plein air painting and photography. Although the photos show the falls on a sunny day, he wanted to depict the scene as it looks on a cloudy day. His demonstration is a great example of how to change the lighting shown in a photograph with the aid of a plein air sketch.

REFERENCE PHOTO

Use this photo as the main reference photo for your painting. To modify the scene from a sunny day to a cloudy day, remove the yellow tones that reflect the sunlit trees in the water. Also reduce the reflection in the foreground water because it would be diminished on a gray day. Finally, reduce the highlights shown on the rocks in the photo to help indicate the softer light of a cloudy day.

MATERIALS

Surface

Wallis sanded pastel paper (museum grade)

Palette

Gouache
WINSOR & NEWTON DESIGNER'S GOUACHE: Burnt Sienna, Cobalt Blue, Ultramarine

Pastels
REMBRANDT MEDIUM SOFT PASTELS: 411 Burnt Sienna; 409 Burnt Umber; 331 Madder Lake Deep; 235 Orange; 234 Raw Sienna

ROWNEY SOFT PASTELS: 433.4 and 433.6 Purple; 381.1 Viridian

SENNELIER SOFT PASTELS: 177 Black Green; 421 and 423 Blue Grey; 353 Cobalt Blue; 513 Ivory Black; 222 Phthalo Blue; 287 Prussian Blue; 480, 481 and 482 Purplish Blue Grey; 426 Reddish Brown Grey; 211 Reseda Grey Green; 388 Ultramarine Deep; 434 Van Dyke Brown; 442 Violet Brown Lake; 250 Viridian; 525 White

SCHMINCKE SOFT PASTELS: 680 Bluish Green; 930 Greenish Gray 1; 770 May Green; 40 Permanent Yellow 3 Deep

UNISON SOFT PASTELS: A30 Purple

Brushes

½-inch (13mm) camel hair sumi round
Flat

Other

Charcoal stick
Masking tape (3 inches [7.6cm] wide)
Stiff board

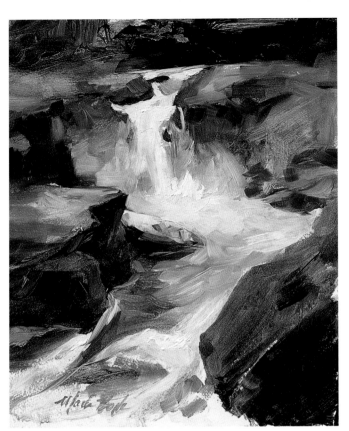

Paint on Location for True Color

A good studio painting begins outdoors. Travel to the scene you wish to paint and do a plein air painting. That way, you will have an understanding of local colors to supplement the photos you take of the subject. Use a lightweight back-packer's easel filled with the medium you are most comfortable with. I prefer Winsor & Newton Gouache or Winsor & Newton Artisian Water Mixable Oils for ease of cleaning.

To supplement the reference photos, I used this sketch to recall the aqua-blue color in the falls and the blue-gray color in the water by the rocks. In fact, I used this sketch to paint most of the details in the water.

2 Plan the Composition

The drawing at far left (below) shows the center of interest on the upper left-hand side. The drawing to the immediate left (below) is a close-up cropping of the water-fall, with the center of interest in the upper third of the scene. The drawing above the others (left) shows the center of interest on the upper right-hand side. All of these layouts have good compositional balance. You will paint the drawing above the other two (left).

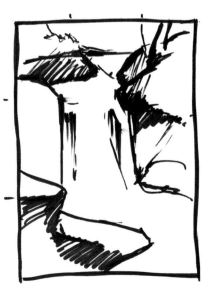

3 Paint a Watercolor Wash

Tape the sanded pastel paper to a stiff board with masking tape. Start with a color wash to cut down the intimidating white surface. Use the flat brush to paint a wash of Winsor & Newton Burnt Sienna at the top, graduating into Cobalt Blue in the middle and Ultramarine at the bottom. You will notice these light colors tend to "pop" in a beautiful way.

4 Block In the Outline

Use charcoal and Rembrandt 409 Burnt Umber to block in the waterfall and surrounding rocks. Use the references to draw the rocks, taking what you like best from each. Begin a rough estimate of midtones by smudging charcoal across the rock areas. You can remove the outlines with your fingers or with a brush if you make any mistakes.

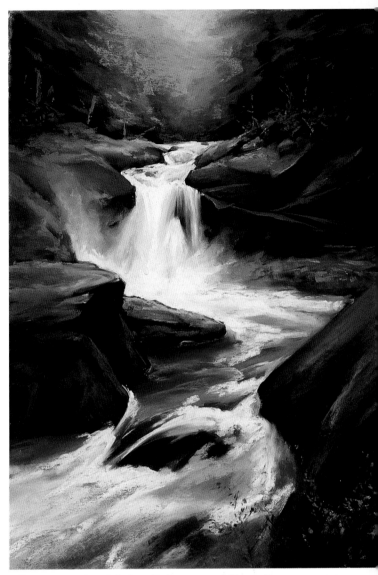

5 Block In the Darks and Midtones

Lay in Sennelier 250 Viridian, 177 Black Green and 211 Reseda Grey Green on the left- and right-hand sides, blending to Sennelier 250 Viridian and 222 Phthalo Blue above the falls. Use your finger to blend these colors together. Use Sennelier 513 Ivory Black; 480, 481 and 482 Purplish Blue Grey; 426 Reddish Brown Grey; 421 and 423 Blue Grey; 434 Van Dyke Brown and 442 Violet Brown Lake to build up the shadow areas on the rocks around the falls. Lay in Sennelier 353 Cobalt Blue, 388 Ultramarine Deep and 287 Prussian Blue on the middle and lower areas of the river. Use Schmincke 770 May Green and 930 Greenish Gray 1 on the upper moss areas of the rocks on the left and right sides.

6 Finish the Light Colors and Details

Take the painting outside and hold it vertically, tapping it lightly on the ground to shake off the excess pastel dust. Lay in Rowney 381.1 Viridian in the shadow areas of the waterfall and upper areas of the river, blending into darker blues on the lower river. Use Sennelier 525 White for the white water areas of the falls, blending into Rowney 381.1 Viridian. For warm highlight areas on the rocks and the riverbanks, use Rembrandt 411 Burnt Sienna, 234 Raw Sienna and 235 Orange. Create middle tones on the rocks with Unison A30 Purple. Lay down highlight areas in the rocks with Rowney 433.4 and 433.6 Purple.

To add interest, use Schmincke 680 Bluish Green on the trees and the brush above the falls. For a splash of color, add specks of Rembrandt 331 Madder Lake Deep and Schmincke 40 Permanent Yellow 3 Deep at the foot of the brush and over the mossy areas of the rocks to simulate flowers and berries.

SILVER FALLS

Mark Boyle

18" × 24" (46cm × 61cm)

Sunset in Acrylic

BY BART RULON Bart Rulon painted this dramatic sky by combining several reference photographs. For many years he had planned to paint the panoramic view of the Olympic Mountains which he could see from his studio window. One summer night the conditions were perfect for a painting, and Bart made sure to capture the scene in photographs with a panoramic view in mind.

MATERIALS

Surface
15½ × 40-inch (39cm × 102cm) hardboard panel (primed with acrylic gesso)

Palette
GOLDEN FLUID ACRYLICS: Cadmium Yellow Light, Raw Sienna, Raw Umber, Titanium White

LIQUITEX MEDIUM VISCOSITY ACRYLIC ARTIST COLOR: Ivory Black, Naphthol Red Light, Ultramarine Blue

Brushes
No. 12 flat

Nos. 000, 1, 3 and 5 rounds

Other
Standard no. 2 pencil

Water (as a medium with each mixture)

REFERENCE PHOTOS

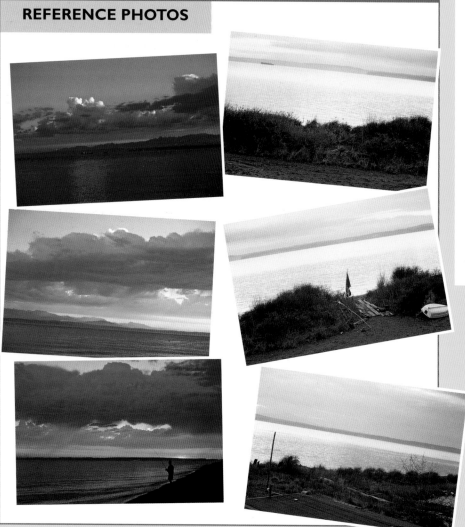

Sketch a Thumbnail

The best sketch shows the beach in the foreground. I went back to the scene to take the photographs that show the stretch of foreground. I made sure to return at sunset to simulate the lighting in the original photos. The new references also provide extra details to include in my painting.

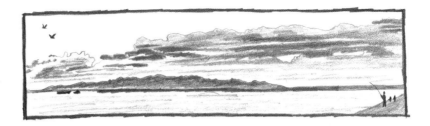

2 Draw the Base Lines

Draw the outlines of the mountains, clouds and foreground on scrap paper that is the same size as the board. Turn over your drawing and trace the pencil lines on the back side of your drawing with a standard no. 2 pencil. Tape the drawing to the board and retrace the drawing on the original side with a heavy hand.

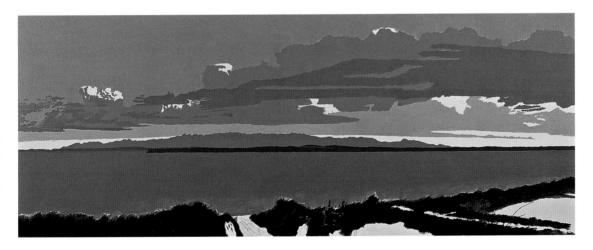

3 Block In the Major Colors

Block in the foreground with a mixture of Raw Umber, Raw Sienna and Ivory Black using a no. 12 flat. Keep the paint thin and soft on the top edge of the vegetation by using less paint and more pressure on the brush. For the water and the dark clouds, use a mixture of Ultramarine Blue, Titanium White and Naphthol Red Light. Add more Naphthol Red Light to the water and cloud mixture for the mountains. Carefully follow the lines of the top of the mountain with

a no. 5 round and the same mixture. Add more Titanium White and fill in the rest of the dark clouds with a no. 12 flat. Paint the shoreline in the distance with a mix of Ultramarine Blue, Cadmium Yellow Light, Naphthol Red Light, Titanium White and Ivory Black using a no. 5 round. Block in the sky with a mixture of Ultramarine Blue, Titanium White and Cadmium Yellow Light.

4 Add Color Variation

Paint the dark ripples in the water with Ultramarine Blue, Naphthol Red Light, Titanium White and a touch of Ivory Black using a no. 1 round. On the left side of the sky, where it gets lighter as it moves toward the horizon, paint a mixture of Ultramarine Blue, Titanium White and Cadmium Yellow Light. Start at the top of this area and scumble the paint on the edge

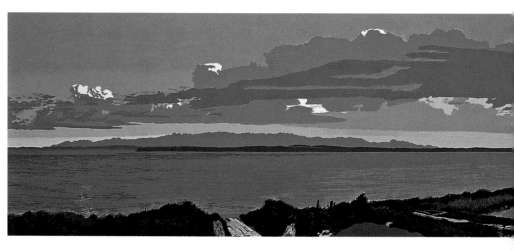

where it meets the dry base with a no. 12 flat. Add Titanium White little by little for a gradual change in value as you work your way down, using the no. 5 round brush near the clouds for control. Paint the gaps in the clouds. For the orange part of the sky near the sunset, paint a mixture of Cadmium Yellow Light, Naphthol Red Light and Titanium White with a no. 5. Save some of this mixture for the reflection in the water later.

Mix a purplish color for the reflection of the sky in the water with Naphthol Red Light, Ultramarine Blue and Titanium White. As you move from left to right, add the orange mixture you saved using the no. 3 and no. 1 rounds.

Start the wooden paths by blocking in earth tones with varying mixtures of Raw Umber, Ultramarine Blue, Ivory Black, Titanium White and Naphthol Red Light using the no. 5, no. 3 and no. 1 brushes. Use more Titanium White for light areas and more Ivory Black for shadow areas. Start defining the brown brush using the no. 5 and mixtures of Raw Umber, Raw Sienna and Ivory Black that are lighter than the dark brown base color. From this, make two more mixtures so you have three in all. Add Cadmium Yellow Light to both. Then add Ultramarine Blue to one and use this for the variety of colors in the vegetation.

5 Add the Sun and Reflections

Paint gradations of value in the darkest areas of clouds with varying mixtures of Naphthol Red Light, Ultramarine Blue and Titanium White using the no. 12 flat and no. 5 and no. 3 rounds. Add more Titanium White as the values move toward the midtone range. With the no. 5 round, paint the setting sun with Cadmium Yellow Light straight out of the

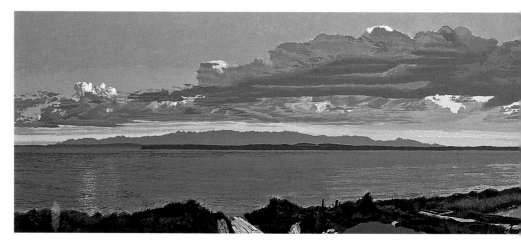

tube, building thicker layers toward the middle. Paint a more pink mixture of Naphthol Red Light, Ultramarine Blue and Titanium White for the reflection of warm light on the clouds directly above and around the sun using the no. 5 and 3 brushes.

Paint reflections of the sun on the water with a mixture of Naphthol Red Light, Cadmium Yellow Light, Titanium White and a touch of Ultramarine Blue using the no. 3 and no. 1 rounds.

Paint the reflections of the sunlit clouds in the water on the left with the same brushes and a mixture of Naphthol Red Light, Ultramarine Blue and Titanium White. Add more white for the lightest parts of the reflection and more blue for the darkest ones. For the clouds that cause those reflections, soften the edges where pink meets deep blue with an intermediate mixture of the two applied with a no. 3 brush, using a scumbling technique.

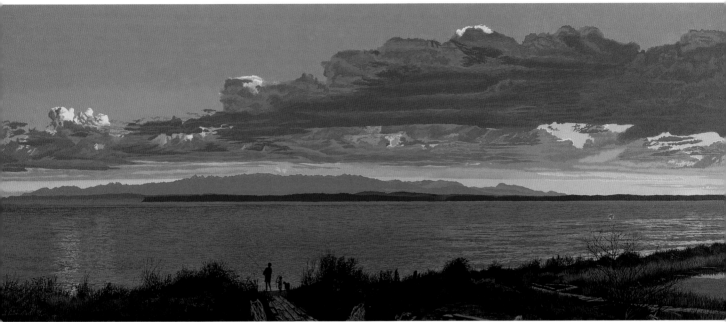

6 Step Back and Reevaluate

Now is a great time to really examine what the painting needs from a distance. Getting a critique from a friend can be helpful at this stage. For a fresh view, look at the reversed image of the painting in a mirror.

Go back to the darkest clouds. Take just a little paint from a mixture of Naphthol Red Light, Ultramarine Blue and Titanium White with the no. 5 or no. 3 rounds and scumble the reddish reflections from the sun on the bottom edges of the clouds to keep the edges soft. Add Titanium White to the mixture and glaze it on the right side of the mountains to indicate an atmospheric effect. To glaze, use plenty of water to thin the paint so some of the dark blue shows through. Add more dark ripples to the water with the no. 3 and no. 1 rounds and the mixture from step 4. Rely less on the reference photographs now and more on what you can tell the painting needs to succeed. Push and pull lights and darks until the water looks more believable.

Subdue the color of the sun so it doesn't attract all of the viewer's attention. Mix Cadmium Yellow Light with the mixture you used for the orange sky around the sun in step 4. Make four mixes, each one with more Cadmium Yellow, and mix them wet-into-wet with the no. 5 and no. 3 rounds. Make a small semi-circle over the horizon line with the brightest, most yellow mixture closest to the land to indicate where the sun has just gone down. The reference photo doesn't show that the lagoon in the far right-hand corner would reflect the same colors in the sky above it. Make slightly darker versions of the following mixtures: from step 3 for the dark cloud base, from earlier in this step for the sun's reflections on the clouds and from step 4 for the sky. Paint the reflections in the lagoon with a no. 5 round.

Now work details into the foreground vegetation using a wide range of dark colors approximated from the reference photos with the no. 5, no. 3 and no. 1 rounds. Once you are satisfied with the water and the paint has dried, paint the tops of the brush and the vegetation with the no. 3, no. 1 and no. 000 rounds and two mixtures: one of Ivory Black, Raw Umber and Titanium White and another of the same colors with a little Cadmium Yellow Light and Ultramarine Blue added. You might notice that the wooden paths look too bright, so mix the same colors you used in step 4 with less white added to paint them darker. As a final touch, add people on the beach in the foreground using various dark mixtures with the no. 3, no. 1 and no. 000 rounds. If you use people from your own photographs, be sure to adjust the lighting on the figures to harmonize with the painting.

SUNSET ON THE OLYMPICS
Bart Rulon
15½" × 40" (39cm × 102cm)

61

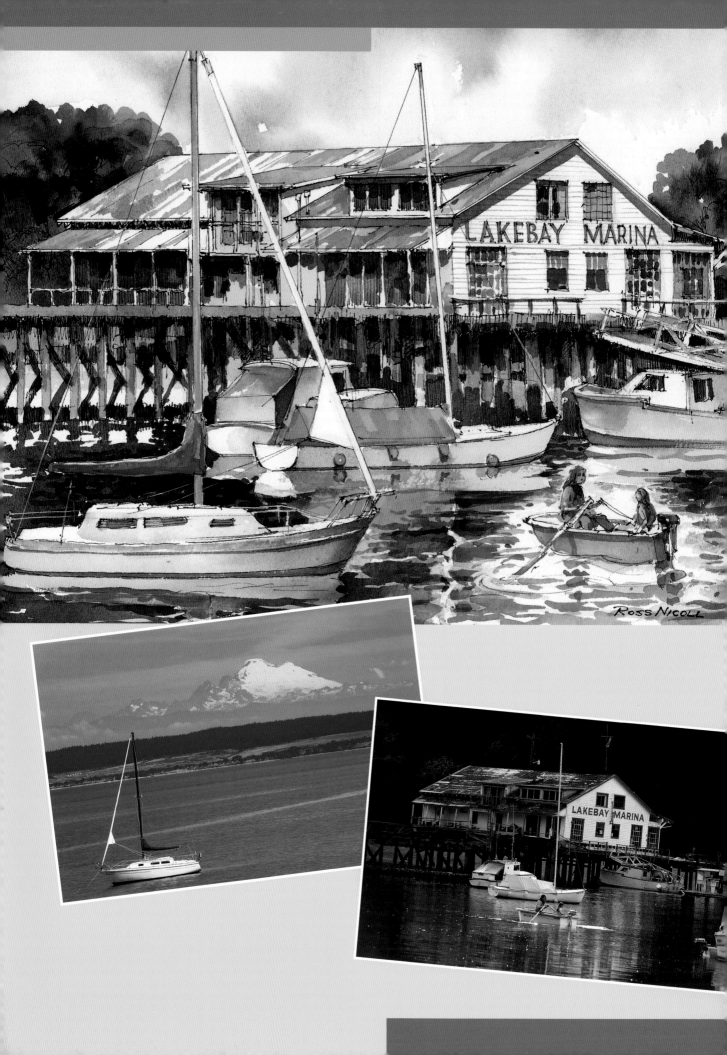

ROSS NICOLL

3 SEASCAPES and NAUTICAL SCENES

From small marina bays to the vast ocean, seascapes and nautical scenes make great subjects for your paintings. The seamless union of water and sky is not only breathtaking, but provides the artist with a true challenge. After all, capturing the reflective nature and flowing movement of water in your paintings is no easy feat. It requires careful study of your scene and demands that you examine the relationship between light and water. But once again, not everyone lives close to the shoreline or has time to travel to the nearest coast. Reference photographs make the perfect alternative for the artist who wants to paint seascapes but is at a disadvantage due to his or her location.

Just as with landscapes, painting seascapes from reference photos is a great deal simpler

than working on location. This is particularly true if you want to paint the ocean at a specific time of day or during a certain tide. For example, if you're interested in painting the sea at sunset, you'll only have a few hours at best to complete your painting before the lighting conditions change. But photos eternally capture the scene, alleviating any pressure to finish quickly.

You'll work with several different mediums in this chapter, creating a range of diverse seascapes. Not only will you reproduce crisp, sparkling water, you'll also have the chance to paint boats, lighthouses and other nautical objects. Remember, each of the paintings in this chapter is the artist's unique interpretation of the reference materials. Challenge yourself by adding your own personal touches to each piece.

Sunset at Sea in Oil

BY CAROLYN E. LEWIS This moody dusk scene was photographed on Kloea Beach in Molokai, Hawaii. Carolyn Lewis's evocative oil rendition is spectacular.

REFERENCE PHOTO

To prepare your canvas, mix Liquitex Acrylic Gesso White and Liquitex Colored Acrylic Gesso Burnt Umber to cover the bright white of the canvas. Roll on two coats using a foam roller, and sand the canvas between dried coats with extra-fine sandpaper.

Sketch the Composition
Draw a sketch directly on the canvas with a no. 6 Winsor & Newton Monarch short filbert brush using Burnt Umber and a little paint thinner.

MATERIALS

Surface
Stretched cotton canvas

Palette
WINSOR & NEWTON ARTISTS' OIL COLORS: Alizarin Crimson, Burnt Sienna, Burnt Umber, Cadmium Red, Cadmium Yellow, French Ultramarine, Payne's Gray, Raw Sienna, Titanium White, Ultra Violet, Yellow Ochre

HOLBEIN ARTIST OIL COLORS: Coral Red

Brushes
1-inch (25mm) Winsor & Newton Monarch glaze brush

Nos. 6 and 8 Winsor & Newton Monarch short filberts

Nos. 2 and 12 Langnickel 5520 Royal Sables

No. 20 Langnickel 5523 Royal Sable

Other
4-inch (10cm) foam roller

Absorbent paper towels

Extra-fine sandpaper

Liquitex Acrylic Gesso (White)

Liquitex Colored Acrylic Gesso (Burnt Umber)

Oval or rectangle glass or wood palette

Trowel palette knife, with about a 3-inch (8cm) blade (for mixing paint)

Weber Martin Turpenoid (paint thinner)

Winsor & Newton Liquin Alkyd Medium

2 Mass in Darks and Paint the Water

Start with the darkest darks, massing in local or dominant color on the hill on the right using Payne's Gray and Alizarin Crimson with a little Liquin. Dab on color using a no. 12 Langnickel brush to simulate trees. Keep the edges soft.

Next, mass in local or dominant color on the upper two clouds using a 1-inch (25mm) Monarch glaze brush and Payne's Gray, Titanium White, Alizarin Crimson, Raw Sienna and a little Liquin. For smaller areas and edges, use a no. 12 Langnickel brush. For the lower clouds, mass in the same way using Payne's Gray, Titanium White, Yellow Ochre and Cadmium Red.

To paint the water, rinse the brushes in paint thinner first. Using your 1-inch (25mm) brush, start applying horizontal strokes in the dark area at the horizon using Titanium White, Payne's Gray, French Ultramarine and Cadmium Red. For the dark area below, use Titanium White, French Ultramarine and Cadmium Red.

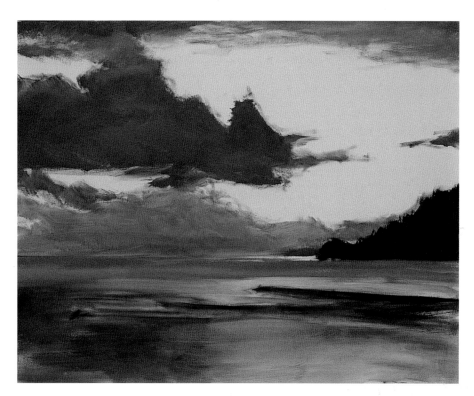

3 Paint the Sky and Continue the Water

If the paint on the clouds has dried, spread on a very thin coat of Liquin. Paint in the darkest part of the sky near the lowest cloud with Titanium White, Coral Red, Cadmium Yellow and Ultra Violet using your no. 20 or no. 12 Langnickel. Move upwards toward the top of the sky, gradually getting lighter as you go by adding more Titanium White to the mixture. Soften existing edges of the clouds into the wet sky with a no.12 Langnickel brush, using the same colors you used for the darkest part of the sky. Paint over the existing clouds, this time bringing out different shapes within the clouds to show form. To unify the water coloration with the rest of the painting, glaze over the bluest part of the water near the horizon using the same colors used in the foreground water mixed with a little Liquin. Then, sparingly glaze over the foreground water with the colors originally used for the blue water at the horizon thinned with a little Liquin.

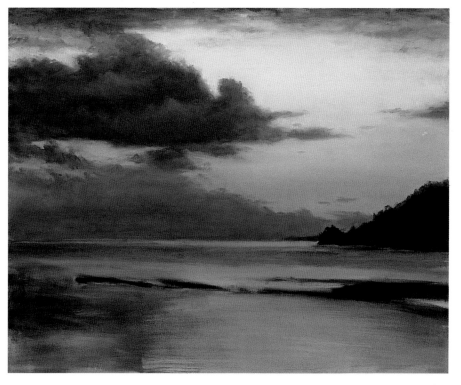

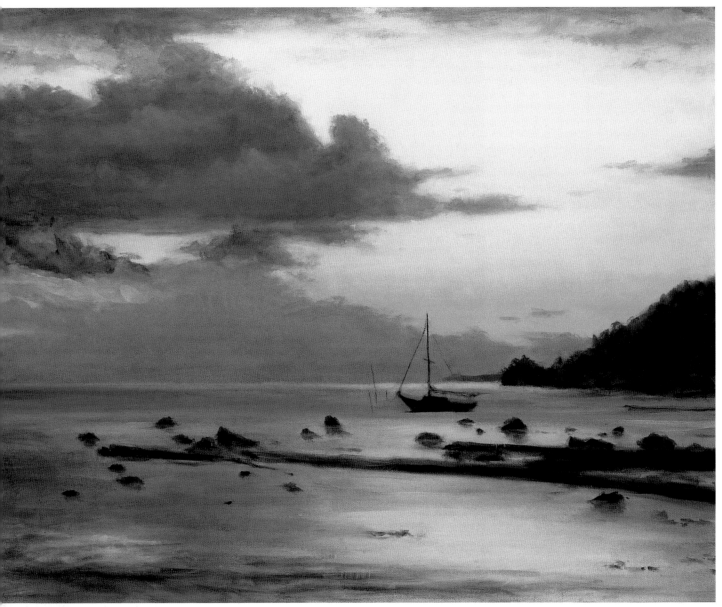

4 Paint the Lighter Sky Reflections in the Water

Start with the darkest part of coral sky reflection in the water above the pier. Paint horizontal strokes of Titanium White, Coral Red, Cadmium Yellow and Ultra Violet using your no. 20 Langnickel. Add more Titanium White as you work toward the bottom. Use your no. 12 Langnickel brush for the smaller areas around the pier.

Let the painting dry, then apply a thin coat of Liquin over the entire water area. Put in the rocks, pier and boat using Payne's Gray, Burnt Umber and Burnt Sienna with a no. 8 Monarch short filbert brush. For fine detail, use your no. 2 Langnickel brush.

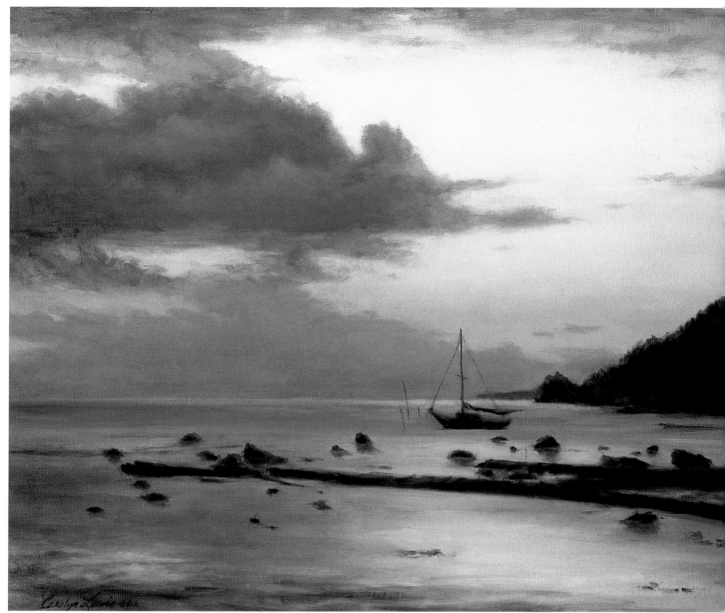

5 Add Highlights

Highlight the boat, rocks and pier using the no. 8 Monarch and the no. 2 Langnickel and the same colors you used for the sky and the reflections in the water (Titanium White, Coral Red, Cadmium Yellow and Ultra Violet). Let the painting dry, then coat it with Liquin all over.

EVENING SOLITUDE
Carolyn E. Lewis
16" × 20" (41cm × 51cm)

Lighthouse at Sunrise in Acrylic

BY DIANNA SHYNE The two images used in this demonstration show how you can combine reference photos from vastly different locales to create an exciting painting. Gary Greene snapped the primary reference photo of Oregon's Yaquina lighthouse. The weather did not cooperate, resulting in a poorly lit and uninteresting scene. Nevertheless, he printed the photo and stored it away. Then he discovered another photo he had on file—sunrise at Onealli Beach in Molokai—and decided the two photographs, together, would make a spectacular painting. He used Adobe Photoshop to delete unwanted elements from the photos, lighten the opacity of the sunrise and merge the two photos together. If you don't have access to such computer programs, you can combine images by hand using a photocopier and tracing paper.

Dianna Shyne added her own interpretation to the composition by making the lighthouse smaller than it is in the reference photo. In order to give the landscape a greater presence, she lengthened the lighthouse tower and added a light. She also altered the lighting to reflect conditions of an Oregon sky in spring.

MATERIALS

Surface
21 × 27-inch (53cm × 69cm) watercolor board

Palette
GOLDEN FLUID ACRYLICS: Dioxazine Purple, Quinacridone Gold

GOLDEN HEAVY BODY ARTIST ACRYLICS: Anthraquinone Blue, Cadmium Orange, Cadmium Red Light, Cadmium Yellow Light, Quinacridone Red, Titanium White

Brushes
2-inch (51mm) synthetic flat

No. 6 mixed synthetic flat

No. 6 mixed synthetic round

No. 16 synthetic bright

Old 3-inch (76mm) house brush

Other
11 × 15-inch (28cm × 38cm) metal Chinese butcher tray palette

Masterson's large Sta-Wet palette paper refills

Paper towels

Spray bottle and water container

Utrecht professional gesso or Golden acrylic molding paste

REFERENCE PHOTOS

Original reference photo

Additional reference photo

Composite reference photo

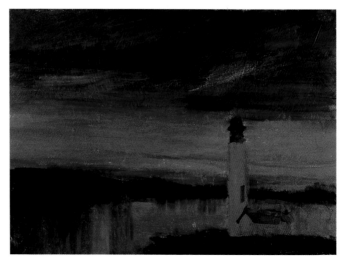

1 Lay Out the Painting

Coat the watercolor board with a layer of gesso or molding paste. Use a 3-inch (76mm) house brush to make brush marks. Let dry for up to twenty-four hours. Fill a water container and a spray bottle with clean water. Spray the panel with water so it is evenly wet. Squeeze out approximately twelve drops of Quinacridone Gold onto the palette. Dampen a 2-inch (51mm) synthetic flat with water and add water to the Quinacridone Gold until it is drippy.

Apply the paint in horizontal brushstrokes from top to bottom. Work quickly so the paint does not dry. Dampen a paper towel and remove paint wherever the painting will be light in value. Use the same amount of Quinacridone Gold, but this time do not dilute it. Using a 2-inch (51mm) synthetic flat, apply the paint to the panel wherever the painting will be darkest in value. This will serve as the underpainting. Allow it to dry thoroughly.

Clean the palette and line the bottom with a paper towel. Wet the towel completely, squeezing out excess water. Lay a single sheet of acrylic palette paper over the towel and dampen it with more water. Smooth the palette paper with your hands until it is flat. This step is very important to ensure that the paints do not dry out during the painting session.

Along one side of the palette, squeeze out quarter-size amounts of acrylic paint in this order: Titanium White, Cadmium Yellow Light, Cadmium Orange, Cadmium Red Light, Quinacridone Red and Anthraquinone Blue.

2 Mix the Dark Colors

Use the center of the palette to mix the dark and middle tones of the painting. For the dark purple color in the painting, mix several drops of Dioxazine Purple with a small amount of Cadmium Red Light. Add small touches of Anthraquinone Blue or Cadmium Orange until the color becomes a very warm purple.

For the red sky color, combine Cadmium Red Light and Quinacridone Red, adjusting the color until it is a warm red. Avoid using Titanium White in your mixture. For the lavender color of the lighthouse, use a small amount of the dark red mixture and a dab of Titanium White. Adjust this color with bits of Dioxazine Purple or Cadmium Orange until it is slightly lighter than the land.

Next, dampen the surface with the sprayer. Using the mixtures, paint the areas that represent the dark land formations with the dark purple mixture. Using loose, feathery brushstrokes, paint the sky with the mixture of Cadmium Red Light and Quinacridone Red. Finally, paint in the area that represents the lighthouse with the mixture of lavender.

Drag some of the dark color vertically through the water from the land above and use some of the dark mixture to define details on the lighthouse.

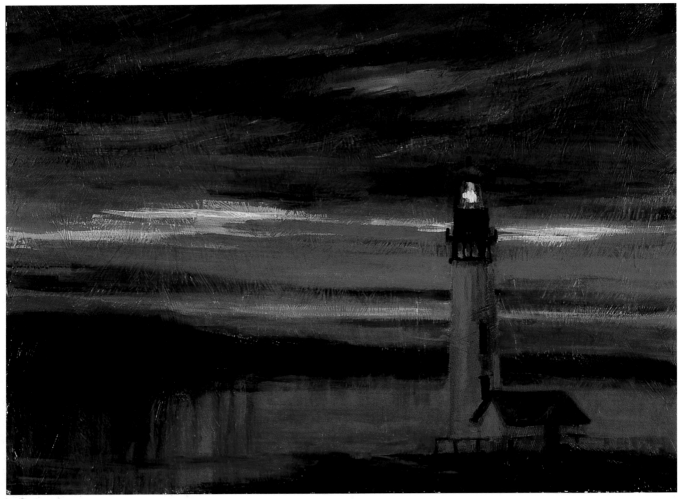

3 Mix the Light Colors

Paint in the sky and highlights on the water using a small amount of Cadmium Yellow Light mixed with Titanium White. Decide where the lightest part of the sky should be placed and paint this area with the Cadmium Yellow Light. Use a dark purple mixture to redefine the shapes and details of the lighthouse, the small fence and the landscape. Use the no. 6 synthetic flat and round to add details to the ground. To make the shape more interesting, add a narrow brushstroke of red to indicate the light from the sky. To create the shadow of the lighthouse, add a little of the dark purple mixture to the light purple mixture used to paint the lighthouse. Brush the darker value onto the center and right-hand side of the lighthouse to give it roundness.

Use the yellow and white mixture for the light in the lighthouse. Add this detail when the lighthouse is complete and positioned correctly. Load a no. 16 brush with Cadmium Orange and lightly scumble this color onto the horizon directly behind the hills. Use the same color lightly on the underside of the dark clouds for roundness. Wipe off the brush and drag a small amount of the dark through the lower part of the sky. Keep the brushstroke light. If any stroke gets too dark, wipe it away with a damp paper towel before it begins to dry.

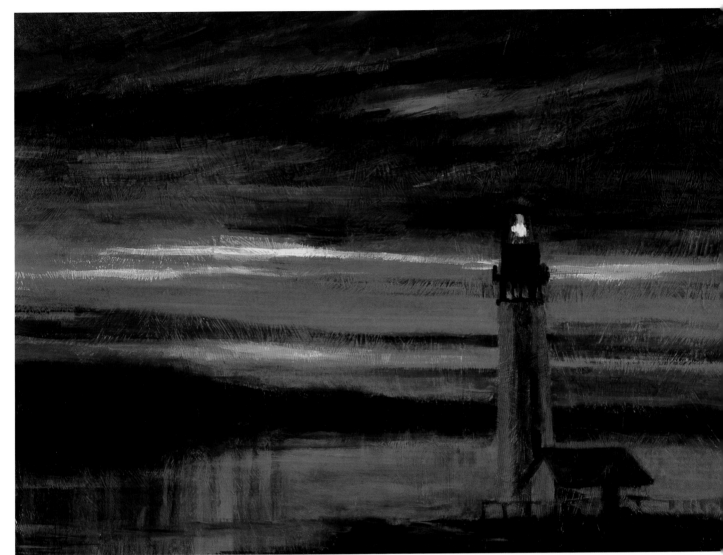

LIGHTHOUSE AT SUNRISE
Dianna Shyne
21" x 27" (53cm x 69cm)

4 Finish

Mix Cadmium Orange with Cadmium Yellow Light and apply this mixture with a no. 16 bright to the horizon. Use more of the dark purple mixture to add finishing details on the lighthouse. Slightly darken the center of the lighthouse to imply roundness. Brush a tiny bit of the red mixture along the left side of the lighthouse and the left side of the second building to indicate reflected light. Drag the same mixture through water to break through the reflections.

Waves Hitting a Rocky Shore in Oil

BY JUNE CAREY June Carey took the reference photographs for this beautiful scene of Bird Island in the Golden Gate National Recreation Area near San Francisco, California. Her demonstration is a great example of what elements to leave in and what to take out when using reference photos. She offers this advice: When you choose to paint a scene from a photo, ask yourself what you see in the photo that makes you want to paint it and what in the photo prevents it from being the best painting it can be? For composition, use index cards with windows cut out to frame up different areas on the reference photos. This is a good way to experiment with blocking out different areas. For consistency, be sure to consider the dimensions of the finished painting when "framing up" these photos.

MATERIALS

Surface

16 × 20-inch (41cm × 51cm) stretched canvas

Palette

MAX GRUMBACHER ARTISTS' OIL COLORS: Chromium Oxide Green, Phthalo Green (Blue Shade), Titanium Soft White

WEBER OIL PAINTS: Permalba White

WINSOR & NEWTON ARTISTS' OIL COLORS: Burnt Sienna, Cadmium Yellow, Permanent Magenta, Raw Sienna, Sap Green

WINSOR & NEWTON WINTON OIL COLORS: Cadmium Red Light, Dioxazine Purple, French Ultramarine

Brushes

Loew Cornell Shader Series 7000 nos. 2 and 6

Robert Simmons Craft Painter Flat Shader nos. 6 and 8

Winsor & Newton University Bright Series 237 nos. 4, 6 and 8

Other

Blair Gloss Spray Var for Oil Painting

Grumbacher Damar Retouch Varnish

Weber Turpenoid

REFERENCE PHOTOS

Use these three smaller photos to find better light and color on the bluffs and to study the area where the bluff comes down to meet the rocks.

In the main reference photograph of Bird Island, at right, the land mass is dark and equal in area to the bright water. The area of highest contrast is the point where the bright wave in the foreground meets the rocks at the bottom of the photo. I cut a 3½ × 5-inch (9cm × 13cm) hole in a 4 × 6-inch (10cm × 15cm) index card to frame up the area. As a result, I decided to leave out the rocks on the bottom and some of the land on the right side of the photo. You can see the lines where I framed the photo.

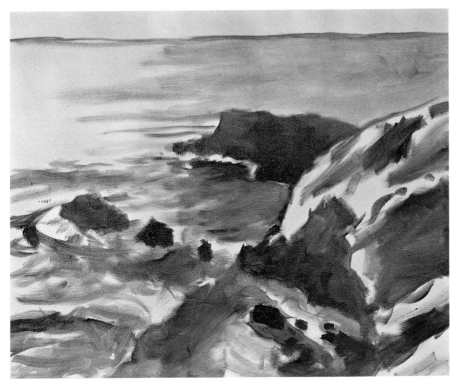

Rough in the Masses

Mix a plumlike color using Permanent Magenta, Turpenoid and a variety of lighter colors to gray it, such as Dioxazine Purple, Raw Sienna, Permalba White and Burnt Sienna. Use this mixture with the no. 8 Winsor & Newton brush to draw in a wash of color, blocking in areas of dark and light by varying the heaviness of the wash. This value wash will help you see the whole design.

Always save some of your original colors to use in later mixes.

Build Color

Use the following mixtures mixed with Turpenoid with the no. 8 and no. 4 Winsor & Newton Bright flat brushes: the plum mixture used in step 1; Phthalo Green (Blue Shade), Dioxazine Purple and small amounts of Burnt Sienna and Permalba White for the darkest darks in the water; thin washes of Burnt Sienna and Raw Sienna for the warm color on the bluff; Sap Green, Cadmium Yellow and Burnt Sienna for the green plants and the grass on the bluffs and Permanent Magenta, Raw Sienna and Permalba White for the bluff as it goes out to the point and fades into the sun. Build the darkest shadows in the waves with a mixture of the plum mixture, the mixture used for the darkest darks of the water and Chromium Oxide Green. Work midtones into the waves with delicate washes of a mixture of Raw Sienna, Chromium Oxide Green and Permalba White. Mix a good amount of Permalba White and Cadmium Yellow to add the highlights caused by the sun's path on the water. Add tiny amounts of Cadmium Red Light to the mixture as you work toward the horizon to make it recede into the distance. Paint shadows on the foam with a

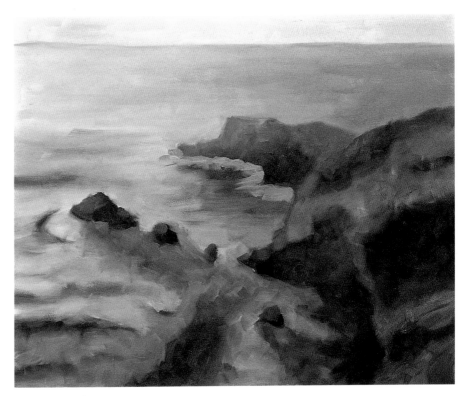

mixture of French Ultramarine and Permalba White. Use this mixture for reflective areas on the rocks as well. At this stage, avoid too many hard edges. Develop the rough shapes and relative values and cover the entire canvas with color.

3 Adjust the Values for a Better Composition

It's time to perfect the overall design to give the painting the best initial impact. Ask yourself where you want the viewer's eye to go. Here, the area of focus should be the bright path of light created by the reflections of the sun on the water in the lower left third of the scene. Also, a potential compositional problem must be solved before moving on: There tends to be a giant X in the composition, and its center falls where the wave is breaking on the point toward the center right. You must decide which line should dominate. Soften the contrast and edge sharpness of the line you don't want to dominate by using cooler colors with less contrast. You want the eye to follow the paths of shadows and light coming toward you rather than following the line that angles off to the upper right (created by the breaking wave connected to the land mass).

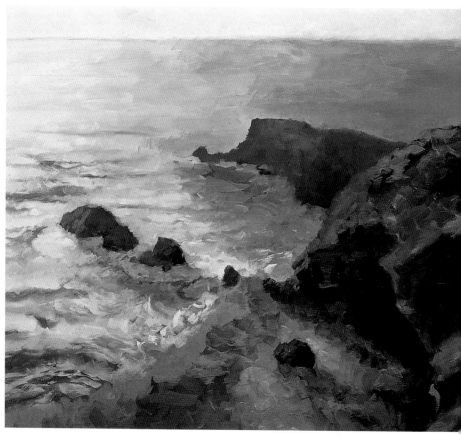

Do not mix any medium with your paint from this step forward. Roughly begin to develop the areas of focus and the relationship of their edges, such as the rocks farthest to the left and the brightness of the water around them. To help fuse these rocks into the glare of the sun, use the no. 8 Robert Simmons brush to lighten the values on the rocks, creating a soft peach color by adding Titanium Soft White first, then small amounts of the plum mixture, Cadmium Yellow and Cadmium Red Light. Add Chromium Oxide Green as you work into the deep shadows on the rocks. Study the general water movement in both the light and shadow areas. Apply the darkest darks and lightest lights in the water, then the most distant blues and warmest golds in the foreground. You are still adjusting the composition before building up the details in the waves, rocks and land. Every color and value applied now becomes relative to the world you are creating in this painting. Values and colors that are not realistic will prevent the viewer from getting into the scene.

On the land, roughly throw in the colors and adjust the edges. Paint sharply focused lines where you want to draw the viewer's eye, and paint blurred edges in areas to which you do not want to attract the viewer's eye immediately. With the no. 6 and no. 8 Robert Simmons brushes, use Burnt Sienna and Raw Umber almost straight out of the tube to paint much of the light on the land. For most of the greens, mix Cadmium Yellow and Sap Green, then deepen them with Dioxazine Purple and Phthalo Green (Blue Shade) in the shadows. For the lighter greens, warm up the mixture with Cadmium Red Light.

4 Add Details

Develop the main area of interest in the cove's foreground water using the no. 8 Robert Simmons brush. Start by mixing the darkest shade of the shadows with some of the plum mixture and Chromium Oxide Green. Mix a medium tone base of some of the dark shade and Permalba White. Make other medium-tone colors by adding Raw Sienna and Chromium Oxide Green to the base mixture. Blend these tones wet-into-wet to develop the pattern and rhythm of the waves. Be aware of how important the dark, reflective area below the farthest point of land is to the design.

As you work your way into the light, use some of the initial piles of paint, adding light and warmth. For the bright sunlight, start with Permalba White mixed with Raw Sienna and Cadmium Yellow. Vary this mixture as you move into the distance by adding a tiny amount of Cadmium Red Light and French Ultramarine. Build a row of piles as each mixture is adjusted for value and color toward the light. Keep comparing the color on the end of your knife to the sketch and the photo. Use the broken texture of the water as an excuse for the brush strokes of different colors. Study the movement of the water and be aware of perspective, as closer waves appear larger and distant waves are smaller and less focused. Occasionally dip the no. 8 Robert Simmons brush into Raw Sienna and Chromium Oxide Green to vary the medium tones between cool green and a warmer gold while working toward the path of light. For the water in the distance, again start on the far right with the darkest shade mixed with Permalba White, Phthalo Green (Blue Shade), French Ultramarine and a bit of Raw Sienna. Then study the photo closely to mix the light shade. Work wet-into-wet, using the brushstrokes to create the texture of the wavelets. Be aware of the warm yellows and reds in the water while working toward the path of reflected sun—a very important part of capturing the effect of the streaming sunlight. Make the shades of paint lighter and slightly warmer as you work from right to left by adding more Raw Sienna, Permalba White and a little Cadmium Yellow. The cooler colors almost disappear in the light. Leave a soft edge on the water around the land in the background to help bring the edges in the foreground forward. The difference between cast shadows and actual reflections can be very subtle.

The areas of churning water in the foreground are complex and take a great deal of study to understand. It is best not to try

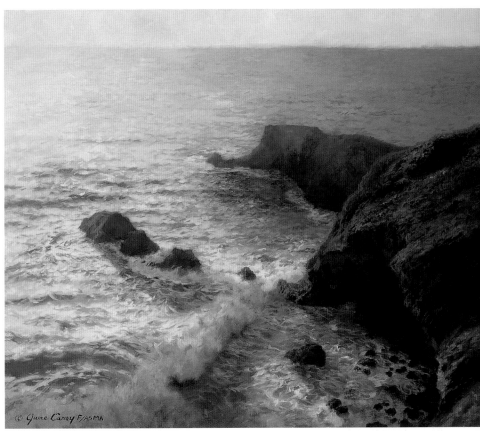

LAST LIGHT AT BIRD ISLAND
June Carey
16" × 20" (41cm × 51cm)

to paint each ripple but to develop the general movement and feel with your brushstrokes using both the no. 6 and no. 8 Robert Simmons brushes. Remember, even though the camera has stopped the water, it is still moving, and this makes it interesting. Save the real focus for the last touches of highlights when you best know where they will most benefit the overall design.

For the final details, study the reference photos to paint the delicate highlights and the colors and textures in the rocks and land. Since no white paint covers completely, you can always add another dimension of value to the brightest areas of the water by adding highlights of Titanium Soft White mixed with a tiny bit of Cadmium Yellow using the no. 2 and no. 6 Loew Cornell brushes. The rocks are wet near the water so they should have highlights, too. The cooler white highlights on the foamy water can be very subtle. At the end of this step, a light coat of varnish unifies the flat areas and points out anything that needs slight adjustment. Start by spraying a light coat of Grumbacher Damar Retouch Varnish. Once the painting is finished and dry, spray it with Blair Gloss Spray Var.

Lakebay Marina in Mixed Media

BY ROSS NICOLL The appealing old building and pier in this photo had always been a favorite of Gary Greene's, and the photo has resided in his reference photo library for many years. To improve the composition, he reversed the anchored sailboat from the secondary photo and added it to the foreground using Adobe Photoshop. This alteration helped frame the rustic marina. He also moved the rowboat to the right side to help draw the eye into the composition. If you do not have access to a computer program like this, you can make an effective composite yourself using simple materials such as tracing paper or a photocopier. Artist Ross Nicoll, working in watercolor and ink, improvised the water, sky and background trees to produce this charming painting.

MATERIALS

Surface
13 × 17-inch (33cm × 43cm) 140-lb. (300gsm) cold-press watercolor paper

Palette
DANIEL SMITH EXTRA FINE WATERCOLORS: Alizarin Crimson, Burnt Sienna, French Ultramarine, Hansa Yellow Medium, Prussian Blue, Quinacridone Burnt Orange, Raw Sienna

Brushes
1-inch (25mm) flat
No. 0 round rigger
No. 10 round

Other
18 × 24-inch (46cm × 61cm) ½-inch-thick (13mm) Gator board
Black ultrafine point felt marker
Kneaded eraser
Masking tape
No. 2 or HB graphite pencil
Ruler
Watercolor palette
White gouache

REFERENCE PHOTOS

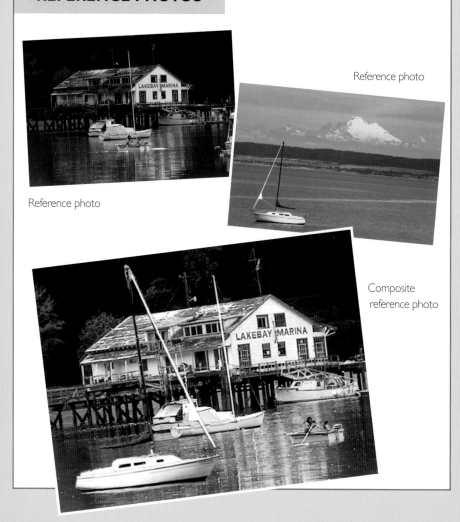

Reference photo

Reference photo

Composite reference photo

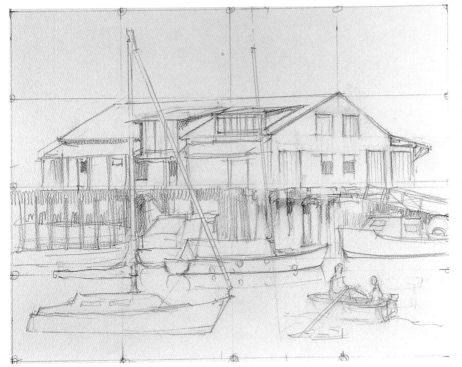

Lay Out the Painting

Tape the paper onto an 18 × 24-inch (46cm × 61cm) piece of Gator board. Lightly pencil in a 13 × 17-inch (33cm × 43cm) rectangle that is 1½" (4cm) larger than the size of the finished work. Transfer the reference photo onto the paper using a grid system. Divide a photocopy of the reference photo into halves and then quarters. Lightly draw the same grid lines on the watercolor paper. Using these grid markings, lightly sketch in the locations of the features of the reference picture. These features are the top roofline of the big shed, the peak of its roof at the right end, the equivalent peak at its left end and the horizontal line of the dock. Next, use the grids to position the boats and deck houses. Keep the pencil work light but dark enough to see.

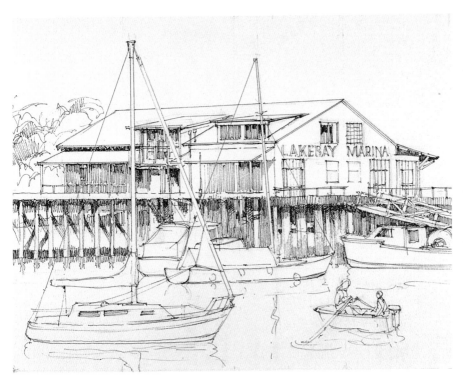

2 Define the Details

With the black marker, define certain details such as the tops of the masts. Use a ruler to draw the masts, the edges of buildings and the rigging lines. Leave the rigging lines unfinished for a later step. Draw in some of the vertical elements, such as the dock pilings and building windows. Continue to add smaller details that may have been omitted from the pencil layout. It's important to be accurate because the ink will show through the watercolor.

After completing the ink drawing, use the kneaded eraser to erase the pencil lines so the ink stands alone. Touch up details that may have been left out during this step.

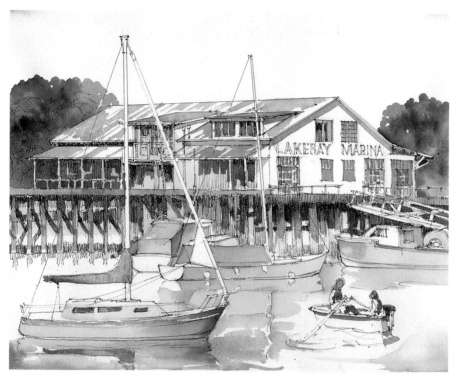

3 Apply the Wash

With a no. 10 round, apply a wash of Burnt Sienna and French Ultramarine to shadow areas below the roof edges and under the dock. Keep this wash somewhat transparent so you can add more layers of color later.

For the sail cover, use a wash of French Ultramarine and Raw Sienna. For the tarpaulins, use Raw Sienna with touches of Hansa Yellow Medium. To darken the background, use a mixture of Burnt Sienna and French Ultramarine.

Lightly paint the boat hulls with a thin wash of Burnt Sienna and French Ultramarine. Leave the paper bare in the places that will have the brightest highlights.

4 Define the Forms

With a no. 10 round, intensify the shadow underneath the dock by adding more of the Burnt Sienna and French Ultramarine mixture. With this same color, darken the reflection of the boat to the left side of the sail and around the other boats and yellow tarpaulins. Darken some of the shadows underneath the dock with a black marker.

Using a no. 0 rigger, apply gouache to the masts of the two boats to the left side and to the furled foresail. This is necessary because surrounding washes may run slightly over the edges of these important features. Paint the sail a slightly grayed white. For the masts, apply a mixture of Burnt Sienna and French Ultramarine.

Use the rigger to apply white gouache to those parts of the rigging lines that you drew in ink but since have been obscured by color washes.

With a no. 10 round, apply a little Alizarin Crimson, Hansa Yellow Medium and Quinacridone Burnt Orange to liven up the colors on the building roof, the figures in the rowboat, the yellow tarpaulins and other details.

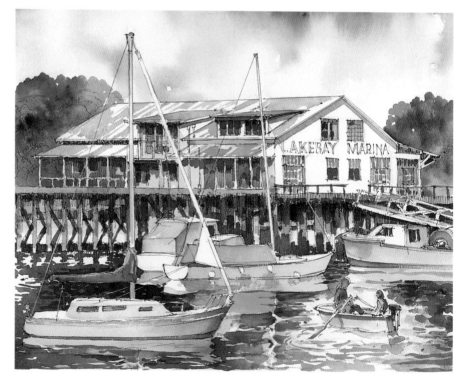

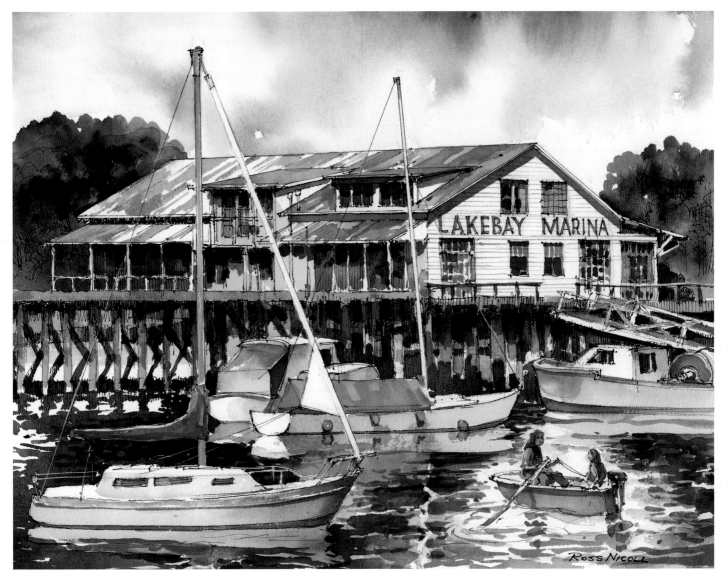

5 Add Finishing Touches

Using a 1-inch (25mm) flat, apply a wash of clean water to the sky area. Bring the wash down carefully to the upper edge of the shed's roof, making sure you don't wet the tops of the two masts. While this wash is wet, use a no. 10 round to add a few touches of Prussian Blue here and there. While it's still wet, apply a little French Ultramarine to other parts of the sky for variation. Leave the sky above the roof of the shed blank. Also, add a mixture of Burnt Sienna and French Ultramarine to the top edge of the shed. Use this same mixture to create the shadows on the underside of small clouds. Keep in mind that a slightly blotchy sky looks more interesting than a flat wash of color.

After the sky has dried, paint the background trees with a no. 10 round. Apply French Ultramarine and Raw Sienna to the lower parts of the trees. Apply a mixture of Raw Sienna and Prussian Blue to the light green treetops. Add a little Hansa Yellow Medium to liven up the green. For contrast, use the black marker to define the lower parts of the trees. Using the no. 0 rigger, paint the masts' reflections with white gouache, making them shimmer. Paint white gouache where the oars enter the water. Paint ripples with Burnt Sienna and French Ultramarine to show the oars breaking through the water.

LAKEBAY MARINA
Ross Nicoll
13" × 17" (33cm × 43cm)

Skiffs at Ease in Oil

BY TED PANKOWSKI While attending a local wooden boat festival, Gary Greene came upon a wealth of interesting vessels of all sizes, including these rowboats moored to the dock. He composed the image using a 28mm lens. His goal was to emphasize the strong qualities of line, form and color. Unfortunately, he was unable to crop out some of the unimportant objects in the background. Using Adobe Photoshop, Gary removed the distracting elements to make the final reference photo, which is a much stronger composition. Again, if you do not have access to such a computer program, you can alter reference photos using photocopies or tracing paper.

Talented oil painter Ted Pankowski transformed this rather tight composition into a beautiful impressionistic scene, adding his own elements to the final painting.

MATERIALS

Surface

16 × 20-inch (41cm × 51cm) 300-lb. (640gsm) cold-press watercolor paper

Palette

MAX GRUMBACHER ARTISTS' OIL COLORS (WATER SOLUBLE): Cadmium-Barium Red Light, Cadmium-Barium Yellow Light, Cadmium-Barium Yellow Medium, Cobalt Blue, French Ultramarine Blue, Quinacridone Orange, Quinacridone Red, Titanium White, Viridian, Yellow Ochre

Brushes

Nos. 4, 6 and 8 flats

Nos. 2, 4, 6 and 8 rounds

Other

18 × 24-inch (46cm × 61cm) foamcore board

Acrylic gesso

Masking tape

REFERENCE PHOTOS

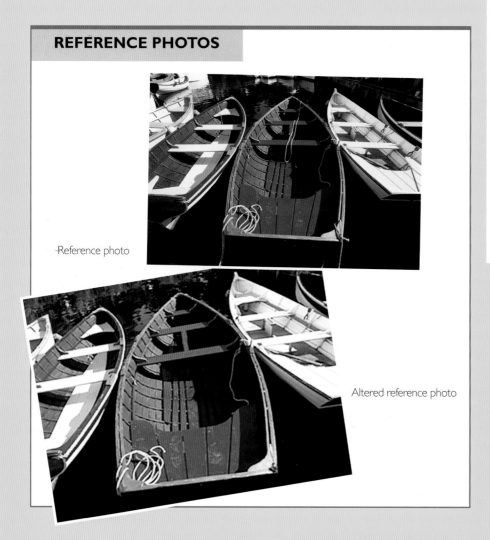

Reference photo

Altered reference photo

Prepare the Surface and Preliminary Sketch

Coat both sides of the watercolor paper with white acrylic gesso. When it's dry, tape the paper to an 18 × 24-inch (46cm × 61cm) piece of foamcore. The benefit of using Grumbacher Max Artists' Oil Colors (water-soluble) is the flexibility of painting on paper with an oil-based medium. Like watercolors, much of the painting can be done in thin washes. Leave some areas of paper showing through.

Sketch in major shapes of the boats with a no. 2 round and Yellow Ochre. Leave out all the nonessential details and concentrate on the major shapes. If needed, lay out both the watercolor paper and the photograph in grids of sixteen equal rectangles. The grids will make it easier to transfer the image from the photograph to the paper.

2 Block in the Drawing

Use both no. 6 or 8 flats and rounds to paint in the shapes of the boats and surrounding water. A round works well for the water and sides of the hulls. A flat brush works well for the seats and other flat surfaces.

Keep the darks and lights separated. Begin with the darks, keeping the paint thin and transparent. Use Titanium White sparingly. Block in the shadows under the seats, curves of the hulls and decking.

Keep the edges loose. It is not necessary to paint exactly within the lines of the drawing underneath. Use this stage of painting as an opportunity to adjust perspective. Paint larger areas with a no. 6 or 8 round and use a no. 4 or 6 round for the smaller areas.

Paint the violet shadows of the red boat with a mixture of Quinacridone Red, French Ultramarine Blue, Cobalt Blue and

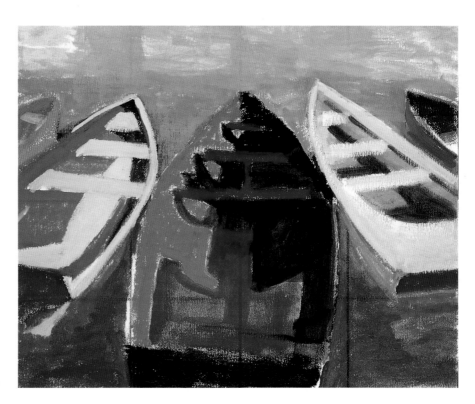

a small amount of Titanium White. Paint the bright reds on the seats with a mixture of Quinacridone Red and Cobalt Blue and a small amount of Titanium White. Add Cadmium-Barium Red Light and Cadmium-Barium Yellow Medium where the reds are brightest. For the grays on the inside hulls, lighten the mixture of Quinacridone Red and Cobalt Blue with Yellow Ochre and Titanium White.

Using a no. 4 round, paint the dark shadows of the boats to the right and left of the red boat with a mix of Cobalt Blue,

Viridian, a touch of Quinacridone Red and Titanium White. Paint the sunlight inside the boats with Titanium White, Yellow Ochre and a touch of Viridian. The seats and hull are in full sun and therefore brighter. Instead of Viridian, add Quinacridone Red and a touch of Cadmium-Barium Yellow Medium to the white mixture. Use a no. 4 or 6 flat. Paint the very backs of the boats with pure Quinacridone Orange.

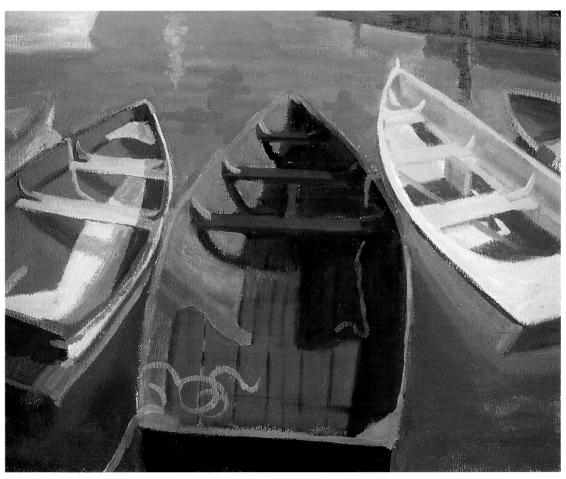

3 Model the Forms

Use the no. 2 and 4 rounds to refine the drawing. Adjust the values to bring out the characteristics of each major feature. Repaint the darkest shadows with a transparent wash of French Ultramarine Blue and Quinacridone Red. Touch up the sunny areas with Quinacridone Red and Cadmium-Barium Red Light. Repaint the gray areas with a violet mixture of Quinacridone Red, Cobalt Blue and Titanium White, adding Yellow Ochre where the inside hulls of the boats are brightest.

To balance the intense reds of the center boat with the blue-greens of the water, repaint the water above the boats with a bright mixture of Cobalt Blue, Viridian, Cadmium-Barium Yellow Light and Titanium White. Paint in the reflections in the water at the upper left with Titanium White and Quinacridone Red. Mix Quinacridone Red and Cadmium-Barium Yellow Medium and paint in the shadows at the upper right. With a no. 4 round, paint in the ropes with a mixture of French Ultramarine Blue and Titanium White.

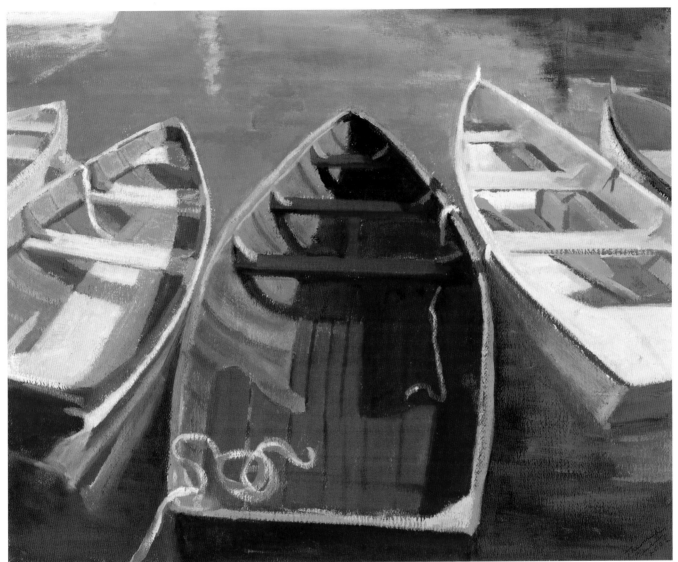

4 Paint the Highlights and Accents

Paint the highlights thickly and opaquely with a no. 4 or 6 flat. Refine the colors and shapes of the smaller details. For example, lighten some of the curves of the ropes with a touch of Titanium White.

Paint the wood trim around the top edges of the boats with bright mixtures of Titanium White, Cadmium-Barium Yellow Medium and Quinacridone Orange. Lighten the water at the top of the painting with Titanium White, Viridian and Cobalt Blue. With Titanium White and a touch of Cadmium-Barium Yellow Medium, brighten up the white seats that are in direct sunlight.

SKIFFS AT EASE
Ted Pankowski
16" × 20" (41cm × 51cm)

Accents belong in the deepest shadows of the interiors and backs of the boats. Repaint the darker shadows under the seats of the red boat with a transparent mixture of French Ultramarine Blue and Quinacridone Red. Bring attention to the skiffs by adding a dark shape to the lower right of the water using French Ultramarine Blue and Quinacridone Red. To complete the painting, repaint the very back of the boats in Quinacridone Orange.

Floats in Colored Pencil

BY GARY GREENE While strolling along a dock in the fishing town of Westport, Washington, these colorful floats immediately caught Gary Greene's eye, and he decided to shoot a few reference photos. Before he began to paint, however, Gary felt that cropping the extraneous portions of the original photo and making a few adjustments would strengthen this eye-arresting subject. He removed the numbers carved on the floats by cutting blank yellow areas adjacent to the numbers and pasting over them. Then he used an airbrush tool to hide his alterations. Using the original photograph, Gary cut the bottom of the lower float in the center and pasted it into the altered copy. Following the same process, he covered up the distracting background with additional floats that were copied, cut and pasted from adjacent floats. Finally, he simplified the ropes by removing those that distracted from the composition. You can get similar results without a computer by photocopying images or desired elements and transferring them with tracing paper.

Evidently, the floats were all yellow to begin with and the fishermen later painted on the red and green stripes for identification. In order to achieve the painted-on appearance, Gary used an underpainting technique described in step 2 of the demonstration.

MATERIALS

Surface

15 × 23-inch (38cm × 58cm) Strathmore white four-ply museum board

Palette

FABER-CASTELL POLYCHROMOS COLORED PENCILS: Cadmium Yellow, Golden Ochre, Warm Grey (II, III, IV,V,VI)

PRISMACOLOR ART STIX: Canary Yellow

PRISMACOLOR COLORED PENCILS: Apple Green, Black, Canary Yellow, Crimson Lake, Crimson Red, Dark Green, Dark Umber, Goldenrod, Grass Green, Lemon Yellow, Parrot Green, Poppy Red, Scarlet Lake, Sienna Brown, Sunburst Yellow, True Green, Tuscan Red, Warm Grey 90%, Yellow Ochre

PRISMACOLOR VERITHIN PENCILS: Black, Crimson Red, Dark Brown, Grass Green, Poppy Red, Warm Grey 20%

Other

2B graphite pencil

Bestine rubber cement thinner

Cotton-tipped applicators

French curve set

Kneaded eraser

Koh-I-Noor imbibed eraser

Krylon workable fixative

Lyra Splender pencil (a pigment-free colored pencil for blending)

Pencil sharpener

Plastic ellipse template

Small, narrow-mouth glass jar with screw-top cap

REFERENCE PHOTOS

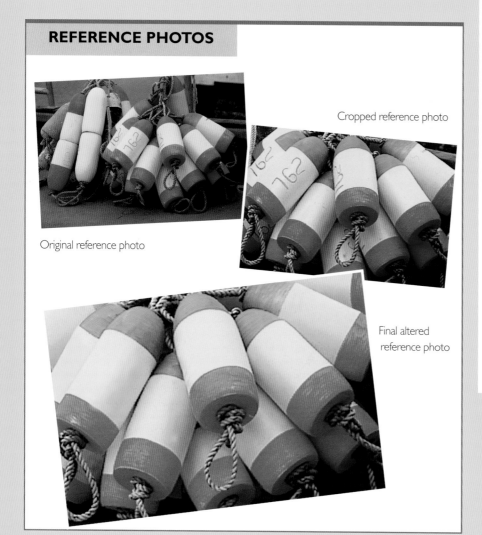

Cropped reference photo

Original reference photo

Final altered reference photo

Lay Out the Painting

Use a 2B graphite pencil to lay out the painting. Following the ropes, redraw the lines with Warm Grey III. Redraw the floats with Golden Ochre. Use ellipse templates and french curves for accuracy. Remove graphite lines with a kneaded eraser, leaving the colored pencil lines.

2 Apply Underpainting

Apply Warm Grey II to the darker values of the ropes. Apply Bestine rubber cement thinner with a cotton swab to produce an easily controlled application of color in small areas without streaking. The Bestine evaporates quickly and leaves no residue on the paper.

Pour about ¼ ounce (7grams) of Bestine into a small jar with a narrow mouth and cap it immediately to prevent fumes from escaping. When ready to use, loosen the cap, dip the applicator into the Bestine and immediately replace the cap. To avoid skin contact, use cotton swabs with long wood handles. Work in a ventilated area and keep Bestine away from flames. Unlike turpentine and similar solvents, Bestine does not leave a lingering odor.

Apply Warm Grey III to background areas and on the darker values of the floats. Apply Bestine rubber cement thinner with a cotton swab.

Use strokes that follow the cylindrical shape of the floats. Apply Canary Yellow and Cadmium Yellow to the yellow floats.

3 Paint the Ropes and Floats

For this step, use a well-sharpened pencil at all times. With Warm Grey V or VI, apply short, linear pencil strokes to one side of the ropes and perpendicular to the twists. Apply longer linear strokes with Warm Grey III, creating roundness by layering color gradually to areas that are highlighted. Layering is the most common technique with colored pencils, so use light pencil pressure. Start with the darkest colors first to create complex hues, values and gradations. Darken the creases of the ropes using Warm Grey III. Apply Warm Grey VI to darkest areas.

In the yellow areas of the floats, erase the highlighted areas with a kneaded eraser. Layer Warm Grey IV onto the shadows only. Use Goldenrod, Golden Ochre, Yellow Ochre and Sunburst Yellow

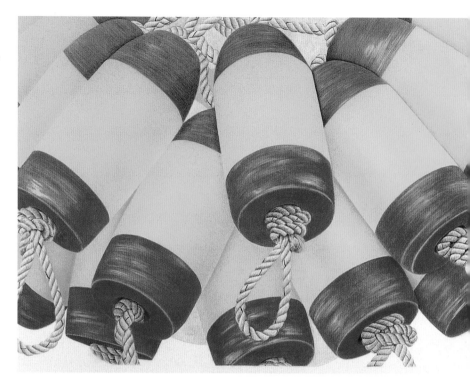

following the curves of the floats in the underpainting. If colors become too dark, adjust by adding lighter colors. Gradually layer in Cadmium Yellow, Canary Yellow and Lemon Yellow over the darker values and into erased areas. Touch up the darkest values with Sunburst Yellow, midvalues with Cadmium Yellow and lightest values with Lemon Yellow. Repeat until the surface is completely covered. Burnish with a Lyra Splender or clean blending pencil. Burnishing involves layering then blending the colored pencil together until the entire paper surface is covered. Apply color lightly, layering lighter colors on top of darker colors.

For the darkest green areas, use Dark Green and Grass Green. Layer Parrot Green, True Green and Apple Green over the entire green area, including the dark values. Burnish with

the blending pencil, dragging color into some of the yellow areas. Apply True Green and Apple Green in touches to the yellow area. Again, burnish newly added colors with a blending pencil.

For the top of the float, use Crimson Lake for the darkest values. Layer Crimson Red, Scarlet Lake and Poppy Red over the entire red area, including dark values. Burnish the entire area with the blending pencil, again dragging more color into portions of the yellow areas. Add touches of Scarlet Lake and Poppy Red and continue to blend. For the bottom of the float, layer in Tuscan Red, Crimson Lake and Crimson Red. Burnish these colors using Scarlet Lake and Poppy Red; finish by blending with Crimson Lake.

FLOATS
Gary Greene
15" × 23" (38cm × 58cm)

4 Finish the Floats

To finish the floats, lightly layer Warm Grey IV, Goldenrod, Yellow Ochre and Cadmium Yellow onto the yellow areas. Next, burnish this area with the blending pencil. Repeat this process until the entire section is covered. Lightly layer Warm Grey IV, Grass Green, Dark Green and True Green onto the green areas. Using the blending pencil, burnish this section.

Lightly layer in Warm Grey IV, Tuscan Red, Crimson Lake and Scarlet Lake to the red areas. Again, use the blending pencil to burnish this area. In a gradation, layer Black, Warm Gray 90%, Dark Umber and Sienna Brown. Lightly burnish with the blending pencil. Repeat as necessary until the entire paper surface is covered.

For the finishing touches, clean up any rough edges with Black, Crimson Red, Poppy Red, Dark Brown, Grass Green or Warm Gray 20% Verithin pencils.

For the background area at the bottom, layer a gradation of Black, Warm Gray 90%, Dark Umber and Sienna Brown. Lightly burnish with the blending pencil. Repeat as necessary until the entire paper surface is covered.

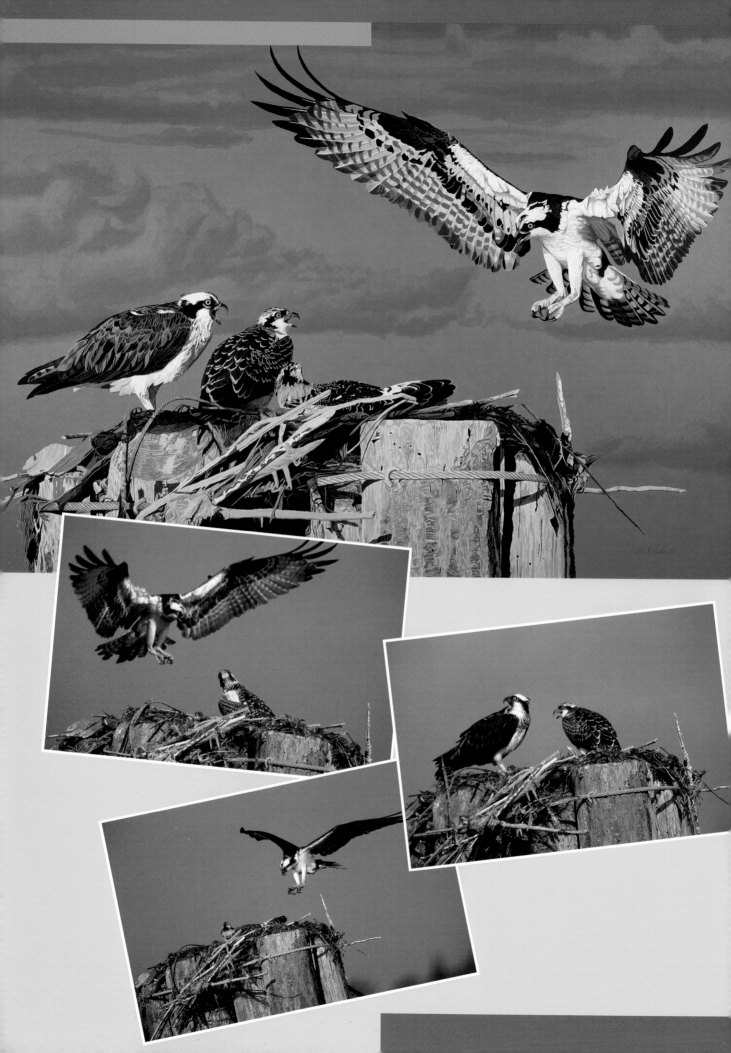

4 BIRDS

As any bird enthusiast knows, sometimes location means everything. Though many songbirds can be lured to your backyard using a variety of bird feeders or baths, certain species live only in particular regions or climates. This is true of the cardinal, who lives primarily in the Eastern United States and is seldom seen farther north than the Dakotas. Other types of birds rarely stray from their habitats. For example, if you're interested in painting water or shorebirds such as pelicans, chances are you'll need to travel to the nearest coast. Does this mean you're limited to painting those species that frequent your backyard? Not if you use reference photographs. With photos as your guide, you can paint any bird you desire.

Of course, you may be most intrigued by the birds you've spotted from your living room window. Even so, you'll find painting these birds from life nearly impossible. Birds aren't likely to

stay in the same position long enough for a person to finish a sketch, let alone a painting, so instead of trying to create a masterpiece in minutes, grab your camera and take as many photographs as possible. If photographing from indoors, be sure to use a window that can be opened, as having glass between your camera and the bird will decrease the quality of your pictures. In most cases you'll still need to conceal yourself in some way so you don't frighten the birds. Try filling the window with a piece of cardboard with a small peephole cut out for your lens.

In this chapter, you'll come across an assortment of birds, some you've probably seen at your feeder like the goldfinch or tanager, and others that you don't encounter every day, such as the osprey, a known predator and hunter of fish. Once you've completed the demonstrations, go take your own reference photos of the birds you love and create your own unique compositions.

American Goldfinch in Mixed Media

BY SUEELLEN ROSS Sueellen Ross has developed a unique technique that combines ink, watercolor, acrylic and colored pencil to produce consistently beautiful results. Her signature technique has very distinct steps that are easy to follow. The photos she used as her main references for her goldfinch painting were taken by a friend of hers at a back-yard bird feeder. She also used a goldfinch that hit a window in her neighborhood as a color and feather reference. Magazine photos from her clip files helped fill in the details. Sueellen always keeps several bird field guides close at hand to double-check on colors that might not be true in the pictures.

MATERIALS

Surface
24 × 16-inch (61cm × 41 cm) Arches 140-lb. (300gsm) hot-press watercolor paper

Palette

Acrylics
LIQUITEX MEDIUM VISCOSITY ACRYLIC ARTIST COLORS: Value 5 Neutral Gray

Colored Pencils
PRISMACOLOR COLORED PENCILS: Black, Burnt Ochre, Goldenrod, Light Cerulean Blue, Sepia, White

Watercolors
WINSOR & NEWTON ARTISTS' WATERCOLORS: Aureolin, Burnt Sienna, Cadmium Yellow, Charcoal Gray, Indanthrene Blue, New Gamboge, Quinacridone Gold, Raw Umber, Rose Doré, Sepia

Brushes

Ink
Nos. 0 and 5 rounds

Watercolor
Nos. 0, 5 and 10 rounds

Other
Black drawing pen

FW Acrylic Artist's Black India ink

HB graphite pencil

Magic Rub eraser

REFERENCE PHOTOS

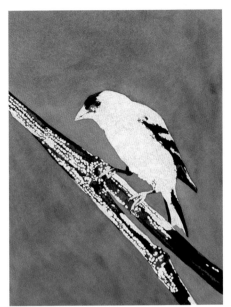

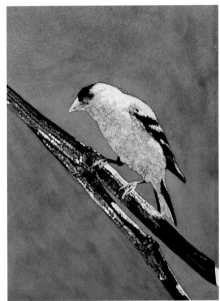

1 Complete Drawing and Add Ink

On a piece of watercolor paper, do a detailed and complete pencil drawing of the bird and the branch. Start with an overall outline sketch, then refine each area showing its exact structure and where the light and shadows will fall.

Place a small dot of waterproof India ink somewhere in each of the very darkest areas. This will serve as a reference as you fill in the darks. Now go back and outline each dark area with a pen. Fill in the outlines with a heavier pen or a small brush. Do not overuse the ink. It is only used for the very darkest areas.

2 Lay Background Wash, Start Grisaille

Paint a pale wash of Quinacridone Gold in the sky area. When it's dry, glaze Indanthrene Blue over the first color. (Don't worry if the wash isn't perfect; you can fix it later with colored pencil.)

Grisaille is a monochromatic underpainting, usually done in shades of gray, to be layered over with glazes. Start filling in tonal values on the bird and branch, going from dark to light. Build your painting one color at a time, getting lighter and lighter as you go. For the bird, paint three stages using Charcoal Gray watercolor. Begin with your darkest value and add water to create each following lighter shade. Paint the branch in the same manner using Sepia watercolor.

3 Paint From Dark to Light

Continue grisaille on the bird using a paler gray made with Value 5 Neutral Gray acrylic. Paint three stages of color. Again, paint the darkest value, add water to create a lighter shade, and so on.

Paint two lighter values of Sepia watercolor on the branch.

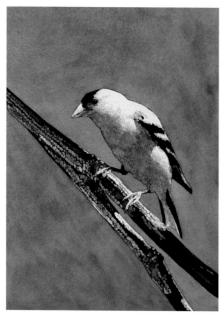

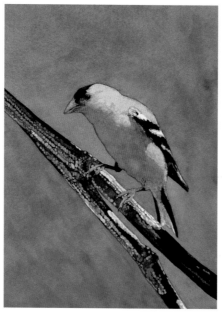

4 Adjust Values, Finish Color and Erase

Darken the shadows on the bird using Charcoal Gray watercolor.

Finish the watercolor stage on the branch, leaving the white paper as your lightest value. Use New Gamboge watercolor mixed with Burnt Sienna for your lightest, brightest values.

Now erase all traces of graphite pencil using a Magic Rub eraser.

5 Add Final Color

Carefully glaze yellow over your grisaille on the bird. Do not lift the undercoats by scrubbing or overworking. Use Aureolin on the lighter areas and Cadmium Yellow on the bottom. Avoid the white areas on the wings and under the tail.

For the bird's bill and feet, mix Rose Doré and Raw Umber watercolors and glaze the mixture over the grisaille.

On the branch, add a final pale, warm mixture of New Gamboge and Burnt Sienna.

6 Add Lights, Brights and Details With Pencil, and Fix Background Wash

Edge the top and back of the bird with White Prismacolor pencil. Use it only along the edge; don't cover the bright yellow. Put white highlights on the bill and feet only where they are hit by light. Shade the bill and feet with Burnt Ochre pencil, and glaze lightly with Goldenrod pencil to warm the color. Darken and detail the shadowy areas around the bill, feet and eyes with a Sepia pencil. Blend the shadow edges between the light and dark yellow on the bird with a Goldenrod pencil. Warm the dark yellow shadows by glazing lightly with a Burnt Ochre pencil. Clean and sharpen the inked areas with a Black pencil when you are finished with the bird.

Blend and soften the darkest brown edges of the branch into the ink with a Sepia pencil. Blend and soften lighter areas with a Burnt Ochre pencil. Glaze the branch with a Goldenrod pencil to blend and warm the wood colors. With a Black pencil, sharpen the shadows around the bird's feet.

If your background sky wash needs evening up (and this one does), go over it with a Light Cerulean Blue pencil.

Sueellen used the same sequence of steps
to incorporate an interesting habitat for the
goldfinch.

VINEYARD VISITOR
Sueellen Ross
24" × 16" (61cm × 41cm)

Cardinals in Water-Soluble Oil

BY BART RULON To create this painting, Bart Rulon combined two different photos into a single composition. This demo is a good example of learning what to leave in and what to take out of your photos. Bart photographed both the male and female cardinals from his photo blind near a bird feeder in central Kentucky. Both birds were photographed on the same day. He positioned his photo blind directly under the feeder so that the birds would approach it with caution and land in the trees nearby for a natural background.

MATERIALS

Surface

12 × 9-inch (30cm × 23cm) hardboard panel primed with gesso

Palette

MAX GRUMBACHER ARTISTS' OIL COLORS: Burnt Sienna, Cadmium-Barium Red Light, Cadmium-Barium Yellow Light, Ivory Black, Permanent Blue, Raw Sienna, Raw Umber, Thio Violet, Titanium White

Brushes

No. 10 Grumbacher Renoir 626-R filbert sable

Nos. 4 and 7 Grumbacher Renoir 626-R round sables

Nos. 0 and 00 Winsor & Newton Monarch rounds

Other

Plastic wrap

Water as a medium with each painting mixture

REFERENCE PHOTOS

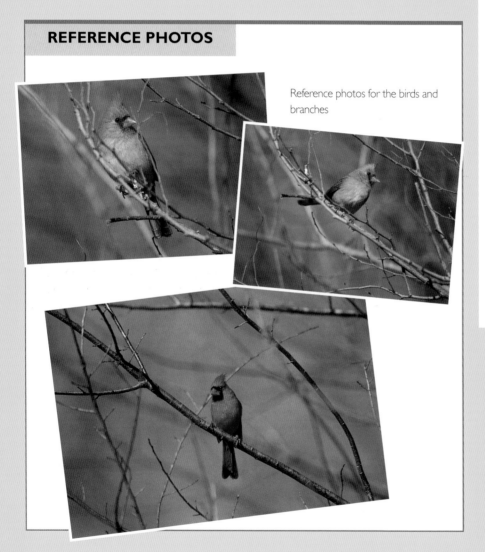

Reference photos for the birds and branches

Draw simple outlines of the birds and place them in a variety of positions to come up with the best composition.

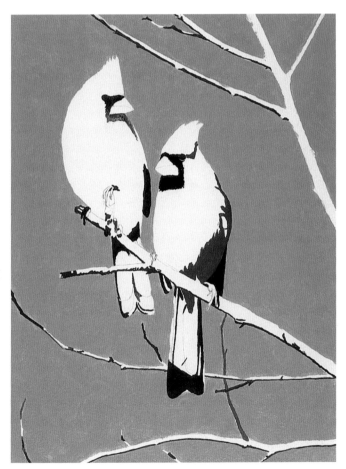

| Block In Colors

In order to keep the focus on the birds in this painting, take out the busy background you see in the photos and replace it with clear blue sky. Keep the main branches shown in the foreground in the photo of the female. Block in the sky with a mix of Permanent Blue, Titanium White and Thio Violet using the no. 10 filbert. Use the no. 4 round for the rest of this step. Paint the undersides of the branches using various mixtures of brown consisting of Raw Umber, Permanent Blue, Burnt Sienna, Ivory Black and Titanium White.

For the shadows on the undersides of the cardinals' tails, mix Raw Umber, Burnt Sienna, Thio Violet, Cadmium-Barium Red Light and Ivory Black. Add more Cadmium-Barium Red Light to this mix for the red on the male's lower belly. Mix Ivory Black, Raw Umber, Permanent Blue and a touch of Titanium White for the black bib around the male's beak. Add more Raw Umber and Titanium White to the mix for the female's bib. Block in the eyes on both birds with a mix of Burnt Sienna, Raw Umber and Ivory Black.

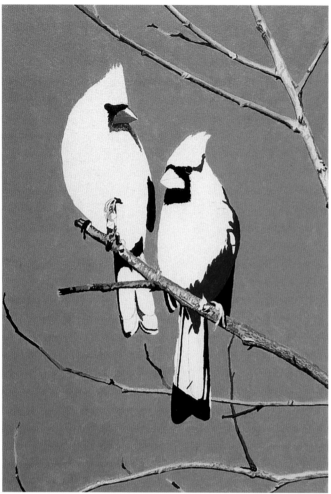

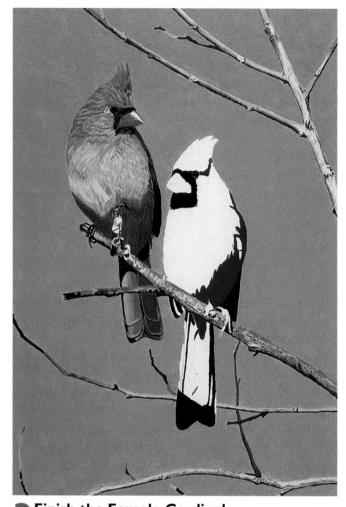

2 Paint and Blend the Branches

Create seven different mixtures of paint for the branches, ranging from the lightest lights to the darkest darks. The mixtures should contain various amounts of Raw Sienna, Thio Violet, Permanent Blue, Burnt Sienna, Raw Umber, Ivory Black and Titanium White. Use the no. 4 round to paint the colors on the branches wet-into-wet, blending colors where needed. Start with the dark colors on the branches and blend lighter colors on top of them. Underpaint the female's beak with a mix of Cadmium-Barium Red Light and a touch of Cadmium-Barium Yellow Light.

3 Finish the Female Cardinal

Use the no. 7 round to block in the color on the head and neck of the female cardinal with a mix of Raw Sienna, Raw Umber, Permanent Blue and Titanium White. Make a darker mixture for the lower belly by adding less Raw Sienna and less Titanium White to the previous mix. Paint the dark feather details on the bib around her beak with a mix of Ivory Black, Raw Umber and Titanium White using the no. 00 round. Use the no. 00 round and a mix of Ivory Black, Raw Umber and Permanent Blue to paint the dark pupil and the outside edges of the eye. Mix Cadmium-Barium Yellow Light, Raw Sienna and Titanium White for the base color on the chest. Blend to a lighter mix, with Raw Umber added, for the middle belly. On top of this base you will paint darker and lighter colors wet-into-wet with the no. 00. Pay close attention to the feather directions shown in the photo and concentrate on the patterns caused by the feathers. Continue working on the tail with a mix of Cadmium-Barium Red Light, Thio Violet, Burnt Sienna, Raw Umber and Ivory Black for a base color. Then add more Titanium White and Cadmium-Barium Red Light for the lighter areas, mixing wet-into-wet.

4 Finish the Male Cardinal

Start by painting the underside of the beak with a mixture of Cadmium-Barium Red Light, Thio Violet, Burnt Sienna and Ivory Black. Use a mix of Cadmium-Barium Red Light, Cadmium-Barium Yellow Light, Thio Violet and Titanium White for the lighter parts of the beak. Use enough water mixed in with the paint so you can paint thinly enough for the white gesso to show through and brighten the colors.

For the red plumage of the male, create seven different mixtures of red ranging from the darkest red in the body to the lightest highlights. Make the mixtures using different combinations of Cadmium-Barium Red Light, Thio Violet, Cadmium-Barium Yellow Light and Titanium White. Add Burnt Sienna and Ivory Black to only the darkest mixtures. Paint a basecoat of the medium red color (see the palette photo below) and let this coat dry partially overnight. Put plastic wrap over your palette to keep your colors from drying out. The next day the undercoat should still be a little wet, but thickened, and you can paint the lighter and darker colors wet-into-wet on top of it with the no. 00. Pay close attention to the direction of the feathers indicated in the photo here. Paint the dark pupil and edges of the eye with a mix of Ivory Black and Raw Umber using the no. 00 round brush. Start the tail with a dark mixture of Cadmium-Barium Red Light, Thio Violet, Burnt Sienna and Ivory Black, then work from dark to light, wet-into-wet, adding more Titanium White to the mixture for lighter areas. Use the no. 4, no. 0 and no. 00 rounds for the tail.

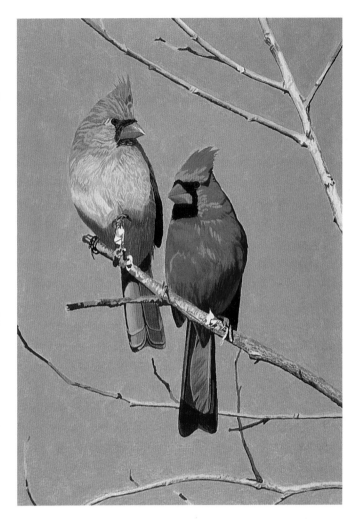

Basecoat color

Color mixtures for the male cardinal

5 Refine the Details and Redo the Sky

Brighten up the highlights on the eyes of both cardinals with another dab of Titanium White using the no. 00 round. Add more details to the head of the female using the no. 00 round and a light mix of Cadmium-Barium Yellow Light, Raw Sienna and Titanium White. Finish the edges of both birds' bibs with the no. 00 round, emphasizing the fine lines of feathers sticking out from the edges of the bibs.

Reevaluate the branches and add details where needed to make them look realistic. The sky needs more punch to make this painting work; mix Permanent Blue, Titanium White and a touch of Cadmium-Barium Yellow Light to make the sky bluer. Use the small round brushes near the edges of the birds and the branches, being careful not to overpaint what you've already completed. In open areas, use the no. 10 filbert.

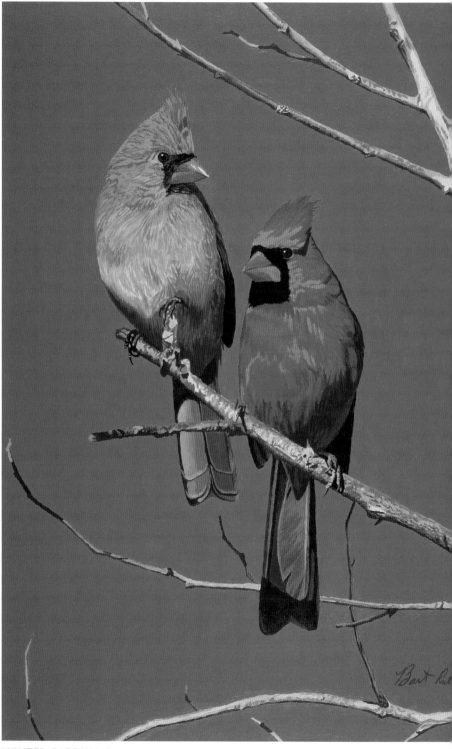

WINTER CARDINALS
Bart Rulon
12" × 9" (30cm × 23cm)

Yellow-Headed Blackbird in Pastel

BY MARK BOYLE Mark Boyle photographed the yellow-headed blackbird for this painting in Eastern Washington. Yellow-headed blackbirds are one of his favorite subjects. He offers this advice: "Do as much research as possible for your paintings. Yellow-headed blackbirds are scattered throughout the western United States, usually in dry terrain on the shores of a pond or lake. The birds are easier to photograph during the courting and nesting phases."

REFERENCE PHOTO

MATERIALS

Surface

24 × 18-inch (61cm × 46cm) Ersta sanded pastel paper, 400 grit (medium)

Palette

Gouache

WINSOR & NEWTON DESIGNER'S GOUACHE: Alizarin Crimson, Burnt Umber, Chinese Orange, Havannah Lake, Indigo, Yellow Ochre

Pastels

REMBRANDT MEDIUM SOFT PASTELS: 409 Burnt Umber; 608.3 Chrome Green Deep; 231.3 Gold Ochre; 235.3 Orange; 234.5 Raw Sienna; 522.8 Turquoise Blue; 227.5 and 227.7 Yellow Ochre

ROWNEY SOFT PASTELS: 345 Green Grey

SCHMINKE SOFT PASTELS: 180 Burnt Sienna; 940 Greenish Grey 2; 130 Ochre Light; 20 Permanent Yellow 1 Lemon; 40 Permanent Yellow 3 Deep; 630 Ultramarine Deep

SENNELIER SOFT PASTELS: 208 Apple Green; 177 Black Green; 375 Burnt Madder; 742 English Blue; 467 Intense Blue; 513 Ivory Black; 169 Moss Grey Green; 210 and 211 Reseda Grey Green; 80 Vermilion; 525 White

UNISON SOFT PASTELS: A29 and A30 Purple

Brushes

½-inch (12mm) camel hair sumi round

Other

Black permanent marker

Charcoal stick, ¼ inch (6mm)

Masking tape, 3 inches (8cm) wide

Stiff plywood board

Tracing paper

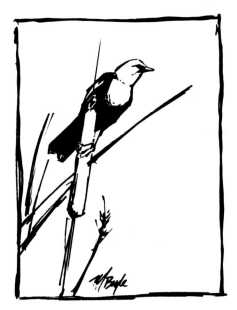
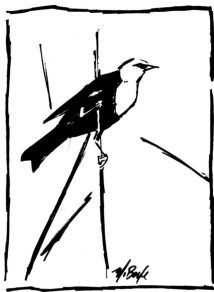
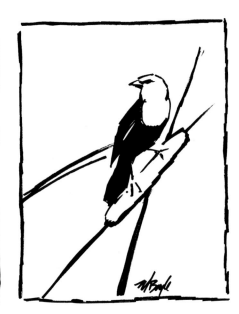

In this painting Mark wanted to depict a single male yellow-headed blackbird. (The females tend to be more pale in appearance.) Start by using a black permanent marker to draw your layout sketches on tracing paper. Place the main weight of the subject on either the left or right side of the composition. Mark did three sketches but ultimately chose the middle sketch (above) due to the overall pose and angle of the bird.

Apply a Coat of Gouache

Tape the sanded pastel paper to a plywood board or other flat surface. Cover the paper with warm washes of gouache to rid the paper of its starkness. The warm colors will show through the pastel texture at the end. Start by applying Winsor & Newton Havannah Lake, Burnt Umber, Indigo, Chinese Orange, Yellow Ochre and Alizarin Crimson with the camel hair brush. As the paint begins to dry, splash on water droplets to create additional texture.

2 Block In the Outline

Use a charcoal stick to sketch the bird. The charcoal is easy to sweep away if you make a mistake. Lay in the direction and angles of the marsh grasses.

3 Block In the Yellow and Black

Start the bird by laying in Schminke 40 Permanent Yellow 3 Deep as the base color for the blackbird's head. In the light areas lay in 20 Permanent Yellow 1 Lemon. In the shadow areas of the bird's head lay in Schminke 130 Ochre Light, Rembrandt 234.5 Raw Sienna and a touch of Rembrandt 522.8 Turquoise Blue for reflected light under the breast. Fill in the dark shadow areas on his body with Sennelier 513 Ivory Black. Apply a coat of Rembrandt 409 Burnt Umber on the light areas of the bird. Be sure to soften the edges of the light areas of the bird on the back and belly. Sweep in light strokes of Sennelier 169 Moss Grey Green at different angles for the grasses.

4 Complete the Background and Add Final Touches

For the background, be spontaneous with the angles of the grasses and placement of the seed heads in order to lead the viewer's eye into the painting. Mark completely changed the background from what he saw in his reference photograph. Paint the seed heads with Rembrandt 235.3 Orange, 234.5 Raw Sienna, 227.5 and 227.7 Yellow Ochre, and 231.3 Gold Ochre. Apply sweeping base strokes for the grasses using Sennelier 169 Moss Grey Green, 210 and 211 Reseda Grey Green, Rowney 345 Green Grey, Schminke 940 Greenish Grey 2 and Rembrandt 608.3 Chrome Green Deep. Next, use Sennelier 208 Apple Green and Sennelier 742 English Blue for the highlights on the grasses. Use Sennelier 177 Black Green for the dark shadows under the grasses.

The background contains Schminke 630 Ultramarine Deep, Sennelier 467 Intense Blue, 80 Vermilion and 375 Burnt Madder, and Unison A29 and A30 Purple. Soften transitions between colors by blending lightly with your fingers. Lay Schminke 180 Burnt Sienna and Rembrandt 235.3 Orange onto the stick where the bird is perched. Lay Sennelier 525 White onto the bird's feathers underneath and behind the stick. To finish the painting, touch up the bird's highlight areas with Schminke 20 Permanent Yellow 1 Lemon.

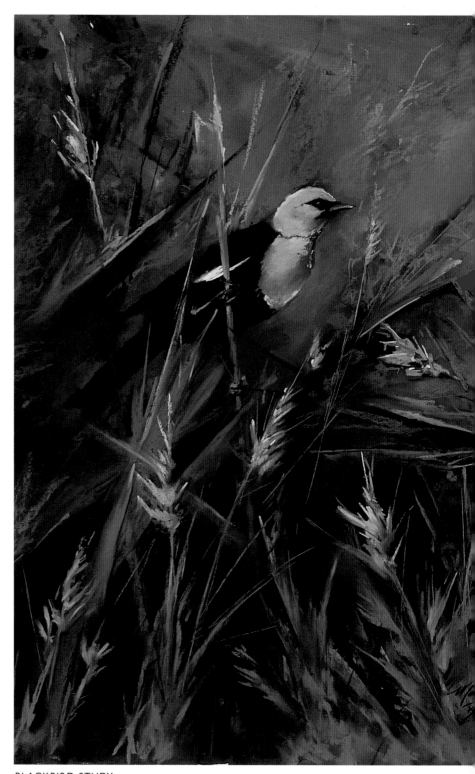

BLACKBIRD STUDY
Mark Boyle
24" × 18" (61cm × 46cm)

Ospreys in Acrylic

BY BART RULON This painting by Bart Rulon demonstrates how to combine several photos to make an interesting painting that tells a story. Bart took the reference photos of the ospreys and their nest a few miles from his home. Over a period of several weeks, Bart and a friend paddled a canoe to an island where they could get close enough to photograph the ospreys's nesting activities. Bart purposefully selected photos that picture light coming from the same direction and time of day for consistent lighting and shadows. The painting shows the adult female osprey on the nest with the young birds as the adult male returns from a hunt.

MATERIALS

Surface

24 × 36-inch (61cm × 91cm) hardboard panel primed with gesso

Palette

GOLDEN HEAVY BODY ARTIST ACRYLICS: Burnt Sienna, Burnt Umber, Cadmium Yellow Light, Mars Black, Raw Sienna, Raw Umber, Titanium White, Ultramarine Blue

LIQUITEX MEDIUM VISCOSITY ACRYLIC ARTIST COLOR: Naphthol Red Light

Brushes

Nos. 8 and 20 filberts

No. 12 flat

Nos. 00, 1, 3 and 5 rounds

Other

Empty film canister

Water as a medium for each painting mixture

REFERENCE PHOTOS

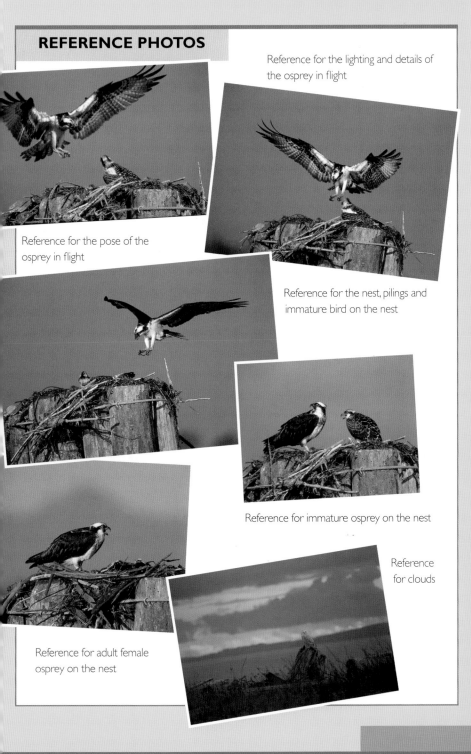

Reference for the lighting and details of the osprey in flight

Reference for the pose of the osprey in flight

Reference for the nest, pilings and immature bird on the nest

Reference for immature osprey on the nest

Reference for clouds

Reference for adult female osprey on the nest

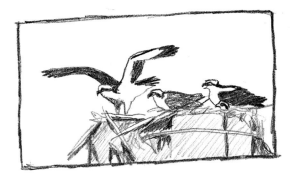

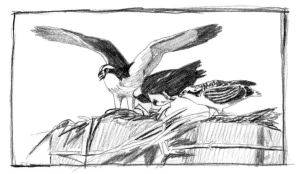

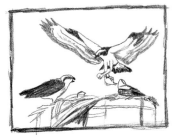

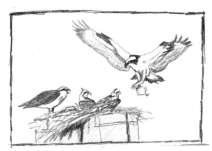

Test different compositions with thumbnail sketches.

Create the Drawing

Work out the anatomy of the birds on scrap paper to make sure they look correct before you transfer them to the board. Be sure to tilt up the young bird's head so he is looking directly at the male osprey in the air.

2 Block In

Start by blocking in the color of the sky with a mixture of Ultramarine Blue, Titanium White and a touch of Cadmium Yellow Light. Use the no. 20 filbert and no. 12 flat for the open areas and the no. 8 filbert and no. 5 round as you get close to the edges of the birds and nest. Make enough sky mixture to save for later in the painting. Store the excess paint in an empty film canister with a few drops of water. For the darkest feather colors on the ospreys, mix Mars Black with Raw Umber and paint them with the no. 8 filbert and the no. 5 round. Use the same brushes and dark mixture to block in the shadows in the nest and on the pilings. Block in some of the brown colors in the osprey on the left side with mixes of Burnt Sienna, Burnt Umber, Raw Sienna and Ultramarine Blue. Use this mix with more Ultramarine Blue and some Titanium White added to block in the patterns on the wing feathers of the flying bird with the no. 5 round. Block in a variety of mixes on the nest

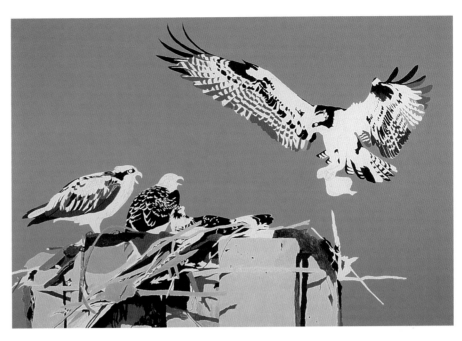

material, paying attention to the photo and shooting for the average color for each branch or area. Use the no. 8 filbert and the no. 5 round. Block in the color on the pilings with a mix of Raw Sienna and Titanium White.

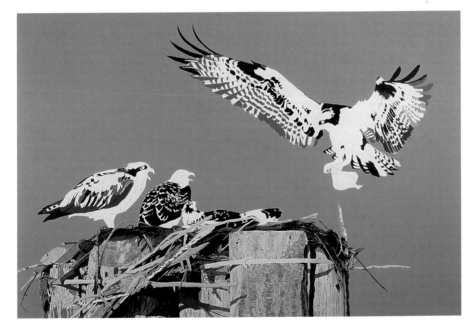

3 Use Dark and Light Colors for the Nest

In the previous step, you blocked in the average colors. In this step, you will paint darker and lighter colors on the nest and pilings. Work back and forth between dark and light for each area. There are too many different colors in the nest material to mention here, but each mixture includes Raw Sienna, which helps warm up the colors to indicate late afternoon sun. Paint the bark on the pilings with a mix of Raw Sienna, Ultramarine Blue, Cadmium Yellow Light and Titanium White for the greenish areas, and Raw Sienna, Burnt Sienna and Titanium White for the brownish areas. Use a variety of brushes, ranging from the no. 8 filbert to the no. 1 round, to paint the details on the nest sticks. The bluish shadows cast by the nest on the pilings take a mix of Ultramarine Blue, Naphthol Red Light, Mars Black, Raw Umber and Titanium White.

4 Paint the Birds on the Nest

Begin with the adult female osprey on the left side of the nest. Paint her eye with a mixture of Cadmium Yellow Light, Titanium White and a touch of Raw Sienna using the no. 1 round. Work from dark to light on the feathers of her back and wings with mixtures of Burnt Sienna, Raw Sienna, Raw Umber, Mars Black and Titanium White using the no. 5, no. 3 and no. 1 rounds. Use less Mars Black and Raw Umber and more Titanium White and Raw Sienna for the lighter feather areas. Mix Ultramarine Blue, Naphthol Red Light, Raw Umber and Titanium White for the shadows on her belly. Use this same mixture with more Naphthol Red Light added to block in her beak.

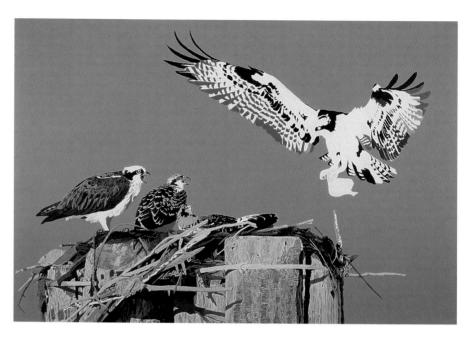

The immature ospreys in the middle of the nest have different coloring than the adults. Paint the eye with the no. 1 round and a mix of Naphthol Red Light, Cadmium Yellow Light, Raw Sienna and Titanium White. For the feather edges on their backs, wings and the backs of their necks, paint a mixture of Raw Sienna and Titanium White using the no. 3, no. 1 and no. 00 rounds. Block in their beaks with the same mix used for the adult. Paint the feather details on the top of their heads with a mix of Mars Black and Raw Umber using the no. 00 round. Paint feather details over the darkest parts of their bodies with a slightly lighter mix of Raw Umber, Mars Black and Titanium White.

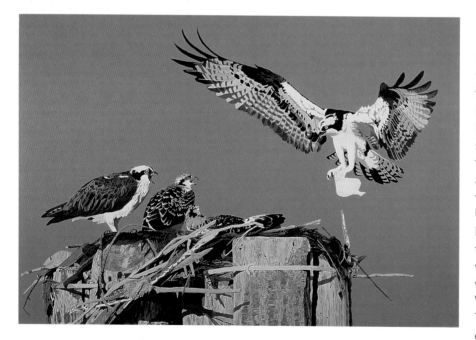

5 Show the Adult Osprey Landing

My reference photos of the osprey in flight are of the female, but I wanted the painting to show the male coming in to the nest. Male ospreys usually have little or no dark streaks on their chests, so don't paint the streaks you see in the reference photo. Paint the shadow areas on the bird's belly, tail and the white part of the wing with a mix of Ultramarine Blue, Naphthol Red Light, Raw Sienna and Titanium White using the no. 3 and no. 1 rounds. Paint the warm color on the long wing feathers with a mix of Raw Sienna and Titanium White using the no. 5 and no. 3 rounds. Then work in some of the darker feather details in the same feathers by adding Raw Umber, Ultramarine Blue and more Raw Sienna to the mix. Fill in more of the dark pattern on these wing feathers with various colors of brown. Start to warm up the color on the belly of the bird with thin glazes of Raw Sienna mixed with Titanium White. Paint the eye with the no. 1 round and a mix of Cadmium Yellow Light, Titanium White and a touch of Raw Sienna.

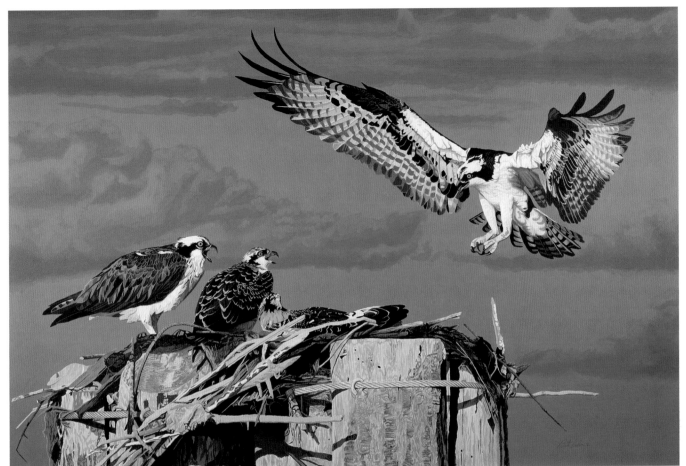

6 Add Clouds and Refine the Details

The sky needs some clouds for interest, and I decided to paint out the fish in the osprey's talons with the sky mixture that was saved back in step 1. Paint over the area blocked out for the fish first, then add a little Ultramarine Blue and Naphthol Red Light to the sky mixture. Use this new mix to block in the clouds with the no. 20 filbert and no. 12 flat. Refer to the cloud reference photo to make a pleasing combination of clouds. Add more Naphthol Red Light and Titanium White to the cloud mix to give the clouds form and some light from the sun. Make this lighter mixture subtle and paint it thinly with the no. 12 flat and no. 8 filbert to keep the clouds soft.

To finish the bird in flight, add and refine all of the wing patterns and markings, working from dark to light and vice versa where necessary. Pay attention to how the patterns interlock with each other from one feather to the next. Warm up the color on his white belly and the white areas on his wings with the no. 3 round and more thin layers of Raw Sienna mixed with Titanium White. Doing so helps indicate the warmth of the late afternoon sun. Paint more of the subtle shadows on the white underparts with the no. 3 and no. 1 rounds and a mixture of Ultramarine Blue, Naphthol Red Light, Raw Sienna and Titanium White. Add more white for the subtlest shadows. Be sure to stand back often while painting this step to see if the colors and values work in the picture as a whole. Start the lower legs with a mix of Raw Sienna and Titanium White using the no. 5 round, then add Raw Umber, Ultramarine Blue and Naphthol Red Light to the mix and paint the shadows using the no. 3 round.

Refine the warm feather edges on the backs and wings of the immature birds in the nest by varying their values relative to the sun using the no. 00 round. Clean up these feather edges against the dark parts of the feathers by carefully referring back to the reference photo. Finish the beaks on all of the birds in the painting with mixtures that are darker than the base color, using Ultramarine Blue, Naphthol Red Light, Raw Umber, Mars Black and Titanium White and the no. 1 round. Warm up all white parts of the birds on the nest with mixes of Raw Sienna and Titanium White using the no. 3 and no. 1 rounds. Paint this mixture with more Raw Sienna added on the right sides of the birds to help indicate the direction of the sun as indicated in the photos. Finally, paint pure Titanium White highlights in all the ospreys' eyes using the no. 00 round. Be sure to make all the highlights consistent with the direction of the sun.

RETURN TO THE NEST
Bart Rulon
24" × 36" (61cm × 91cm)

Four Pelicans in Pastel

BY NORMA AUER ADAMS This remarkable pastel painting demonstration by Norma Auer Adams shows that with a little cropping you can transform a simple reference photo into a stunning work of art. Although her process may seem complex, it reveals masterful methods to achieve a successful painting. She shot this picturesque reference photo near La Jolla, California. The comical demeanor of the pelicans is irresistible and provides a great starting point.

REFERENCE PHOTOS

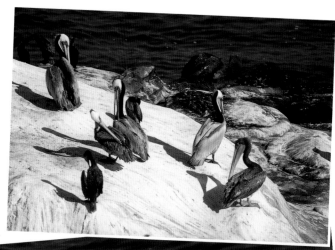

Reference photo

Cropped reference photo

MATERIALS

Surface

30 × 44-inch (76cm × 112cm) 100% cotton fiber drafting vellum

30 × 44-inch (76cm × 112cm) 100% rag vellum finish white paper

Palette

Pastel Pencils
CONTÉ PENCILS: 9 Black; 42 Sepia

DERWENT PASTEL PENCILS: 57B and 57F Brown Ochre; 62D Burnt Sienna; 72B Chinese White; 66B, 66D and 66F Chocolate; 74D Dark Olive; 25B and 25F Dark Violet; 6B Deep Cadmium; 70B, 70D and 70H French Grey; 78D Green Umber; 36B Indigo; 35D Prussian Blue; 32F Spectrum Blue; 11B Spectrum Orange; 64B Terracotta

Pastels
REMBRANDT MEDIUM SOFT PASTELS: 700.5 Black; 727.5 and 727.7 Bluish Grey; 411.3 Burnt Sienna; 409.1, 409.3, 409.5, 409.7 and 409.9 Burnt Umber; 343.3 Caput Mortuum Red; 512.3 and 512.10 Cobalt Blue Ultramarine; 202.3 and 202.9 Deep Yellow; 231.3 Gold Ochre; 709.1 Green Grey; 704.1, 704.7, 704.8 and 704.9 Grey; 538.10 Mars Violet; 235.3 Orange; 371.3 Permanent Red Deep; 370.5 Permanent Red Light; 234.8 Raw Sienna; 408.3, 408.9 and 408.10 Raw Umber; 545.7 and 545.8 Red Violet Deep; 506.3 Ultramarine Deep; 100.5 White; 227.7 and 227.9 Yellow Ochre

SCHMINCKE SOFT PASTELS: 99B Black; 24B Caput Mortuum Deep; 64B Cobalt Blue Tone; 81B Cold Green Deep; 16B Flesh Ochre; 65O Greenish Blue; 93D Greenish Grey 1; 98J, 98N and 98O Neutral Grey; 29O Olive Ochre Deep; 42B Permanent Red 1 Pale; 66B Prussian Blue; 50M Purple 2; 1O White

Other

30 × 44-inch (76cm × 112cm) drawing board or masonite

Artist's low-tack tape

Craft knife with no. 11 blade

Kneaded eraser

Lascaux fixative

No. 2 graphite pencil

Rolls or sheets of clear Frisk film

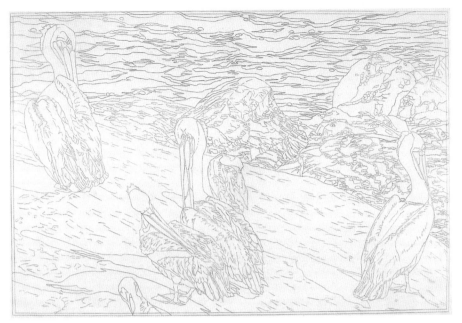

Lay Out the Painting

Crop the photograph to select a subject. On a piece of drafting vellum, draw the image the same size as the painting using a no. 2 graphite pencil. During the layout stage, use a kneaded eraser to correct the drawing. Transfer the drawing to a piece of rag vellum by placing the drafting vellum underneath the rag vellum. Lightly redraw the image. Finish the drawing with a graphite pencil and attach it to a drawing board or piece of masonite with artist's tape, creating a border on all sides. Cover the entire surface with a layer of Frisk film.

2 Paint the Water

To begin laying in the water, cut around the frisked area using a craft knife. Use light pressure when cutting through the Frisk film. Remove the cut piece of film and begin establishing the areas of color.

A For light areas. Apply Rembrandt 100.5 White, 512.3 and 512.10 Cobalt Blue Ultramarine, 538.10 Mars Violet and 545.7 and 545.8 Red Violet Deep. Apply Schmincke 65O Greenish Blue, 1O White and 50M Purple 2.

B For dark areas. Apply Rembrandt 512.3 and 512.10 Cobalt Blue Ultramarine and Schmincke 64B Cobalt Blue Tone. After applying pigments, use your fingertips to blend pastels together. Follow the direction of the original pastel strokes.

C Finishing the water. Blend with your fingers, working back and forth between light and dark areas. Use Derwent pastel pencils to define details, blending with the pencil rather than your fingers. Apply Rembrandt 506.3 Ultramarine Deep, Schmincke 66B Prussian Blue, 24B Caput Mortuum Deep and 81B Cold Green Deep. Apply Derwent 35D Prussian Blue and Conte 42 Sepia to the darker areas of the water. For light areas, apply Rembrandt 512.3 and 512.10 Cobalt Blue Ultramarine and 100.5 White. Use Derwent 72B Chinese White, 32F Spectrum Blue and 25B and 25F Dark Violet.

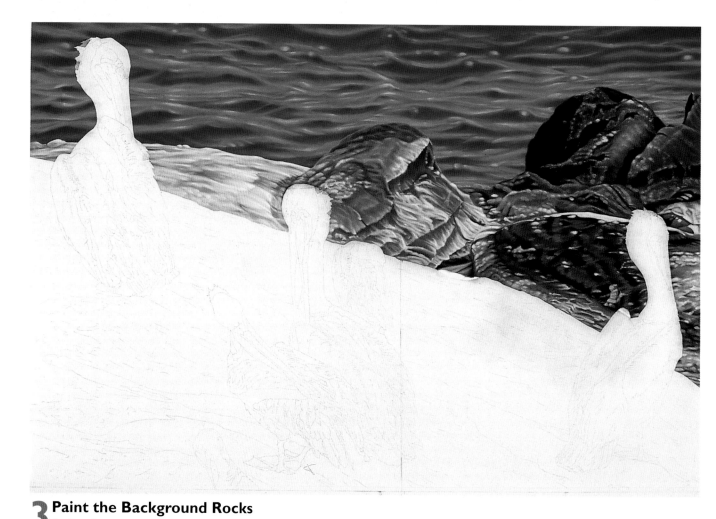

3 Paint the Background Rocks

A Darkest rocks. Remove the Frisk film from the darkest areas of the rocks to the right. Working on the dark shadows first, apply Rembrandt 700.5 Black, 704.1, 704.7, 704.8 and 704.9 Grey, 727.5 and 727.7 Bluish Grey and Schmincke 99B Black, 93D Greenish Grey 1 and 16B Flesh Ochre. Use Derwent 36B Indigo, 74D Dark Olive, 70B, 70D and 70H French Grey, Conté 42 Sepia and 9 Black. Reapply the darkest darks and lightest lights after blending.

B Highlighted areas. Apply Rembrandt 100.5 White, 709.1 Green Grey, 202.3 and 202.9 Deep Yellow, 227.7 and 227.9 Yellow Ochre and 235.3 Orange. Apply Derwent 57B and 57F Brown Ochre and 72B Chinese White.

C Lightest rocks. For the lightest rocks, apply Rembrandt 408.3, 408.9 and 408.10 Raw Umber, 409.1, 409.3, 409.5, 409.7 and 409.9 Burnt Umber, 227.7 and 227.9 Yellow Ochre, 202.3 and 202.9 Deep Yellow and Schmincke 10 White. Apply Derwent 78D Green Umber, 66B, 66D and 66F Chocolate, 6B Deep Cadmium, 11B Spectrum Orange, 25B and 25F Dark Violet, 64B Terracotta, 72B Chinese White and 70B, 70D and 70H French Grey. Finally, apply Conté 42 Sepia.

D Middle values. Remove the Frisk film from the remaining rock areas, leaving the shadow areas. Lay in the details lightly, using Rembrandt 235.3 Orange, 727.5 and 727.7 Bluish Grey, 343.3 Caput Mortuum Red and 234.8 Raw Sienna. Finish with Rembrandt 202.3 and 202.9 Deep Yellow, 704.1, 704.7, 704.8 and 704.9 Grey and 100.5 White. Use Schmincke 98J, 98N and 98O Neutral Grey, 10 White and 29O Olive Ochre Deep.

E Shadows. Remove the Frisk film from the shadow areas and blend the edges where the shadows and rock meet with Derwent and Rembrandt pastels. Apply Rembrandt 727.5 and 727.7 Bluish Grey and 545.7 and 545.8 Red Violet Deep. Use Derwent 57B and 57F Brown Ochre, 72B Chinese White and 70B, 70D and 70H French Grey.

4 Finish the Foreground and Begin the Pelicans

A Remove Frisk film from the rock. Leave the shadow areas untouched. Complete the light areas of the rock before working on the shadows. Underpaint the details lightly with Rembrandt 235.3 Orange, 727.5 and 727.7 Bluish Grey, 343.3 Caput Mortuum Red and 234.8 Raw Sienna. Finish the rocks with Rembrandt 202.3 and 202.9 Deep Yellow, 704.1, 704.7, 704.8 and 704.9 Grey and 100.5 White. Use Schmincke 98J, 98N and 98O Neutral Grey, 1O White and 29O Olive Ochre Deep.

B Shadows. Remove the Frisk film from the shadow areas and complete the rocks. Blend the edges where shadows and rock meet with pastel pencils. Apply Rembrandt 727.5 and 727.7 Bluish Grey and 545.7and 545.8 Red Violet Deep. Next, apply Derwent 57B and 57F Brown Ochre, 72B Chinese White and 70B, 70D and 70H French Grey.

C Center the birds. Remove the Frisk film from the birds one at a time. Complete the light areas of the birds by applying Rembrandt 202.3 and 202.9 Deep Yellow, 371.3 Permanent Red Deep, 409.1, 409.3, 409.5, 409.7 and 409.9 Burnt Umber, 231.3 Gold Ochre, 700.5 Black, 411.3 Burnt Sienna and 234.8 Raw Sienna. Next, apply Schmincke 99B Black and Derwent 57B and 57F Brown Ochre and 66B, 66D and 66F Chocolate.

D Bodies. Apply pastels listed above to the heads of the center birds. Apply Rembrandt 371.3 Permanent Red Deep, 409.1, 409.3, 409.5, 409.7 and 409.9 Burnt Umber, 411.3 Burnt Sienna and 700.5 Black. To finish the bodies, apply Derwent 64B Terracotta and 62D Burnt Sienna.

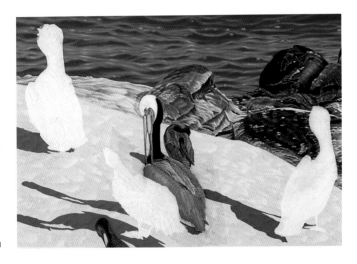

E Heads. To the light areas, apply Rembrandt 409.1, 409.3, 409.5, 409.7 and 409.9 Burnt Umber, 100.5 White and 202.3 and 202.9 Deep Yellow. Use Schmincke 29O Olive Ochre Deep and 1O White. Finally, apply Derwent 70B, 70D and 70H French Grey and 66B, 66D and 66F Chocolate.

F Eyes. Apply Derwent 70B, 70D and 70H French Grey, 57B and 57F Brown Ochre and 72B Chinese White. Next, use Conté 42 Sepia and 9 Black.

G Bills. Apply Rembrandt 371.3 Permanent Red Deep, 370.5 Permanent Red Light, 234.8 Raw Sienna, 202.3 and 202.9 Deep Yellow, 704.1, 704.7, 704.8 and 704.9 Grey and 409.1, 409.3, 409.5, 409.7 and 409.9 Burnt Umber. To finish the bills, apply Schmincke 42B Permanent Red 1 Pale and 98J, 98N and 98O Neutral Grey. Finally, use Derwent 66B, 66D and 66F Chocolate and 6B Deep Cadmium.

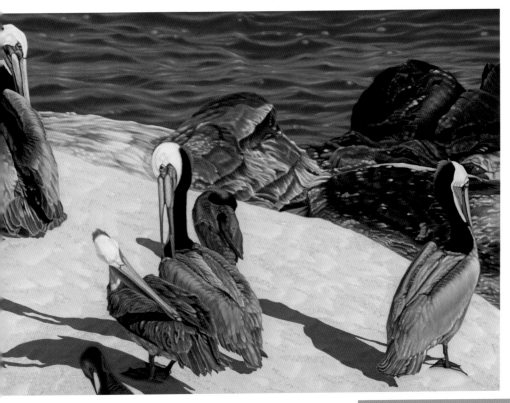

5 Finish

When the drawing is finished, spray the surface with fixative in a well-ventilated area. Remove the artist's tape from around the edges of the painting.

FOUR PELICANS
Norma Auer Adams
28" × 42" (71cm × 107cm)

Western Tanager in Oil

BY SHERRY C. NELSON Sherry Nelson says that good photographs, field sketches and observations are invaluable tools for her decorative artwork. In an attempt to make this scene as realistic as possible, Sherry visually blended individual elements together, creating a unified whole. The result: You have to look twice to find the bird, just as you would have to in a natural setting.

Before you begin painting, prepare your surface with a basecoat coat of Folk Art Acrylic Paint in Linen with a small sponge roller. While still wet, drizzle a little Folk Art Wicker White and drag the sponge roller through it and over the panel to get a splotchy mix of the colors. When it dries, spray on the matte finish to prevent the oils from absorbing too much.

MATERIALS

Surface

16 × 12-inch (41cm × 30cm) Masonite panel

Palette

Acrylics
FOLK ART BY PLAID: Linen, Wicker White

Oils
WINSOR & NEWTON ARTISTS' OIL COLORS: Burnt Sienna, Cadmium Lemon, Cadmium Scarlet, Ivory Black, Prussian Green, Raw Sienna, Raw Umber, Sap Green, Titanium White, Winsor Red, Yellow Ochre

Brushes

Nos. 2, 4, 6 and 8 brights
No. 1 round

Other

Ballpoint pen

Cobalt siccative (optional)

Graphite paper

No. 1311 Krylon Matte Finish

No. 220 wet/dry sandpaper

Odorless thinner

Palette knife

Paper towels

Sponge roller

Tracing paper

REFERENCE PHOTOS

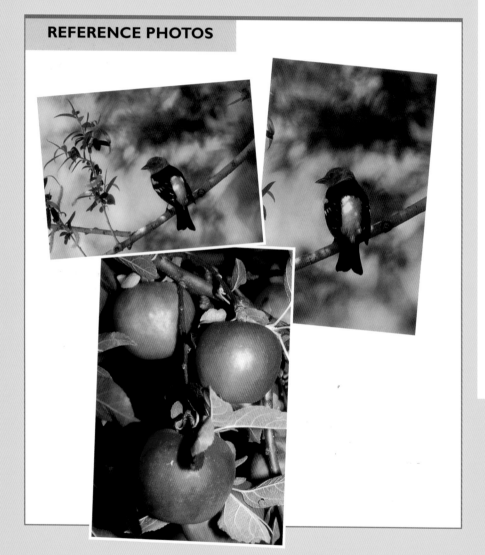

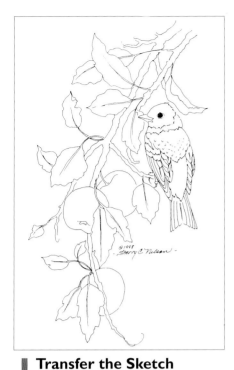

1 Transfer the Sketch

After completing a preliminary drawing, place a piece of graphite paper on your Masonite and lay the drawing on top of it. Cover the drawing with tracing paper for protection, and with a ballpoint pen, transfer the drawing onto the Masonite. Be careful to trace each detail of the bird.

2 Start Painting the Bird

Mix Ivory Black and Raw Umber and apply the basecoat coat for the tail and both areas of the primary wing feathers. Sketch the edges of feathers back in the wet paint to help you remember where to paint them later.

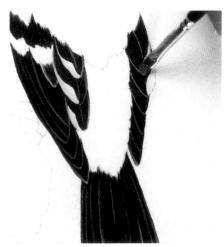

3 Develop Tail and Wings

Paint in the feather edges on the tail and primary feathers using the no. 4 bright brush and Titanium White with a touch of both Raw Sienna and Sap Green. Use the same color mixture to paint in faint lines to represent highlights on the feather barbs.

Paint in detailed areas on the secondary wing feathers and wing coverts with the no. 2 bright and Titanium White. Using the same technique used to create feather edges in step 2, paint in the remaining feathers with a mixture of Ivory Black and Raw Umber.

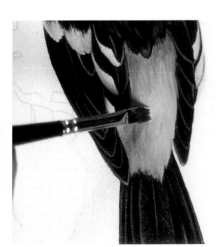

4 Develop Back

Paint in a basecoat of the Ivory Black/Raw Umber mixture for the darker back feathers. Define two or three soft rows of feathers with a dirty white mixture and a no. 4 bright.

Paint a basecoat of Titanium White on the white wing bar using the same brush. Then block in the lower back and rump using a mixture of Cadmium Lemon and Titanium White.

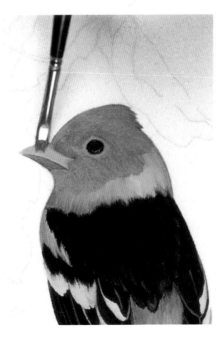

5 Develop Head and Neck

Block in the yellow wing bar and neck with a mixture of Cadmium Lemon and Yellow Ochre, adding a touch of Raw Sienna. Develop highlights with the mixture used for highlights in step 4.

Paint in the eye ring using a no. 1 round and the Cadmium Lemon/Yellow Ochre mixture. Fill in the eye with Ivory Black and paint the remainder of the head using Raw Sienna.

For the beak, apply a basecoat of Raw Sienna and Titanium White on the upper mandible and Raw Sienna with Raw Umber on the lower mandible.

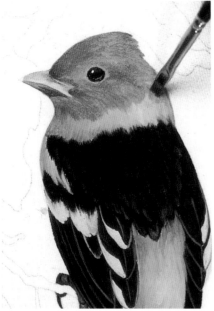

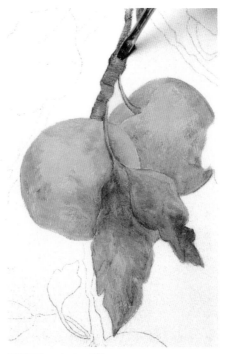

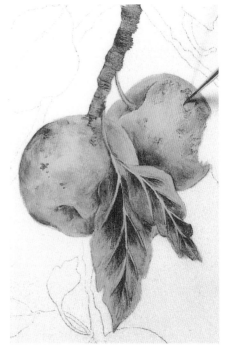

6 Finish Bird Details

Using your no. 2 bright, shade the lower mandible of the beak with Raw Umber and the upper mandible with a mixture of Raw Sienna and Raw Umber. Add highlights on the beak and in the bird's eye using the no. 1 round and pure Titanium White.

Sparsely paint Winsor Red over the areas on the head that you previously coated with Raw Sienna, following the direction of the feathers. Add a few small red feathers over the yellow on the nape and the throat. On the crown and the cheek, deepen the red with a bit of Cadmium Scarlet. Then add some shading on the base of the beak, as well as the chin and crest, using Raw Umber.

Start the toes with a base of Raw Umber and Titanium White, then add highlights using the same mixture with more white added. Use Ivory Black to paint the toenails and dark lines between the scales on the toes.

7 Block in Elements

Apply sparse basecoats of Raw Sienna and Sap Green randomly on the leaves with a no. 6 bright, blending as needed. Block in the apples with Cadmium Lemon and Yellow Ochre in the lightest areas and Raw Sienna in the shadowed areas. Lay Sap Green dirtied with a little Raw Sienna down one side of the branches and Raw Umber and Raw Sienna down the shadow side. Blend these colors together by pulling the chisel edge of a small brush across the branch, giving the look of gnarled, bumpy branches.

8 Develop Details

Using your no. 4 bright, add details to the leaves by shading one side of their vein structure with Prussian Green dulled with earth colors. With your no. 6 bright, shade the Raw Sienna area of the apples with Burnt Sienna. Paint other areas of the apples with a mixture of Sap Green, Raw Sienna and Raw Umber. Add some odorless thinner to this same dirty green mix using a no. 1 round. Add paint speckles on the skin of the apples.

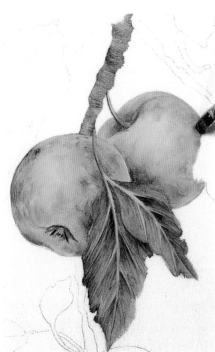

9 Finish Element Details

Create vein structure in the leaves by lifting out color with a damp no. 4 bright or by adding veins with a light value mix. Add touches of Burnt Sienna on the edges of the leaves to emphasize imperfections. Highlight some of the leaves with a mixture of Sap Green and Titanium White and the rest of the leaves with a mixture of Cadmium Lemon, Sap Green and Titanium White.

Strengthen the shadows of the Burnt Sienna areas of the apples with Winsor Red.

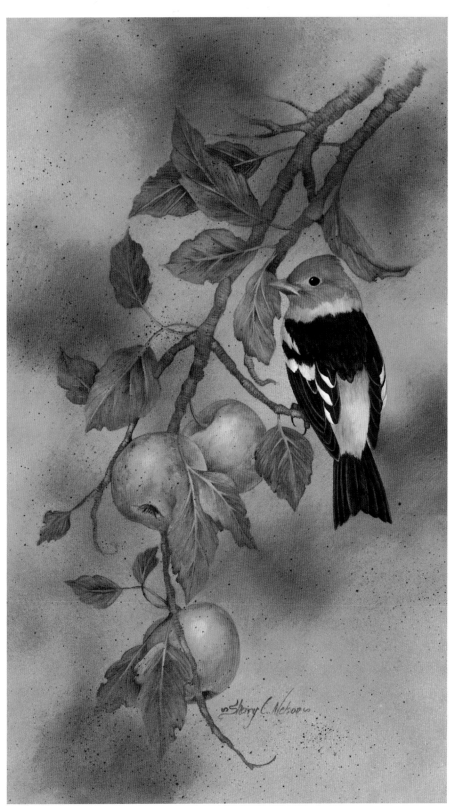

10 Final Touch

After the painting is dry, glaze a little Raw Umber over the apples and leaves to help control the brightness of the colors.

WESTERN TANAGER
Sherry C. Nelson
16" x 12" (41cm x 30cm)

Barrow's Goldeneyes in Acrylic

BY BART RULON Bart Rulon approaches a duck stamp design very differently from the way he approaches a normal painting. Duck stamps usually feature a male/female pair captured in a "perfect pose" within a very large frame. So when Bart set out to find a photograph to work from, he decided to go with one that shows a pair of Barrow's goldeneyes in a classic duck stamp pose. This photograph already has most of the elements that make for a good design: warm, early morning lighting; ducks shown in regal poses; and a soft background of water that makes the ducks stand out. With these elements in place in Bart's photograph, very little has to be changed for his painting.

MATERIALS

Surface
9 × 12-inch (23cm × 30cm) gessoed Masonite panel

Palette

GRUMBACHER ACADEMY ACRYLICS:
Cadmium Yellow Light

LIQUITEX MEDIUM VISCOSITY ACRYLIC
ARTIST COLORS: Cadmium Red Light Hue

WINSOR & NEWTON FINITY ACRYLICS:
Brilliant Yellow, Burnt Sienna, Ivory Black, Raw Sienna, Raw Umber, Titanium White, Ultramarine Blue

Brushes
No. 12 flat
Nos. 00, 2 and 4 rounds

REFERENCE PHOTO

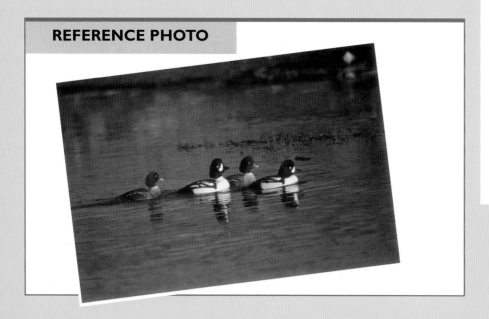

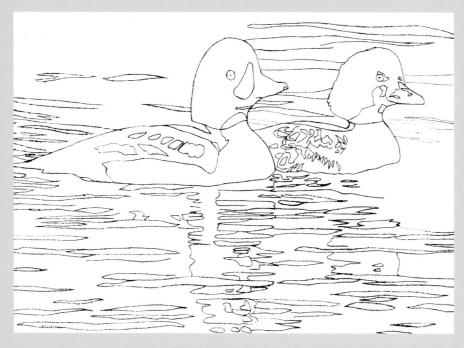

Composition
The biggest question is how large the ducks should be. Make enlarged and reduced photocopies of your initial sketch for comparison. When you have decided on a size, go a little smaller so you can include the birds' reflections in the composition.

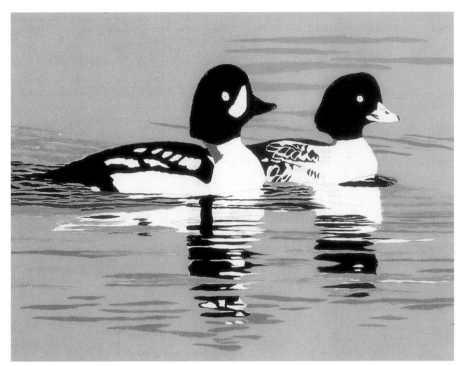

2 Begin Painting

On the gessoed Masonite panel, block in the darks on the head and back of both birds, as well as the reflection of those areas. For the male, use a mixture of Ultramarine Blue and Ivory Black, and for the female, a mixture of Burnt Sienna, Raw Umber, Ultramarine Blue, Ivory Black and Titanium White.

Use a mixture of Raw Sienna, Cadmium Red Light Hue, Titanium White and Burnt Sienna to paint the water with a no. 12 flat brush. Use the no. 4 round and a mixture of Ultramarine Blue, Titanium White and a touch of Cadmium Red Light Hue to paint where the water reflects the sky.

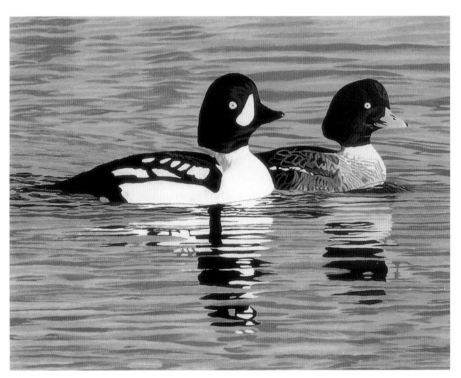

3 Add Details

Refine the water by going back and forth with light and dark mixtures, painting streaks as indicated in the reference photo. Begin the eyes with a base of Cadmium Yellow Light, Brilliant Yellow and Titanium White, adding a base of Ivory Black for the pupil. Add feathers to the goldeneyes with a no. 2 round and a mixture of Ultramarine Blue, Cadmium Red Light Hue and Titanium White for the male and the same colors used in step 2 for the female. Where the feathers are lightest and most colorful, paint pure white first, then glaze over this with the purple mix.

For the white areas on the male, accent the pure white with a warmer mixture of Raw Sienna and white, indicating the warm glow of the early morning sun. Add hints of a light blue mixture to the shadow side of the white markings, and add feather details on the back of the male with a subtle mixture of Raw Umber, Ivory Black and Titanium White. Continue details on the female's back using varying degrees of the same colors from step 2.

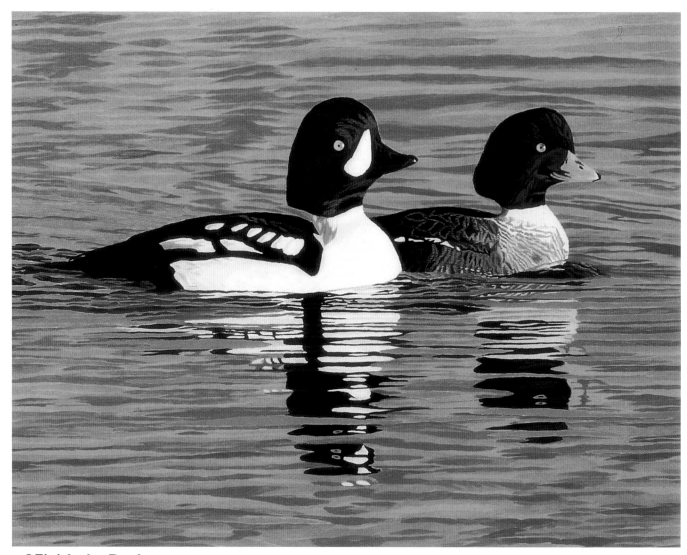

4 Finish the Ducks

Finish the eyes with a no. 00 round brush, adding a mixture of Cadmium Yellow Light, Brilliant Yellow, Ultramarine Blue and Cadmium Red Light Hue to indicate a slight shadow in the middle of each side. Then add a bright white highlight to the leading edge of each eye.

Refine feather details on the female by selectively adding rows of small dark streaks with a no. 00 round, giving a feathered look to the edges. Add subtle feather details on the tail and rump of the male with a no. 2 round and a mixture of Raw Umber, Ivory Black and Titanium White. Give shape to the male's beak by adding subtle shading and highlights with a mixture of Ultramarine Blue, Cadmium Red Light Hue, Ivory Black and Titanium White. Brighten the sunlit highlights on the male's head using the same technique as before, underpainting with white, then glazing with a mixture of Ultramarine Blue, Cadmium Red Light Hue and Titanium White.

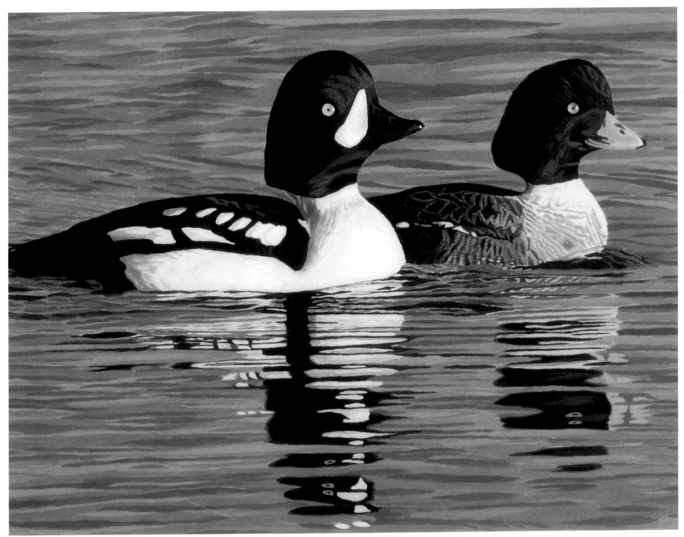

BARROW'S GOLDENEYES
Bart Rulon
9" x 12" (23cm x 30cm)

5 Make Final Adjustments

If the colors in the water of your painting don't match those in the photograph, repaint the background water with the same mixtures used before, but with less Titanium White and more Cadmium Red Light Hue and Burnt Sienna.

Using the direction of the sun as a guide, give the male duck a more realistic shape, shading the white breast and sides using your no. 4 round and various mixtures of Cadmium Red Light Hue, Ultramarine Blue and Titanium White. Paint a mixture of Titanium White, Raw Sienna and Cadmium Red Light Hue adjacent to these shadows to indicate the early morning light. Apply the same process to the white crescent-shaped patch on the head of the male.

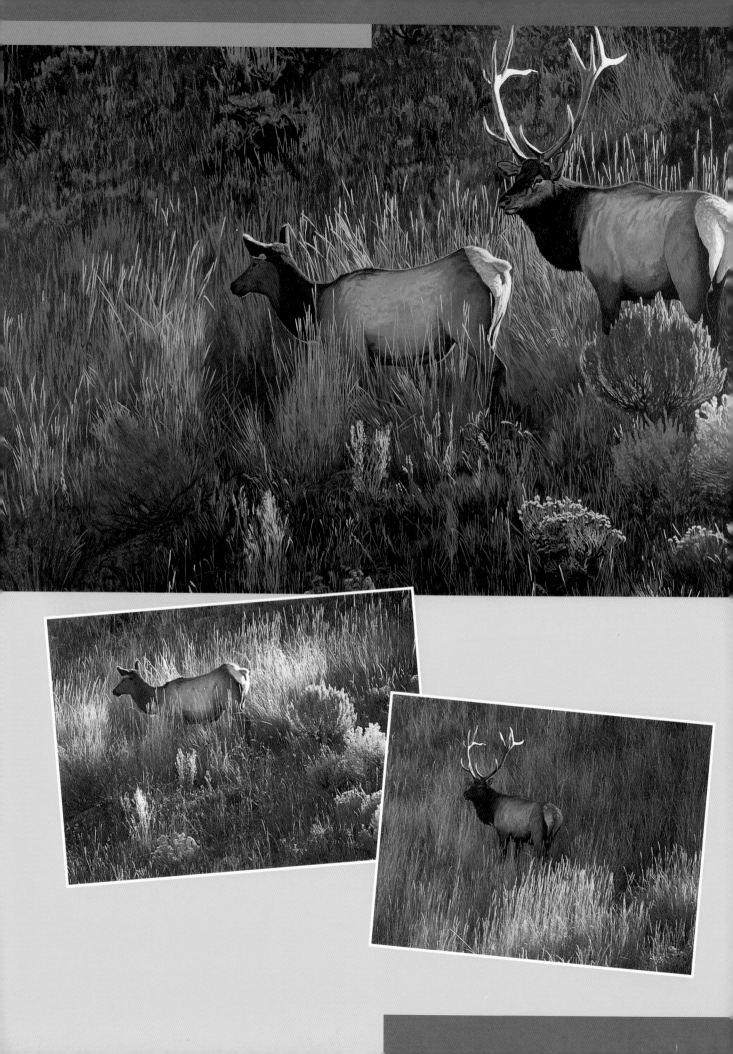

5 WILDLIFE

Certainly some would find it invigorating to travel in the wild, sketching animals for their next paintings. Others, however, would likely wince at the thought of backpacking through the Asian outback to catch a glimpse of a tiger or hiking the Rocky Mountains to spot an elk. They may find such adventures too expensive, time consuming or unsafe. Even if you're in parks or refuges where wildlife is approachable, you still have to exercise caution, paying close attention to the animal's body language and making sure it's comfortable with your presence. Painting animals in captivity, like those at the zoo, definitely presents a safer option, but comes with its own set of disadvantages. The animals aren't guaranteed to always be on display, and if they are, you have to work around other visitors anxious to sneak a peek at your subject. The best way to avoid each of these dilemmas is to use reference photos.

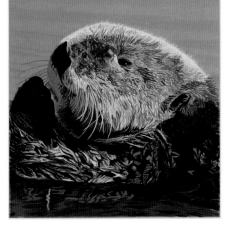

Some wildlife, like small mammals, are common enough near human dwellings that there's no need for an African safari or a kayak trip down the Nile to get a look. Rabbits may live in thickets or grassy fields near your home; squirrels may climb trees in your yard; and raccoons may rummage through your garbage cans. If an opportunity to photograph these creatures presents itself, don't hesitate to take your own pictures. These animals are usually harmless and make great subjects for wildlife paintings.

The demonstrations featured in this chapter cover numerous types of wildlife, providing the artist with a wide range of animals to choose from. Take time to observe how the artists have combined multiple references to create their finished works. You, too, should avoid directly copying from a single photo. Strive to create novel compositions by combining two or more of your own wildlife photos.

Elk in Acrylic

BY BART RULON Once again, Bart Rulon successfully demonstrates how to use several photographs to make an interesting painting. He also shows how to pick out additional reference photographs and use them to fit a subject into a scene with consistent lighting. Bart took the main reference photographs for this painting in Yellowstone National Park within a few minutes of each other, using a 400mm lens and a tripod. Any time you embark on a painting that requires re-creating the lighting on an animal, be sure to find additional reference photos to help pull it off. To make a painting believable, it is essential that the colors and lighting on an animal are consistent with the background.

MATERIALS

Surface
Hardboard panel primed with gesso

Palette
GOLDEN HEAVY BODY ARTIST ACRYLICS: Cadmium Yellow Light, Raw Sienna, Raw Umber, Titanium White

LIQUITEX MEDIUM VISCOSITY ACRYLIC ARTIST COLOR: Burnt Sienna, Ivory Black, Naphthol Red Light, Ultramarine Blue

Brushes
No. 8 filbert

No. 12 flat

Nos. 000, 1, 3 and 5 rounds

Other
Pencil

Scrap paper

Water (used as a medium with each painting mixture)

REFERENCE PHOTOS

Main reference photo

This reference photograph of a cow elk sparked Bart's interest because of its beautiful lighting and nice composition. It serves as the main reference for the background and the cow elk. Use habitat photographs that include an animal in them as a size reference whenever possible.

This photograph serves as a great reference to include a bull elk in the scene because it is taken in the same lighting situation as the above photo, although this elk is standing in the shadows.

Reference photo for the bull elk

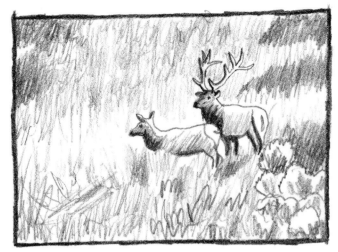

1 Utilize a Thumbnail Sketch

Use thumbnail sketches to work out the composition before starting the drawing. Position the bull in various spots around the cow.

2 Complete the Drawing

Draw the elk on scrap paper and work out all the problems before transferring it to the board. Bull elk are larger than cows, so make sure to make him larger. For the background, draw in the outlines of the sagebrush.

3 Block in the Background

The first step is all about getting approximate colors on the board to help judge later mixtures of paint. Use the no. 12 flat brush and the no. 8 filbert to block in the colors in the background using the middle tones for each area. Make the greens in the foreground and background with a mix of Cadmium Yellow Light, Ultramarine Blue, Raw Umber, Titanium White and Ivory Black. Add more Ultramarine Blue and Ivory Black to the mix for the sagebrush's cooler color.

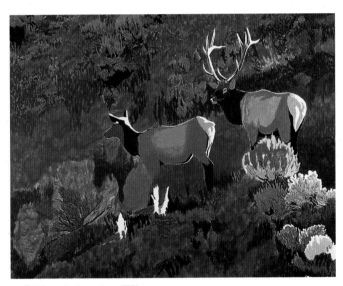

4 Block in the Elk

Use the no. 12 flat brush to block in the sides of the elk with a mixture of Raw Sienna, Titanium White, Raw Umber and Ultramarine Blue. Use less white for the darker areas indicated in the photo. Use the no. 5 round to paint the neck with a dark mixture of Raw Umber, Ivory Black and Titanium White. At this point don't worry about blending. For the rump use a mix of Ultramarine Blue, Naphthol Red Light, Titanium White and a touch of Raw Umber. Leave the highlights white for now. Continue to darken the green colors in the habitat with the same mixtures used in the previous step.

5 Begin the Details

For the background, work from dark to light in areas where dark dominates, and from light to dark in areas where light dominates. Refer to the reference photos closely. Use the no. 3 round for some of the darkest details in the head, neck and body of the elk. Blend the edges where applicable using a scumbling technique. For the skinny highlights on the backs of the elk, use your no. I and no. 000 round brushes to paint a thin layer of Raw Sienna and Titanium White. Add Burnt Sienna to this mix for the highlight on the back of the cow elk. Keep highlight mixes thin so the white beneath can show through the color and make it glow.

For the details in the habitat, paint the shapes and details that jump out at you first. These will help you find your place in the photo for other details later. Afterward, use a combination of painting exactly what you see and improvising. Grass can make you cross-eyed if you try to paint every blade. Paint a few of the highlights in the grasses behind and in front of the elk so you know how dark to make the background in comparison. Mix Titanium White and Raw Sienna for the grass highlights.

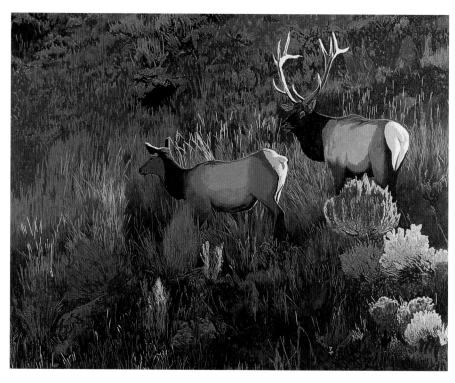

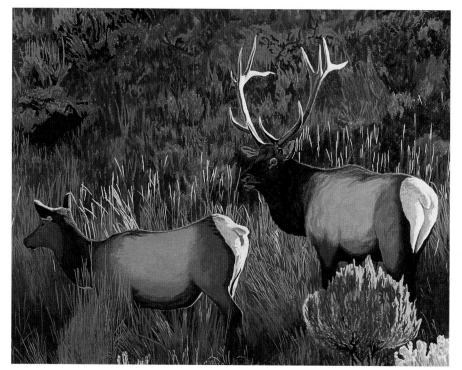

6 Define the Elk

Work in some of the middle tone details on the elk with a combination of scumbling and glazing using the no. 3 and no. I rounds. Glaze a mix of Ultramarine Blue, Naphthol Red Light, Raw Sienna and Titanium White on the back of the elk, using the reference photo as a guide. The blue shade is a reflection of the sky. For the rumps, paint in some of the darker shadow details, and glaze on some warm reflections with a mix of Raw Sienna, Titanium White, Ultramarine Blue and Naphthol Red Light. Finish the antlers, paying special attention to the subtle warm and cool tones shown in the photo. Much of the bright highlight on the elk has a slightly warm tone. Glaze it on with a mix of Titanium White and Raw Sienna.

Continue to refine the tones and details in the habitat with many different brushes and a variety of similar mixtures. Step back and focus on what areas need to be lightened or darkened.

Use this photograph as a guide to create the lighting on the bull's head. In a situation like this, try to find a photo with the head in a similar position and estimate what the path of light will look like.

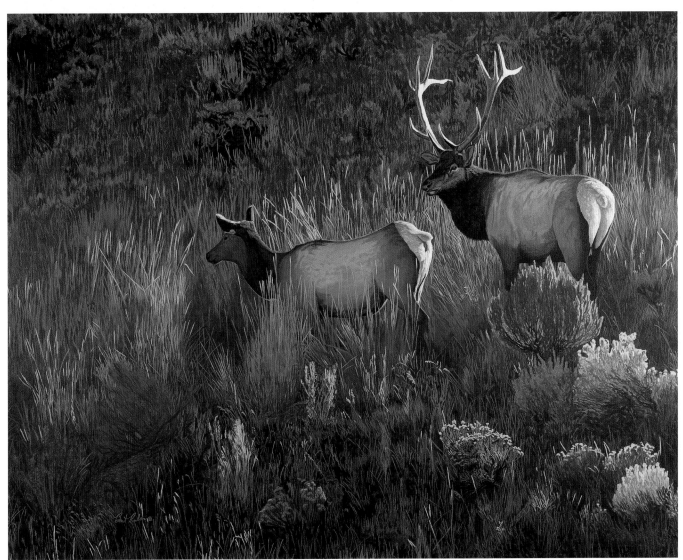

INTO THE LIGHT
Bart Rulon
22" × 28" (56cm × 71cm)

7 Finishing Touches

Finish up the details of the elk, being careful to blend with a scumbling technique to avoid hard edges. Refine the blending of the blue cast from the sky and warm reflections from the grasses on the bellies of the elk. Add light to the bull's face to make him consistent with his new lighting situation. When the cow elk is finished, you can add the grasses in front of her belly. Finish all the highlights caught by light in the grasses. Dull down the rock and the dead bush on the left side with glazes of Raw Umber, Raw Sienna and Ivory Black. To reduce the sharp edges in the background and make it recede, blend the colors with a scumbling and glazing technique. Scumble the dark colors into the light ones, and glaze the light colors into the dark. This helps add to the illusion of depth.

Cougar in Oil

BY KALON BAUGHAN This demonstration will teach you some unique oil painting techniques and how to combine several different reference photographs to form one cohesive painting. You'll combine trees from one landscape photograph with a different landscape, and add cougars from a photo taken at the zoo. Kalon goes the extra mile to photograph his subjects in the wild, but some animals are almost impossible to find in their natural habitat, let alone to photograph. He frequently photographs and sketches zoo animals that are difficult to view in nature.

MATERIALS

Surface
RayMar panel

Palette
WINSOR & NEWTON ARTISTS' OIL COLORS:
Alizarin Crimson, Burnt Sienna, Burnt Umber, Cadmium Lemon, Cadmium Orange, Cadmium Red, Cadmium Yellow, Cerulean Blue, French Ultramarine, Lemon Yellow Hue, Naples Yellow, Permanent Green, Permanent Mauve, Raw Sienna, Raw Umber, Sap Green, Titanium White, Ultra Violet, Viridian Green, Yellow Ochre

Brushes
Nos. 3, 5, 6, 8, 10 and 12 flat sables
No. 1 round

Other
Gray gesso
HB charcoal pencil
Ingres green gray charcoal paper
Krylon Crystal Clear Spray Coating
Liquin
Stabilo aquarellable pencil
White charcoal pencil

REFERENCE PHOTOS

Cougar reference photos

Kalon took these cougar reference photographs at the Minnesota Zoo with a 35mm camera using a 300mm lens and 100 speed film. Although the positioning of the cougar is different in each photograph, it is the same cougar. The challenge here was to use two reference photographs of the same animal in different poses and make it appear as two separate individuals in the painting. The benefit is that by using photos taken at the same time of the same animal, the angle and lighting conditions are consistent.

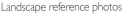

Kalon used two camera formats—35mm and medium format—for taking these landscape reference photographs. The medium format camera, which has a much larger negative, captures details much better (above). The down side to using medium format is that it's cumbersome to use in the field, and the film and developing is much more expensive. Both landscape photos Kalon used for this painting were taken in Yellowstone National Park, and both photos were chosen for the compatibility of the light source and subject matter.

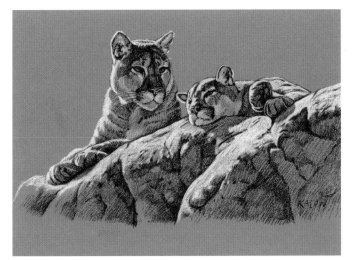

1 Create a Drawing Study

Complete a drawing study to be used as a blueprint for your painting. Use an HB charcoal pencil and white charcoal pencil on Ingres green gray charcoal paper. Take great care in this step to make sure the cougar's anatomy is correct and the integration of different reference photos appears natural. Plan for the placement of the main focal point (the cougar heads). Create a diagonal across the painting surface with the animals' bodies to enhance the level of interest in the composition. Place the feet of the cats at the ends of the diagonal to create a visual balance with their head placement. Create visual tension by focusing the cougars' gazes outside the painting.

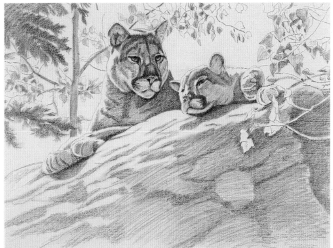

2 Transfer the Drawing

Transfer the drawing study to the painting surface. Prepare a RayMar panel with gray gesso and draw with the Stabilo aquarellable pencil. Fix the drawing onto the gessoed panel using Krylon Crystal Clear Spray Coating before the painting process starts. This allows you to keep the drawing on the panel without it getting smudged with paint.

3 Underpaint the Cougars

The main objective here is to put in the shapes and shades that will be the building blocks of your painting. Block in your light values first using a no. 10 or a no. 12 flat sable brush. This way, you don't muddy your lights with the darker values underneath. Then choose your warm medium values and block them in.

Use three grays when painting the cougars. The first is a warm gray composed of Cadmium Lemon and Permanent Mauve. The second is a cool gray that is a mixture of Viridian Green and Alizarin Crimson. And the third is an orange gray made up of Cadmium Orange and Ultra Violet. All of these grays are easily lightened and dulled down with Titanium White. The other main colors are Raw Sienna, Cadmium Yellow, Cadmium Orange, French Ultramarine and Titanium White.

Note the strong backlighting of the ears and the side and top of the head. Use Titanium White and a touch of Cadmium Yellow to create the effect of light hitting these areas. Create the pinkish color in the ear by using a combination of Cadmium Red and Cadmium Orange mixed with Titanium White. The rest of the areas in the ear are gray tones heavily saturated with Titanium White.

The lighter areas in the muzzle are comprised of very muted shades of gray mixed with Titanium White and a touch of Cadmium Yellow and Cadmium Orange. The orange color in the nose is predominantly Cadmium Orange, with a touch of Cadmium

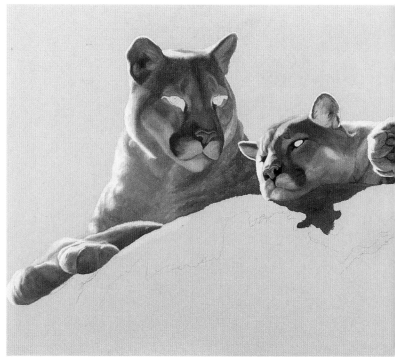

Red, Burnt Sienna, Cadmium Yellow and Titanium White. The darker areas around the muzzle are Burnt Umber mixed with various shades of gray. Use a no. 8 and a no. 6 flat brush to detail the nose. To prevent colors from getting muddy, avoid mixing warm and cool tones.

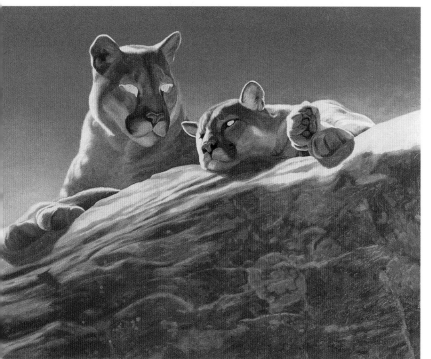

4 Underpaint the Rock and Sky

Premix two colors for the sky. For the lighter color of the sky that appears lower in the painting, use Titanium White, Cerulean Blue, French Ultramarine and Naples Yellow with a touch of Burnt Sienna. For the darker part of the sky, use French Ultramarine, Cerulean Blue, Alizarin Crimson and Titanium White. Use a no. 12 flat sable brush and apply the lighter color first. Then gradate the color by mixing the paint directly on the panel, ending with the pure darker blue mixture at the top.

Next, block in the colors of the rock using grays similar to those premixed for the bodies of the cougars. Use colors for the highlighted part of the rock that are similar to the highlighted parts of the cougars and a similar contrast of warm and cool shades of gray, as in the lower shadowed portion of the rock.

However, add more Cadmium Orange and Alizarin Crimson to the orange color used for the lichens. Use a no. 10 flat sable brush for blocking in the main colors of the rock and reduce the size of the brush to a no. 6 as you begin filling in more detailed areas of the rock, such as the lichens and highlights.

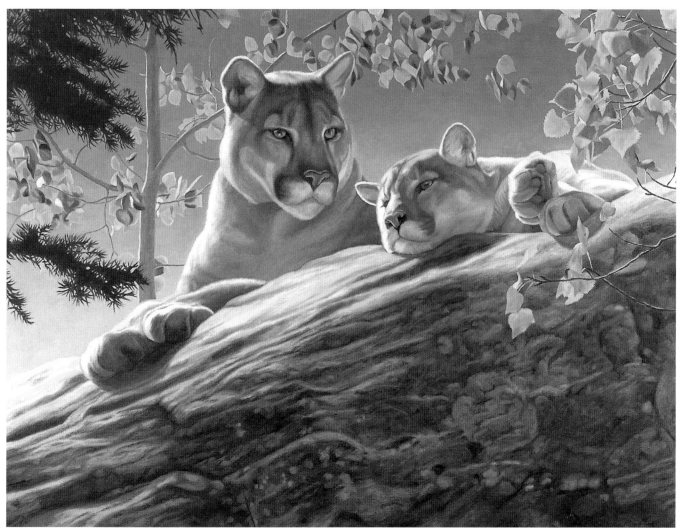

5 Finish the Underpainting

For the underpainting of the eyes, use the Viridian Green-Alizarin Crimson gray mixed for the cooler or bluer areas of the fur around the eyes and in the iris. Use the Cadmium Lemon-Permanent Mauve gray mixed occasionally with Raw Sienna, Cadmium Yellow and Cadmium Orange for the warmer areas, including those in the iris. The darker areas, such as the eyelid and the vertical line on the forehead, are a mixture of Burnt Umber and Raw Umber. Use a no. 3 and a no. 5 flat brush for these areas, while being careful not to mix the cool and warm colors.

Separate the foliage into two main parts on the basis of their color. The aspens are primarily yellowish orange, and the evergreen has a brownish green tint. The aspen leaves have a variety of yellow colors in them such as Lemon Yellow Hue, Naples Yellow, Cadmium Yellow, Yellow Ochre, and Cadmium Orange.

Tone down all shades of yellow with Titanium White. You can also use a dash of a complementary color in each mixture to tone down the color's intensity. Use Sap Green in the area that has greenish tints. Paint the aspen tree trunk and smaller branches with light shades of the same gray used in the cougars and the rock. This helps keep the painting uniform.

Mix the evergreen colors using Sap Green, French Ultramarine and a touch of Cadmium Orange, then add a small amount of Titanium White to soften the color. Block in the aspen and evergreen foliage with a no. 6 flat sable brush, and use a no. 3 flat sable brush for the details and highlighted areas.

Once the underpainting is completely dry, apply a clear coat of Liquin and allow it to dry. This prepares the painting surface for the technique of drybrushing.

6 Drybrush the Cougars

Drybrushing involves loading a brush with just enough paint to rub on the painting surface; the more pressure you apply, the more opaque the layer will be. With less pressure, you will allow the underpainting to show through while enhancing the image with the overlying detail.

Now is the time to create the amount of texture and detail that you desire in your painting. This will transform your painting rather rapidly. All of the texture created will be created by dry-brushing with just three dark colors. Raw Umber is the primary color to use. For warmer textured areas, add Burnt Umber, and for the cooler areas, including your darkest blacks, add French Ultramarine.

First use the dry-brush technique to darken all of your darks and to create the various textures in the fur surrounding the eyes. After the dry-brushed areas are dry, go back into the iris with Permanent Green and very carefully dab in some color using a no. 1 round brush, as cougars tend to have a brownish-green hue to their eyes. Also use lighter values and a no. 1 round brush to touch up the highlights, including the light spots in the eyes.

Then use the dry-brush technique to develop the texture in the fur around the ears. To create the mottled look of the inside of the ear, darken the area that is most in shadow in the center of the ear with Raw Umber. Also use Raw Umber to create the irregular spots in the ear. For the wispy, lighter hairs, use softer

dry-brush strokes, laying down less paint. Develop the rim of the ear with irregular, darker strokes, being careful not to boldly outline the rim.

Finally use combinations of Burnt Umber and Raw Umber to drybrush the textures of the fur over the underpainting. On the nose, drybrush irregular marks to give the cat's nose character. Finally, add the whiskers and the highlights on the jowls by using a no. 1 round brush with a dab of Titanium White and Cadmium Yellow, adding a light blue-gray on the whiskers that are in shadow.

7 Drybrush the Evergreen

Use long, needlelike strokes for the evergreen pine needles, varying the pattern now and then to avoid visual monotony. Use more French Ultramarine on your brush, occasionally adding a touch of Burnt Umber, as pine needles tend to reflect the colors of the sky. Highlight some of the edges with a mixture of Titanium White, Cadmium Orange and Cadmium Yellow.

8 Drybrush the Aspen

For the aspen leaves, tree trunk and limbs, use a brownish mixture for drybrushing and alternate back and forth from Burnt Umber to Raw Sienna for variety. Vary the brushstrokes to indicate the individual character of the limbs, leaves, veins, bug holes in the leaves and dark irregular protrusions on the bark. Use a mixture of Titanium White and Cadmium Yellow to add highlights and to variegate the edges of the leaves that are glowing with backlighting from the sun.

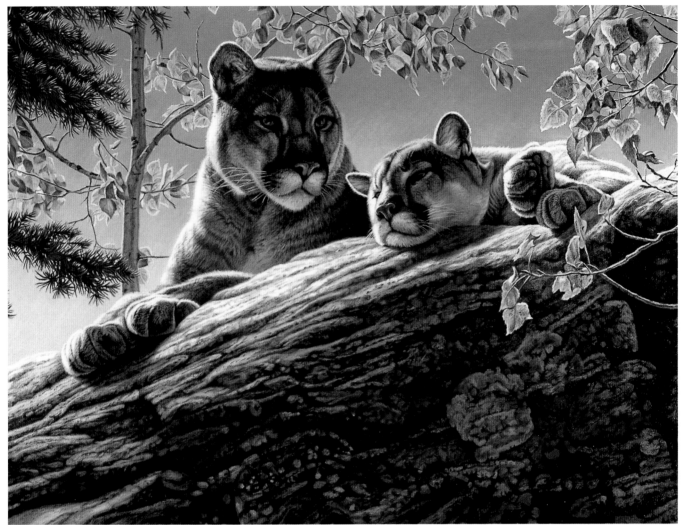

9 Finish the Painting

Last but not least, drybrush the rock to add texture. These are rocks with a large variety of lichen, deep fissurelike cracks and an uneven surface. To add interest, use the full range of drybrushing colors, from warm to cool. Then use a mixture of Titanium White, Cadmium Yellow and Cadmium Orange to emphasize the backlighting on top of the rock and all the rock's small imperfections.

The intense backlighting in this image creates a strong sense of three-dimensionality and warmth. The lyrical branches of the aspen and the bright colors of the leaves soften the masculinity of the solid mass of rock on which the cougar rests. A strength of this painting is the integration of trees and rocks indigenous to the cougar's habitat. Such detail is key to a successful portrayal of nature.

CONTENTMENT
Kalon Baughan
16" x 24" (41cm x 61cm)

Cottontail in Mixed Media

BY SUEELLEN ROSS Sueellen has developed a very unique way of painting with mixed media that produces beautiful results. Her stepwise approach to painting makes her artwork ideal for teaching demonstrations. For this painting, Sueellen started with photographs of a desert cottontail she came across on a trip to Tucson, Arizona. The photograph of the marigolds came from a nearby spot.

REFERENCE PHOTOS

Cottontail reference

Habitat reference

MATERIALS

Surface

Arches 140-lb. (300gsm) hot-press watercolor paper

Palette

Acrylics
LIQUITEX MEDIUM VISCOSITY ACRYLIC ARTIST COLOR: Value 5 Neutral Gray

Colored Pencils
PRISMACOLOR COLORED PENCILS: Apple Green, Black, Burnt Ochre, French Grey 10%, Goldenrod, Jade Green, Light Umber, Olive Green, Orange, Sand, Sepia, Slate Grey, White

Watercolors
WINSOR & NEWTON ARTISTS' WATERCOLORS: Aureolin, Burnt Sienna, Burnt Umber, Charcoal Gray, French Ultramarine, Hooker's Green, New Gamboge, Payne's Gray, Permanent Sap Green, Quinacridone Gold, Raw Umber, Rose Doré, Sepia

Brushes

Nos. 0, 5 and 10 rounds

Other

Drawing pen
FW Acrylic Artist's Black India Ink
HB pencil
Kneaded eraser

| Complete the Drawing and Lay the Shadows

Do a detailed and complete pencil drawing of the rabbit and the background. Pay attention to the flowers and leaves that protrude in front of the hidden rabbit, and where their shadows fall on the ground and on the rabbit. Draw in the texture of the rabbit's fur, the petals and centers of the flowers, even the stones in the dirt and their shadows.

Decide where your darkest values are and fill them in with waterproof India ink. To avoid inking the wrong areas, indicate the darkest values with an ink dot first. Then outline each area with a pen filled with waterproof ink. Fill in larger areas with a brush, and smaller ones with your drawing pen.

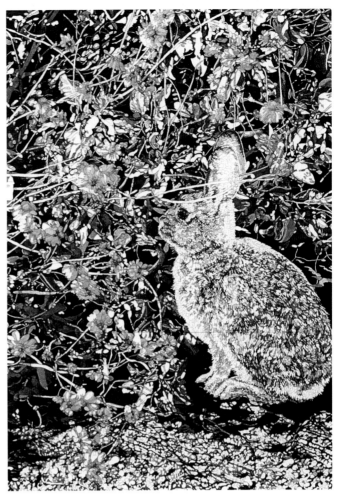

2 Start Adding Watercolor

Move around the painting with watercolor going from dark to light.

In the vegetation, mix Hooker's Green with Sepia for your darkest green. Add a bit of Permanent Sap Green to the mixture, and paint in your second-darkest green. Use Sepia for your darkest brown.

For the dirt, put in your darkest shadows with a mixture of French Ultramarine and Burnt Sienna.

Paint the darkest fur on the rabbit with Charcoal Gray. Use Sepia for the eye.

3 Add More Color

Continue painting with watercolor going from dark to light.

For your third-darkest green in the vegetation areas, add Payne's Gray and water to your green mixture. Then, for your fourth-darkest green, add more Payne's Gray and water.

For the dirt, add more Burnt Sienna and water to your shadow mixture for warmer, paler areas.

Start on the flowers using straight Quinacridone Gold for your darkest yellow. For your second-darkest yellow, add water to your paint. For your third-darkest yellow, add Aureolin to the gold. (To avoid color contamination, postpone painting the flowers in front of the rabbit's ears.)

Switch from your Charcoal Gray watercolor to acrylic Value 5 Neutral Gray for the warmer, paler gray in the rabbit. Then add more water to the acrylic for your next-lighter gray.

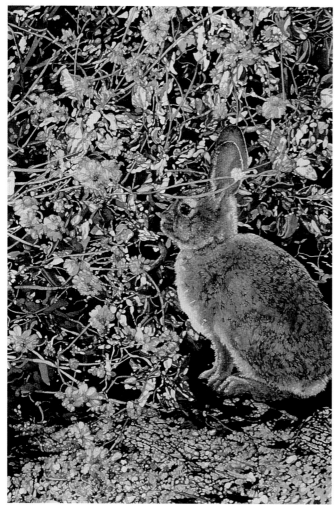

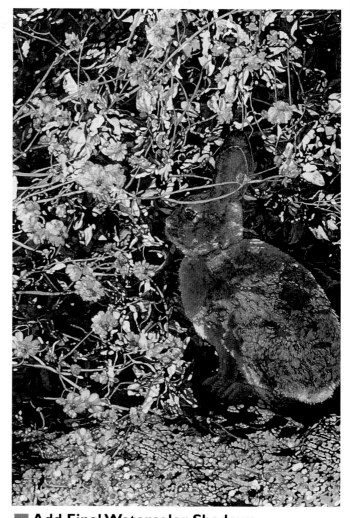

4 Complete Main Colors and Details With Watercolor

In the vegetation, paint the palest greens with straight Payne's Gray. Paint in dead leaves with Raw Umber. Paint the stems with Sap Green mixed with Aureolin.

Protect the white stones by masking them with White Prismacolor pencil. Then paint in your final pale shadows in the dirt with a watered-down mix of French Ultramarine and Burnt Sienna. Add even more water to this mixture, and layer a wash over all the dirt.

Paint the lightest yellow on your flowers with straight Aureolin.

Paint in the final rabbit fur details with pale Value 5 Neutral Gray acrylic. Then do a pale wash of the same acrylic over the whole rabbit, avoiding the eye. This will blend the colors. Now protect the palest areas of fur by masking them with White Prismacolor pencil. Then paint a warm flesh color into the ears with a mix of Raw Umber and Rose Doré. Paint the rest of the body with a pale wash of Burnt Umber, and paint brighter gold areas of the fur with a mixture of Burnt Sienna and New Gamboge.

5 Add Final Watercolor Shadows

Erase all graphite and White pencil on your background and subject.

Add a mixture of French Ultramarine and Burnt Sienna to some of the leaves to put them in deeper shadows.

Paint in the flowers in front of the rabbit's ears using the same colors from steps 3 and 4.

Using the shapes of the shadows from your background reference photo and the same shadow color you used on the leaves, paint the shadows made by the flowers onto the rabbit's body. (Adjust the shapes to conform to the rabbit's anatomy.) Soften the shadow edges with a damp brush.

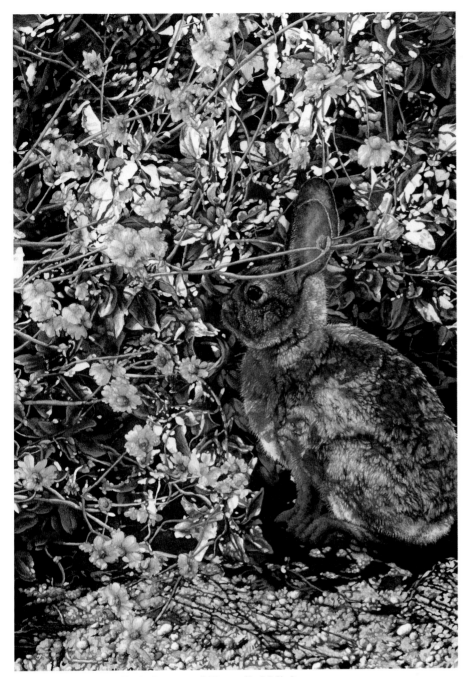

DESERT COTTONTAIL IN DESERT
MARIGOLDS
Sueellen Ross
13" × 9" (33cm × 23cm)

6 Add Lights, Brights and Details With Colored Pencil

Using colored pencils, highlight the darker leaves with Slate Grey. Blend the darker greens with Olive Green, and the paler greens with Jade Green. Use Black pencil to sharpen edges, deepen center veins and deepen shadows on the leaves. Edge the stems with a Burnt Ochre pencil.

Put in additional white stones with White pencil. Soften the edges of the ink shadows and add shadows to the stones with Sepia.

Deepen the shadows in the flower centers and petals with Goldenrod and Apple Green. Add final details and sharpen petal edges with Burnt Ochre.

Where the sun hits the rabbit, highlight the fur at the tips with White pencil. Where the rabbit is in shadow, highlight the tips of the fur with French Grey 10%. To warm up the color on the back of the neck and in the ears, use Burnt Ochre in the darker areas, Orange in the medium areas and Sand in the light areas. Blend and soften the fur edges that are in full sun with Light Umber, and use Sepia to blend and soften the fur in the shadows. Use Black to deepen shadows and to sharpen details on the rabbit.

Sea Otters in Acrylic

BY BART RULON In this demonstration, Bart Rulon illustrates how to create a realistic painting of a pair of sea otters by combining two reference photographs. He also shows you how to paint the soft, fine fur of a sea otter and make it look both dry and wet. Bart took these photographs of wild sea otters at Moss Landing on the California coast. He carefully selected reference photographs that have consistent lighting and work together to make a good composition. It helps that these photos were taken within a few seconds of each other from the same camera angle.

MATERIALS

Surface
Hardboard panel primed with gesso

Palette
GOLDEN HEAVY BODY ARTIST ACRYLICS: Cadmium Yellow Light, Raw Sienna, Raw Umber, Titanium White

LIQUITEX MEDIUM VISCOSITY ACRYLIC ARTIST COLOR: Burnt Sienna, Ivory Black, Naphthol Red Light, Ultramarine Blue

Brushes
No. 12 flat

Nos. 000, 1, 3 and 5 flats

Other
Empty film canister

Pencil

Scrap paper

Sketching paper

Water (used as a medium with each painting mixture)

REFERENCE PHOTOS

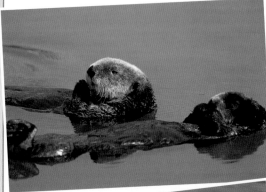

This photograph sparks a good idea for a painting because the placement of the two otters makes a good composition.

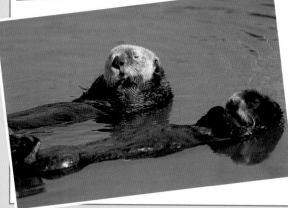

Use the otter on the top of this photograph to change the pose and details of the otter in the foreground of the main reference photo. Keep the approximate placement of the otters shown in the main photo.

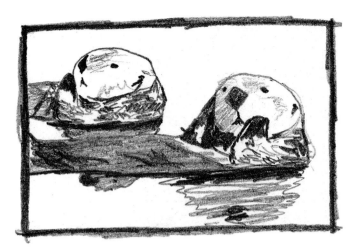

1 Utilize a Thumbnail Sketch
Draw a thumbnail sketch to see if the composition will work.

2 Complete the Drawing
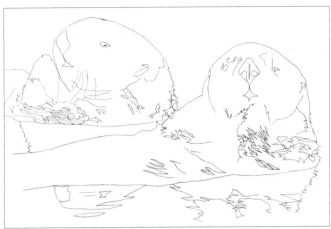

Fine-tune the drawing on a piece of scrap paper. Transfer the drawing to the board by tracing the lines on the reverse side of the paper, then place the drawing right-side up on the board, and retrace, with hard pressure, over the lines again.

3 Block In the Entire Painting
Block in the water with a mix of Ultramarine Blue, Titanium White, Cadmium Yellow Light and Naphthol Red Light using the no. 12 flat and no. 5 round brushes. Save the extra paint for use in later steps.

Block in the eyes, noses and mouths with a mix of Ivory Black and Raw Umber using the no. 3 brush. Add more Raw Umber and block in the dark fur on the otters' necks.

Paint the otters' reflections in the water with a no. 5 round and a mix of Raw Sienna, Cadmium Yellow Light, Ultramarine Blue and Titanium White.

Block in the belly with a mixture of Raw Umber, Burnt Sienna, Ivory Black and Titanium White using the no. 12 flat and no. 5 round brushes.

Paint the lighter brown colors on the neck with the no. 5, no. 3 and no. 1 brushes and mixes of Raw Umber, Raw Sienna, Titanium White and Ivory Black.

Paint the shadow side of the faces with the no. 5 and no. 3 brushes and a mix of Raw Sienna, Titanium White, Naphthol Red Light and Ultramarine Blue.

Block in the nose of the otter on the right side with a mix of Ultramarine Blue, Naphthol Red Light, Titanium White, Raw Umber and Ivory Black.

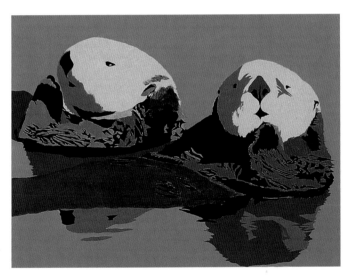

Paint Mixtures for the Otters' Faces

- Raw Sienna and Titanium White
- Raw Sienna, Raw Umber and Titanium White
- Same as the above mix but with more Titanium White added
- Raw Umber, Ivory Black and Titanium White
- Same as the above mix but with more Titanium White added
- Raw Sienna, Burnt Sienna, Raw Umber and Titanium White

4 Add More Colors

This step bridges the gap between the basic block in of colors and the really detailed work. Paint the dark blue hues on the bellies of the otters with a mix of Ultramarine Blue, Naphthol Red Light, Raw Umber, Ivory Black and Titanium White.

Take some of the water mixture saved in the previous step and add more Ultramarine Blue. Use the no. 3 and no. 1 brushes to paint the lightest blue highlights on the bellies, caused by puddles of water and reflections of the sky.

Paint a mix of Raw Sienna and Titanium White on the faces of the otters with the no. 5 and no. 3 brushes.

Start some of the most obvious fur details in the shadows of the faces using the no. 3, no. 1 and no. 000 brushes and a variety of mixtures of Raw Umber, Raw Sienna, Ivory Black, Ultramarine Blue, Naphthol Red Light and Titanium White.

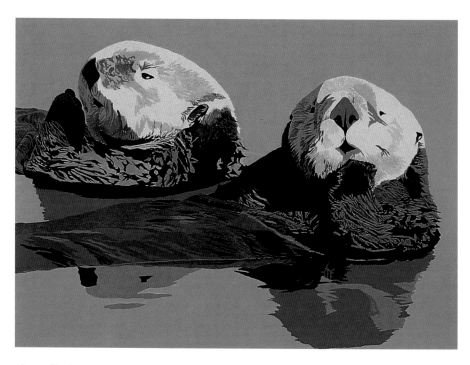

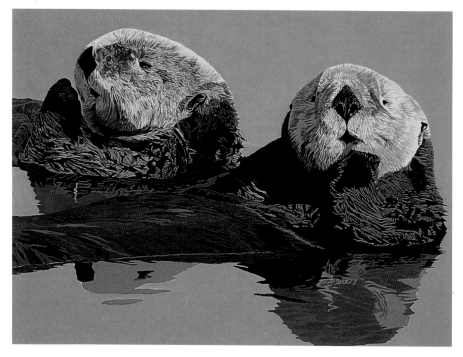

5 Get Detailed

Paint the fur on the otters' faces by pre-mixing six different mixtures of brown ranging from the lightest brown to the darkest brown (see the list of mixtures on the previous page). Paint each color detail where you can see it in the photograph using the no. 3, no. 1 and no. 000 brushes. You will have to make intermediate mixtures from these six piles of paint to catch all the subtle differences in the fur. Where the fur is soft in the photograph, use more water and less pigment as you brush it on. Work back and forth between dark and light to help keep the fur looking soft.

Paint the dark textures on the nose with a dark mix of Ivory Black, Ultramarine Blue, Naphthol Red Light and Titanium White using the no. 1 brush and a stipple-like technique ("dotty" application of paint). Paint the highlights on the nose with the no. 1 brush and Titanium White mixed with a touch of the previous mix.

Work back and forth on the fur details of the neck and shoulders with mixes of Raw Umber, Raw Sienna, Ivory Black, Titanium White and Burnt Sienna.

Paint the reflections of the otters with mixtures of Raw Umber, Raw Sienna, Cadmium Yellow Light, Ultramarine Blue, Titanium White and Ivory Black.

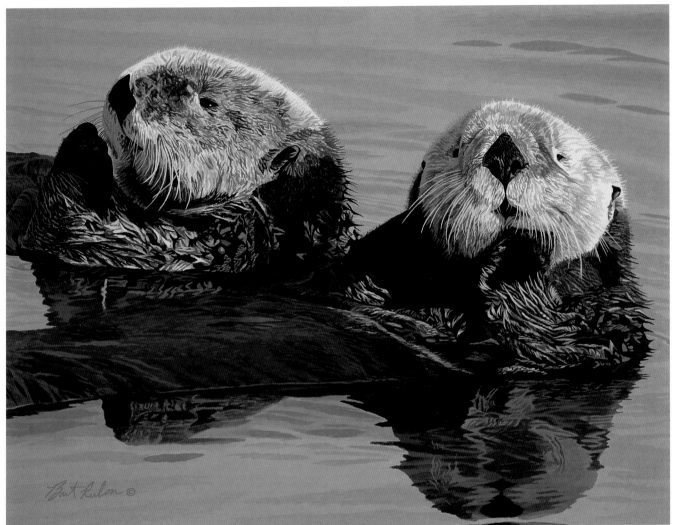

6 Finish With the Highlights and Water

Add the fur highlights with the no. 1 and no. 000 brushes and mixtures of Titanium White, Raw Sienna and Raw Umber (vary the amount of white added). Go back and forth between the highlights and the darkest darks to refine the details of the fur, blending colors wet-into-wet where needed.

Add a little more Ultramarine Blue and Naphthol Red Light to the water mixture from step 3 and with the no. 5, no. 3 and no. 1 brushes, paint this as the subtle ripples in the water and as the darker shade of blue, indicating the otters' bodies under the water's surface. To help balance the composition, add a green reflection in the top right-hand corner of the background with a combination of the blue water mix plus more Ultramarine Blue, Cadmium Yellow Light, Raw Umber and Raw Sienna. Continue to refine the details in the otters' reflections using the same mixtures as in step 5.

After the water is finished, paint the soft edges of fur around the profile of the otters' heads. Take the no. 000 brush, a mix of

SEA OTTERS
Bart Rulon
9" × 12" (23cm × 30cm)

Titanium White and Raw Sienna, and use quick, light brushstrokes to keep the lines thin, transparent and soft. For the darker fur of the bodies' profile, use mixes of Ivory Black, Raw Umber and Titanium White, and make the brushstrokes longer. Finally, mix Titanium White with touches of Raw Sienna and Cadmium Yellow Light, and paint the otters' whiskers with the no. 000 brush. In areas where the background is too bright, you might need to underpaint the whiskers with pure Titanium White, then glaze the whisker mix on top so it stands out enough. Paint the whiskers on the shadow side of the otter on the left with a mix of Raw Sienna, Raw Umber and Titanium White. When the scene looks believable from a distance of three to five feet away, the painting is finished.

Tiger in Watercolor

BY BART RULON As a child, Bart's favorite subjects to draw and learn about were tigers, cheetahs and lions. Since then, his biggest dream has always been to see those and other cats in the wild. Though he could hardly wait to paint the big cats of the world, he decided to wait until he experienced them in the wild. Finally in 2001, with the help of his friend, Sarah Scott, Bart had an opportunity to photograph tigers in the wilds of India. He took these tiger photographs with a 400mm lens from the back of a trained Asian elephant in Kanha National Park. With a guide, Bart was able to approach several tigers within 20 to 30 feet without spooking them or being in danger.

Though he doesn't normally paint portraits of animals, Bart felt his first tiger painting should focus on the tiger's face. This painting demonstrates how to paint the eyes, fur and stripes of a tiger.

MATERIALS

Surface

Arches 300-lb. (640gsm) cold-press watercolor paper

Palette

WINSOR & NEWTON ARTISTS' WATERCOLORS: Burnt Sienna, Burnt Umber, Cadmium Orange, Cadmium Red, Cobalt Blue, French Ultramarine, Neutral Tint, Permanent Alizarin Crimson, Permanent Sap Green, Raw Sienna, Yellow Ochre

Brushes

Nos. 000, 1, 3, 5, 8, 12, and 14 rounds

Other

2B, 6B and 6H pencils

Drawing paper

Hardboard panel

Masking tape

Scrap paper

Tortillions

Water (used as a medium with each painting mixture)

REFERENCE PHOTOS

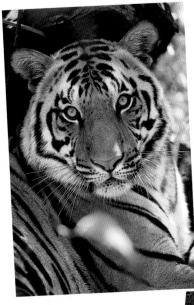

This shot provides a good pose and a close-up view of the details.

Main reference photo

Tree reference photo

Body reference photo

Complete the Drawing

The composition in the photograph is already good. Begin with a drawing study to see if the idea will work, to get a feel for the direction of the fur and to work out any possible problems. As a rule, you normally wouldn't place the subject in the middle of the composition, but sometimes you have to break the rules. Make adjustments until the anatomy looks correct. Use a 2B pencil for light and medium-toned details, and the 6B pencil for dark details. A tortillion will blend the pencil and help create soft edges. Pay special attention to the direction of the fur all over the face, and particularly around the eyes and nose. Here I want the tiger's stare to be intimidating, so I put the eyes front and center.

Enlarge the drawing with a copy machine, and transfer the outline of the tiger and its stripes onto the watercolor paper.

2 Complete an Underpainting

Paint the irises of the tiger's eyes with a mixture of Yellow Ochre and Raw Sienna using the no. 3 brush. Leave the subtle highlights in the eyes dry. Add Burnt Sienna and more Raw Sienna to the mix around the edges of the iris, where the color is more intense. Use the no. 000 brush to paint the subtle dark patterns around the middle of the iris. Carefully build up the irises with several washes of color on top of this.

Start the dark stripes and markings on the body of the tiger with a diluted mix of Neutral Tint and Burnt Umber. Wash Raw Sienna under the eyes, and start in with some of the fur details using the no. 1 brush and the same dark mix for the stripes. Alternate between washes of color and details to keep the edges soft.

Wash a mixture of Yellow Ochre, Raw Sienna and a touch of Burnt Sienna in the lightest orange parts of the body using the no. 14 and no. 12 brushes. Add more Raw Sienna and Burnt Sienna for the darker orange parts of the tiger. The end of the nose is a mixture of Cadmium Red and Cadmium Orange using the no. 5 brush. Paint in more of the tiger's stripes with a wash of Neutral Tint and Burnt Umber.

For the tiger's white chest, paint a broad, thin wash of French Ultramarine, Permanent Alizarin Crimson, Neutral Tint and a touch of Burnt Sienna with the no. 14 brush to indicate the subtle blue shadows. For the details in the ears, start by carefully and softly drawing the fur with a 6H pencil. Paint around the pencil lines, in the negative spaces created, with the no. 1 and no. 000 brushes and a mix of Neutral Tint, Burnt Umber and Permanent Alizarin Crimson.

3 Work on Facial Details

Continue painting the details in the ears. Use the no. 1 and no. 000 brushes to work in the fur details all over the face with thin mixes of Neutral Tint and Burnt Sienna. In the white areas of the face add French Ultramarine to the previous mix. Next, darken the stripes with another wash of Neutral Tint and Burnt Umber. This time, however, use the no. 3, no. 1 and no. 000 brushes around the edges of each stripe to indicate the edges of the fur. Follow the reference photo carefully for these striped edges. Use the no. 5 brush to fill in the middle of the stripes as you go along with the edge details.

Use a watered down version of the stripe mixture with a little Burnt Sienna added to paint the tiny hair details from the eyes to the nose with the no. 000 and no. 1 brushes. Pay special attention to the photo to duplicate the direction of the fur in this step. Notice how the fur patterns tend to radiate from the inside corner of each eye and how the hairs follow the contours of the muzzle. For the subtle fur details in the white parts of the face use the no. 1 and no. 3 brushes and a diluted mix of French Ultramarine, Neutral Tint and Burnt Sienna. As you paint the tiger, try to duplicate the fur details in the photo, improvising as necessary.

4 Work on the Body and the Background

Paint the fur details on the body with the no. 000 and no. 1 brushes and a mix of Neutral Tint and Burnt Umber for the orange areas. Use French Ultramarine, Permanent Alizarin Crimson and Burnt Sienna for the white areas. The direction of fur changes throughout the body, so be sure to pay attention to the reference photo as you progress. Go over the shoulder with a wash of Raw Sienna, Yellow Ochre and Burnt Sienna. Also, paint a wash of this mixture on the muzzle from between the eyes to the nose. Darken the tiger's stripes again, this time with a strong mixture of Neutral Tint and Burnt Umber. Use the no. 000 and no. 1 brushes for the ragged edges of the stripes.

Start the background by alternating between broad washes to indicate color and shadow and a dry-brush technique for the details of the bark. For both, use mixtures of Neutral Tint, French Ultramarine, Permanent Alizarin Crimson and Burnt Sienna. Paint the details with the no. 8, 5, 3 and 1 brushes. Paint the broad washes using a more watered-down mixture, using the no. 12 and 14 brushes. Add a touch of Permanent Sap Green to the tree mixture for areas where the photo shows a greenish tinge.

142

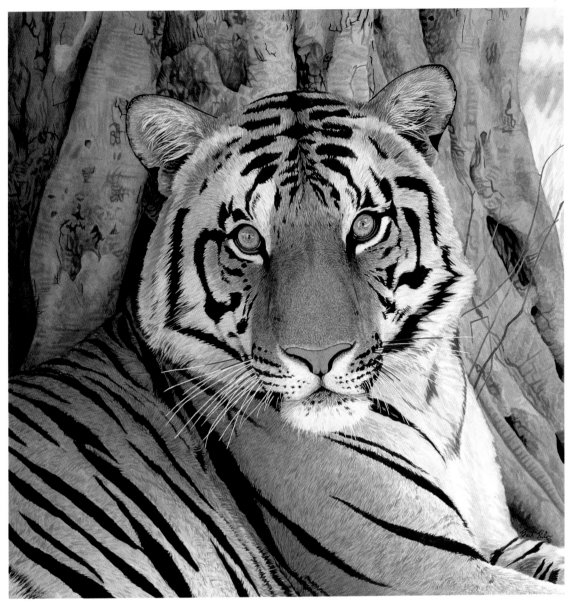

TIGER PORTRAIT
Bart Rulon
22" × 21"
(56cm × 53cm)

5 Adjust Values and Colors

Finish off the details of the tree bark with the mixes of Neutral Tint, French Ultramarine, Permanent Alizarin Crimson and Burnt Sienna. Then wash a watered-down version of this mix over the entire tree to put it in shadow and soften the details, making the tree recede.

The tiger is in the shadow of the tree, and her values will need to get darker too. Achieve this with more broad washes of the colors used in previous steps. Also, paint a thin mix of French Ultramarine, Permanent Alizarin Crimson and Neutral Tint on the ears and white areas of the tiger. Use washes of this bluish mixture to dull down the orange fur where it still looks too bright to be in shadow, especially on the face. Look at the reference photo to see which fur details need to be darkened, such as

around the eyes and nose, and use the no. 000 and no. 1 brushes to reinforce them with the same colors as before. Make the face the most detailed part of the painting since it is the center of interest. Use a heavily pigmented mixture of Neutral Tint and Burnt Umber to finish the stripes, using the no. 8, 3, 1 and 000 brushes as before.

Paint out-of-focus grass in the top right corner with a mix of Raw Sienna, Yellow Ochre and Raw Umber, adding Permanent Sap Green, Neutral Tint and Cobalt Blue for the dark area. Use the no. 12 and no. 8 brushes and paint wet-into-wet so the edges are fuzzy. Paint the small, green leaves over the tiger's head with a mix of Permanent Sap Green and Neutral Tint using the no. 3 brush.

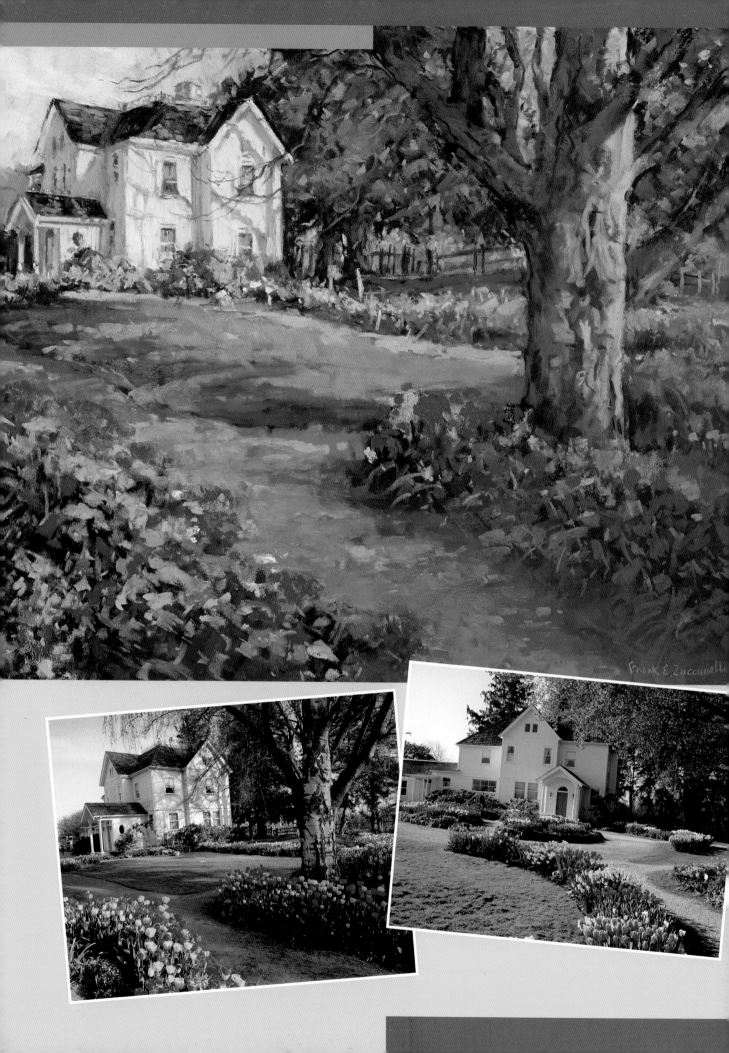

Frank E. Zuccarelli

6 BUILDINGS and BARNS

Perhaps you've driven past a house and found yourself admiring the structure but not the cedar shingles. Or maybe you've noticed a quaint barn obscured behind brush and foliage and wondered how it would look standing alone on a grassy plain. One of the many advantages to painting from reference photos is your ability to create composite images. Working with multiple images gives you the freedom to pick and choose desired elements from each reference and discard those elements you find unappealing. This means you can create a painting using the portico from one reference photo, the windows from another, the brilliant red bricks from a third and so on. The end result is a completely unique composition.

You can gather a great deal of reference photos for your building and barn paintings by making sure that you take your camera along when leaving the house. Whether you prefer modern homes, country cottages or Victorian mansions, you're likely to find something for your reference library everywhere you go. When photographing your favorite buildings and barns, be sure to take pictures from various vantage points. Try positioning yourself on level ground, standing on a hill looking down or in a valley looking up. The more angles and viewpoints you capture, the more options you'll have for your paintings. You can also take photos at various times of day, capturing your subject in different lighting conditions and picking your favorite shots.

In this chapter you'll create a variety of structures including a picturesque barn, a warm and inviting country estate, a scenic lighthouse, a charming covered bridge and a classic Victorian home. If you're feeling especially creative or think you need a challenge, supplement the demonstrations with your own photographs to construct a new and exciting composition.

Bygone Dreams in Oil

BY LARRY WESTON This unusual barn once stood in Sequim, Washington, a pictur-
esque town on the Olympic Peninsula. Several years, housing developments and strip
malls later, this relic of the past is, sadly, no more. However, its memory lives on in this
breathtaking painting by master artist Larry Weston.

The field of yellow flowers was shot at a suburban park in Kirkland, Washington, and
the mid-level clouds were imported from Orcas Island, Washington.

MATERIALS

Surface

18 × 24-inch (46cm × 61cm) Frederic
medium-texture duck canvas

Palette

DANIEL SMITH ORIGINAL OIL PAINT:
Burnt Umber, Cadmium Yellow Deep, Cad-
mium Yellow Medium, Cerulean Blue, French
Ultramarine, Olive Green, Quinacridone
Gold, Quinacridone Rose, Quinacridone
Violet, Raw Sienna, Yellow Ochre

REMBRANDT ARTIST'S OIL COLORS:
Kings Blue

WEBER PERMALBA PROFESSIONAL OIL
COLOR: Permalba White

Brushes

⅛-inch (3mm), ½-inch (12mm) and 1-inch
(25mm) flats (soft hair)

Nos. 3 and 6 rounds (soft hair)

Other

Krylon Kamar Spray Varnish

Liquin

Natural sea sponge

Palette (paper, glass or enamel tray)

Palette mixing knives

Terry towel and/or paper towels

Weber Odorless Turpenoid

REFERENCE PHOTOS

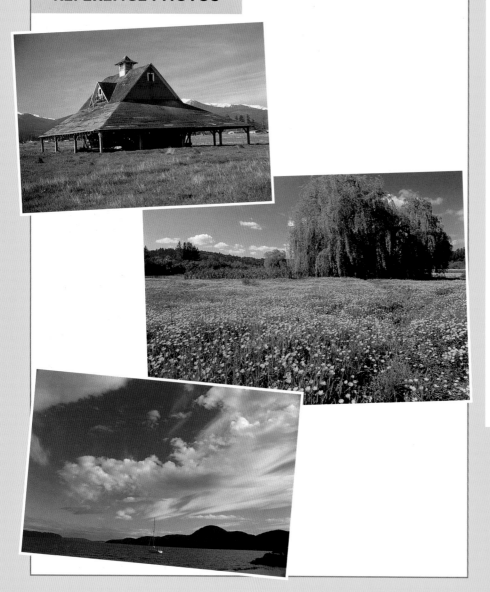

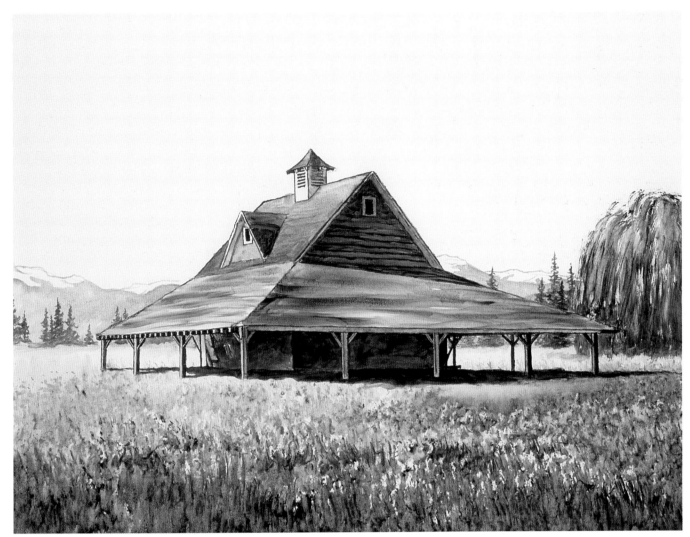

Prepare the Surface and Lay Out the Composition

Select a prestretched and primed 18 × 24-inch (46cm × 61cm) medium-textured canvas. With a no. 3 round brush, establish the major lines of the barn. Graphite from pencils will lift off and muddy the initial colors of a painting, therefore use various thin mixtures of Burnt Umber and French Ultramarine, both mixed with several drops of Liquin. Then add thin glazes with a ½-inch (12mm) flat brush to give the barn its form and to lightly suggest the distant mountains and pine trees.

Create the grass texture using a 1-inch (25mm) square piece of natural sea sponge. Wet the sponge with water and squeeze out excess moisture. Next, dip the damp sponge into the turpenoid, then into your paint. Use short vertical strokes to lightly drag

the sponge downward, using darker mixtures toward the bottom edge. Using the same sponge and technique, suggest a weeping willow tree on the right. (You'll use this same technique to create the grass and willow tree in the final stage of the painting.)

For a mixing medium, use Turpenoid and Liquin. (Liquin is a drying agent, and its properties also make oil pigments very creamy.) Add two or three drops of Liquin and about a dozen drops of Turpenoid to your Permalba White pigment only. Mix thoroughly until soft mounds are created. White is usually added to most of your mixed colors, thereby transferring some of the mixing medium to any newly mixed colors. Only use additional Liquin when mixing colors that will not be mixed with white.

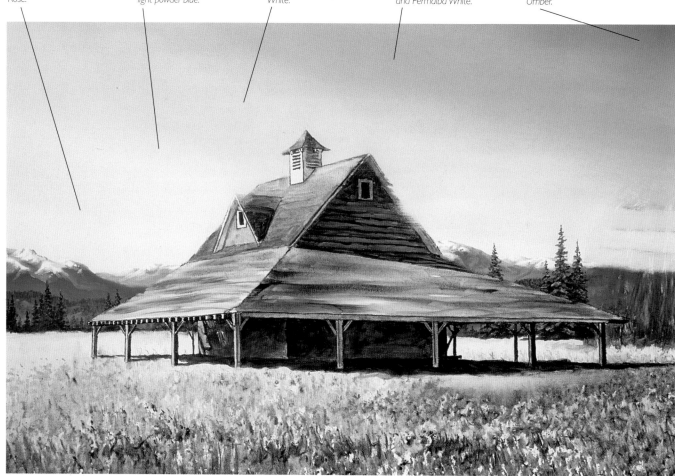

Band 1—For the lowest part of the sky, use Permalba White with a touch of Quinacridone Rose.

Band 2—Use Kings Blue and Permalba White to create a light powder blue.

Band 3—Use Kings Blue, Cerulean Blue and Permalba White.

Band 4—Use Cerulean Blue with a little French Ultramarine and Permalba White.

Band 5—Use Cerulean Blue, French Ultramarine, Permalba White and a touch of Burnt Umber.

2 Paint the Sky and Add the Mountains and Trees

Start painting the sky using five bands of solid colors. The lightest part of the sky, just above the mountains, becomes progressively darker toward the upper-right corner. Using a 1-inch (25mm) flat brush, paint bands of color at a slight angle, making each band wider toward the left side (the light source). Leave about ¼ inch (6mm) of raw canvas between each band. After all of the bands are in place, crosshatch about 1 inch (3 cm) between each band to merge the colors. Continue this procedure until all the bands are locked together. Gently smooth out the crosshatched areas until a nice transition is achieved between each band. When blending, always work from darker mixtures into lighter ones to help retain the dark values. Once the basic sky is complete, allow it to dry before adding clouds. In the meantime, work on other parts of the painting.

Darken the darkest blue used in the sky using Cerulean Blue, French Ultramarine and Burnt Umber. With a ½-inch (12mm) flat brush, block in the mountains, except for the snow on top. For the snow use Permalba White with a trace of Cerulean Blue. Using a no. 6 round brush, block in the snow without touching

the blue. Once completed, use light crosshatching to merge the two colors together.

Use the leftover colors from the sky to suggest some contour within the mountains to break up any flatness.

To paint the large distant trees at the base of the mountain, use nos. 3 and 6 round brushes and mixtures of Olive Green, French Ultramarine and a touch of Burnt Umber. Use quick, little horizontal strokes at the top of the trees. Make the strokes wider with a slight downward motion as you move toward the base of each tree. Add a few highlights on the left side of each tree.

Helpful Hint

Try painting everything darker than it will appear in the final painting. In oils, it is much easier to lighten a dark color than it is to darken a light color.

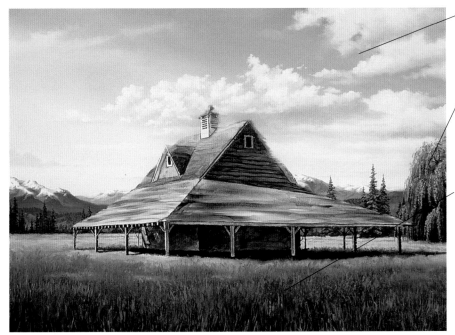

Clouds—Work from dark to light. Using a ½-inch (12mm) flat brush, establish basic shapes by roughing in the billowing effects, then further refine using a no. 6 round. Once dry, add the highlights. The edges of the clouds are not the lightest areas; generally the center of the billows are where the lightest values appear.

Weeping Willow—With the same dark colors used for the grass, create the tree's basic shape using a piece of natural sea sponge. Then sponge on lighter colors, being careful not to cover all of the darker colors. Apply the lightest green and texture with a no. 3 round brush. (Clumps of foliage in the center of the tree are generally the lightest.)

Grass—Paint the distant area using Yellow Ochre and a little Permalba White with a ½-inch (12mm) flat brush. Suggest distance and contour with a grayed-down light green (Yellow Ochre and Cerulean Blue). Use more intense greens down to just below the barn. Suggest dirt near the barn using Raw Sienna and Permalba White. With a 1-inch (25mm) flat brush, underglaze the lower portion of the field, using darker green toward the lower edge of the canvas. Starting just below the barn, paint the grass using the natural sea sponge. While the grass underglaze is still wet, add texture and lighter values. With a no. 3 round brush, paint a few thin brushstrokes along the bottom edge to simulate individual grassy stalks. About 80 percent of this green field will be covered with flowers, so only a few stalks are needed. Allow to completely dry. (All of the greens used in the field are mixtures of Olive Green, French Ultramarine and Burnt Umber. Quinacridone Rose was added to gray down some of the mixtures while Cadmium Yellow Medium and Permalba White were used to enrich and lighten some of them.)

3 Paint the Clouds, Grass and Weeping Willow

Before actually painting the clouds, premix all the colors needed by following the equations listed below.

Mixing Colors for Step 3

Medium blue gray = Permalba White + Cerulean Blue + Quinacridone Rose + Burnt Umber

Light blue violet = Permalba White + Cerulean Blue + Quinacridone Rose

Medium pink violet = Permalba White + Quinacridone Rose + Cerulean Blue

Light pink violet = Permalba White + Quinacridone Rose + Cerulean Blue

Very light pink = Permalba White + Quinacridone Rose

Sponging Hint

Keep the sponging colors thin to avoid little peaks of stiff pigment rising from the surface of the canvas.

4 Underpaint the Barn

Paint the entire barn with flat planes of color using three basic values. For the darkest area (under the barn's roof), use a mixture of Burnt Umber, French Ultramarine and Quinacridone Rose. For the middle values (the roofs and side posts in shadow), use the same colors with a little Permalba White. For the lightest areas, where the sun hits directly on the barn, use combinations of Raw Sienna, Cadmium Yellow Medium, Quinacridone Gold and Permalba White.

Once the blocking-in process is completed, add more interest to the flat areas by adding minor color and value changes. Use a ½-inch (12mm) flat for the larger areas and nos. 3 and 6 rounds for the smaller ones.

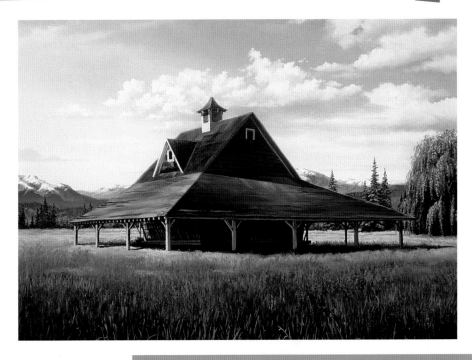

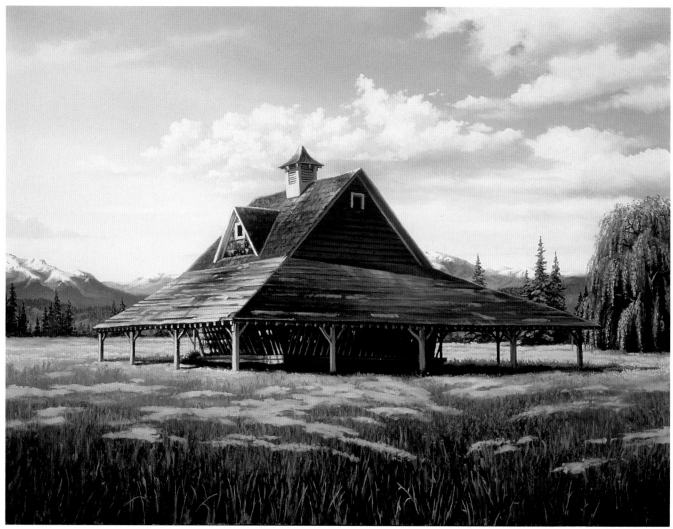

5 Add Detailing to the Barn and Underpaint the Flowers

Add the details in the darkest areas first. Suggest minor objects, such as the vertical boards, by using grayed-down blues (French Ultramarine mixed with Burnt Umber and a touch of Permalba White).

For those highlighted areas of the roof that appear white, use Permalba White with a trace of Cadmium Yellow Medium and Quinacridone Rose. In the shade, use French Ultramarine, Burnt Umber and less Permalba White for the cool white areas.

For the detail and texture of the roof, use cool colors lightly brushed onto the darker areas. Use combinations of French Ultramarine, Burnt Umber, Raw Sienna and Permalba White. Use a ⅛-inch (3mm) flat brush to suggest wood shingles on the upper roof and the boards on the lower left. Use Raw Sienna, Cadmium Yellow Medium, Quinacridone Gold and Permalba

White for the lighter, warmer values of the roofs. Apply value changes of no more than 15 percent on top of one another until the desired value is achieved. Use the same colors to delineate the warm sides of the posts that support the roof.

For the horizontal boards at the base, warm the previous mixtures by adding a little Raw Sienna. To suggest sunlight striking the boards, use mixtures of Raw Sienna, Quinacridone Gold and Permalba White.

Suggest distant flower clusters with light mixtures of Cadmium Yellow Medium and Permalba White. Use Quinacridone Violet to gray down the intensity of distant yellows. Use stronger yellows for the flowers in the middle ground, adding Cadmium Yellow Deep here and there. Allow to dry until tacky.

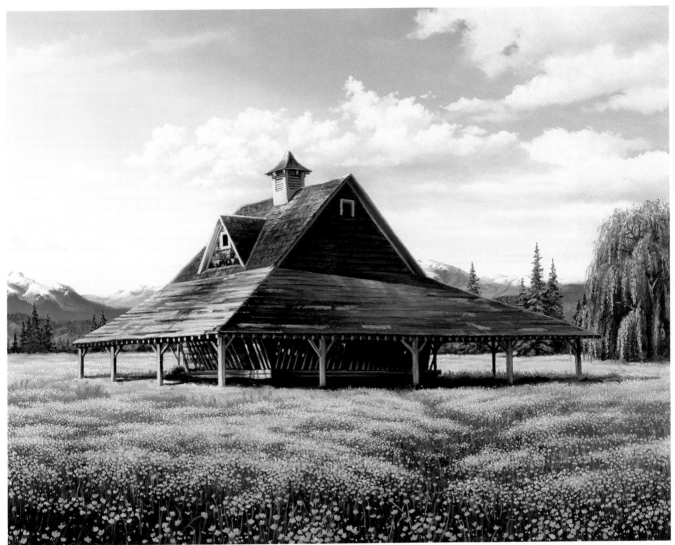

BYGONE DREAMS
Larry Weston
18" × 24" (46cm × 61cm)

6 Finish the Flowers and Add a Final Protective Coat

Use the same colors in the previous step to complete the field of flowers, painting the foreground flowers in a low key, while using the richest yellows for the middle ground. As the flowers recede within the painting, make the yellows lighter and slightly cooler.

Only the flowers in the immediate foreground need to be the shape of the variety being portrayed. After painting the foreground flowers, add the rest of the flowers using random dots made with the tip of a round brush. Group some dots into clusters while leaving others to stand alone. Place the darker as well as the lighter dots over the original brushed-on yellow patterns. Make the dots progressively smaller as the flowers recede.

After your painting is finished and completely dry, brush pure Liquin over the entire surface with a 1-inch (25mm) flat. This will bring life to those colors dulled from the painting process. After the Liquin is dry, use spray varnish for a protective coat.

Work outdoors on a warm, calm day and lay the painting flat on some newspaper. I highly recommend using eye protection and at least a dust mask. Start spraying from the direction that your painting will be viewed. Using a horizontal motion, start at the top and rapidly work down to the bottom, spraying right off the edges of the canvas. Allow the varnish to dry between coats, usually about five minutes. Then rotate the canvas by one-quarter turn and spray again horizontally top to bottom. Keep rotating the canvas and spraying until you have sprayed from all four sides. Spray the fifth and final coat from the direction that you would view the painting. This technique seals all raised surfaces of the painting and provides a nice matte finish.

South Shore Acres in Pastel

BY FRANK E. ZUCCARELLI This scene lies in the lush Skagit Valley, about sixty-five miles north of Seattle, Washington. During the first three weeks of every April, the area becomes a riot of color with hundreds of acres of tulips. It is sprinkled with quaint barns and surrounded on three sides by snowcapped peaks. Frank Zuccarelli captures the breathtaking beauty in his rendition of South Shore Acres.

REFERENCE PHOTOS

MATERIALS

Surface

14 × 18-inch (36cm × 46cm) Wallis sanded pastel paper

Palette

PRISMACOLOR SEMI HARD NUPASTELS: 298 Bottle Green, 299 Cold Very Light Gray, 353 Cordovan, 278 Dark Green, 257 Deep Cadmium Yellow, 207 Deep Chrome Yellow, 277 Ivory, 217 Lemon Yellow, 245 Light Turquoise Blue, 233 Raw Sienna, 208 Sap Green, 333 Titian Brown, 239 Warm Light Gray

SENNELIER SOFT PASTELS: 208 Apple Green, 399 Cadmium Yellow Light, 753 Cinnabar Green, 356 Cobalt Blue, 140 Indigo, 945 Magenta Violet, 901 Nickel Yellow, 305 Scarlet Lake, 390 Ultramarine Deep

Brushes

1-inch (25mm) white bristle oil brush (for corrections)

Other

20 × 24-inch (51cm × 61cm) acid-free foamcore board

3M acid-free spray adhesive

66B Rexel Derwent pastel pencil

HB graphite pencil

Kneaded eraser

Krylon workable fixative

Soft white tissues (to clean pastel sticks)

Prepare the Surface and Lay Out the Composition

On foamcore board, measure a 3-inch (8cm) border with an HB graphite pencil. Thoroughly spray the back of the sanded pastel paper with spray adhesive. Carefully place and adhere the pastel paper to the border of the foamcore board.

Next, using an HB graphite pencil, indicate the layout, paying close attention to proportions and relationships. Darken the lines slightly with the Derwent pastel pencil.

2 Underpaint With Preliminary Colors

Lightly underpaint with Nupastels. Apply 208 Sap Green loosely in the grassy area and foliage. Apply 239 Warm Light Gray to the sky and shadow side of the house. Add 333 Titian Brown to the roof and tree trunk in the foreground.

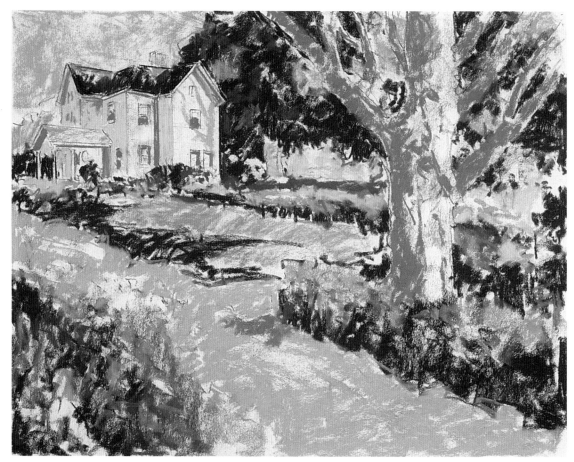

3 Block In the Elements

Sketch in the darks of distant trees, the shadow on the grassy area and foreground growth with 298 Bottle Green. Apply 245 Light Turquoise Blue to the sky and sky holes seen through the dark trees. Apply 239 Warm Light Gray to the mass in the foreground pathway and shadow side of the large tree trunk. Add an irregular patch of 257 Deep Cadmium Yellow beneath the shape of the dark tree, in the middle distance along the side of the house. Use 208 Sap Green to indicate light streaming across the grass. Place yellow flowers in the foreground with 207 Deep Chrome Yellow. Apply a light spray of fixative to the entire painting.

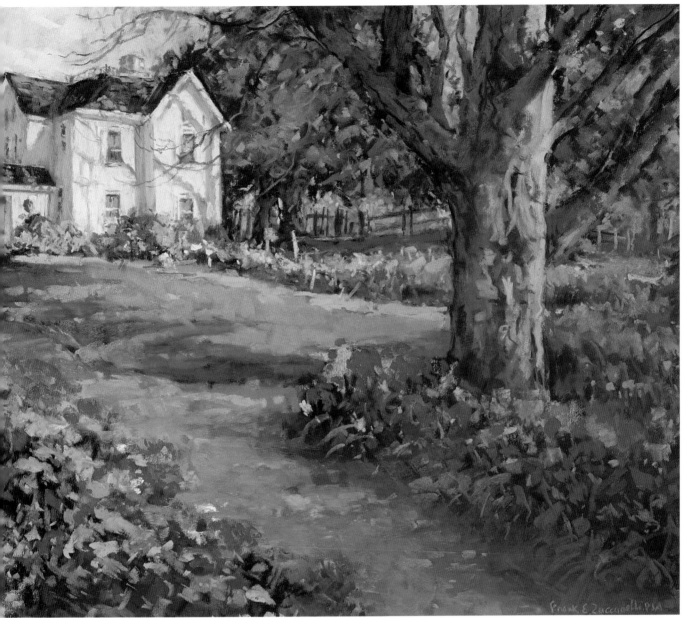

SOUTH SHORE ACRES
Frank E. Zuccarelli
14" × 18" (36cm × 46cm)

4 Layer and Glaze to Finish

Complete the unshadowed parts of the house with 277 Ivory. Use 299 Cold Very Light Gray for the shadows of the house. Apply 233 Raw Sienna to the pathway, touching up with Sennelier 753 Cinnabar Green in some areas.

Touch up the tree trunk, limbs and the fence and roof with 353 Cordovan. Lightly glaze with 390 Ultramarine Deep over the pathway and foreground tree trunk and limbs. Apply 140 Indigo to the sky and glaze over the tree shadows on the side of the house.

Apply 305 Scarlet Lake and 217 Lemon Yellow for flowers in the foreground and middle distance, then 399 Cadmium Yellow Light. Using pressure, apply 901 Nickel Yellow last.

Use 278 Dark Green to refine shadows on the grass and on the underside of the tree. Lightly apply 356 Cobalt Blue to dark shadows on the grass. Apply a light glaze of 208 Apple Green across the lawn in the lightest areas.

Next, apply 239 Warm Light Gray to the light side of the tree trunk. Lightly glaze 945 Magenta Violet on the pathway, sky, shadow side of the house and to the narrow path in middle distance, leading up to the house.

Take the painting outside and tap hard on solid surface to remove excess pastel dust. Note: Do not spray fixative on the finished painting unless all pastel dust has been removed either by tapping the back or using a small handheld vacuum held a few inches above the painting.

Morning Light at Yaquina Head in Watercolor

BY MICHELE COOPER The Yaquina Head lighthouse is located in Newport, Oregon, on the spectacular Oregon coast. Michele Cooper, respected watercolorist and instructor, has captured the essence of this magical structure in flowing, impressionistic washes of watercolor, a truly apropos medium.

REFERENCE PHOTOS

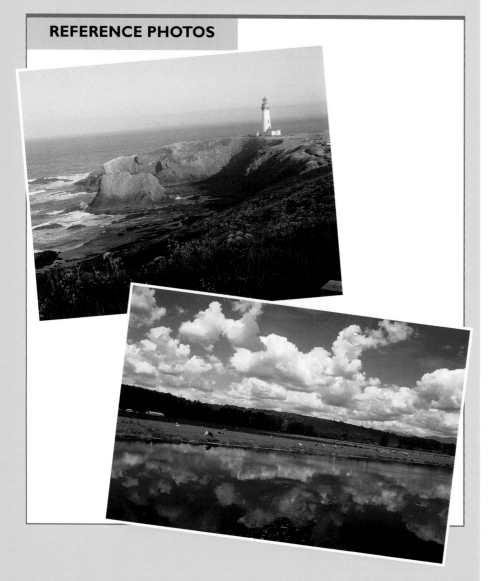

MATERIALS

Surface

15 × 20-inch (38cm × 51cm) 300-lb. (640gsm) cold-press watercolor paper

17 × 22-inch (43cm × 56cm) Gator board (cut larger than the borders of your paper)

Palette

HOLBEIN ARTISTS' WATERCOLORS: Manganese Blue Nova

WINSOR & NEWTON ARTISTS' WATERCOLORS: Alizarin Crimson, Aureolin, Burnt Sienna, Cadmium Orange, French Ultramarine, Ivory Black, New Gamboge, Raw Sienna, Winsor Blue (Green Shade), Winsor Red

Brushes

½-inch (12mm) Winsor & Newton Aquarelle flat

1-inch (25mm) Cirrus flat

2-inch (51mm) Isabey Series 6421 Squirrel wash brush

Nos. 4 and 8 Winsor & Newton Series 7 sable rounds

Other

2B graphite pencil

4 Boston Bulldog clamps

Black watercolor paint for value sketch

Elephant ear (or cellulose) sponge

Hair dryer (optional)

Jones watercolor palette with brush holder in the lid

Kneaded eraser

Paper towels

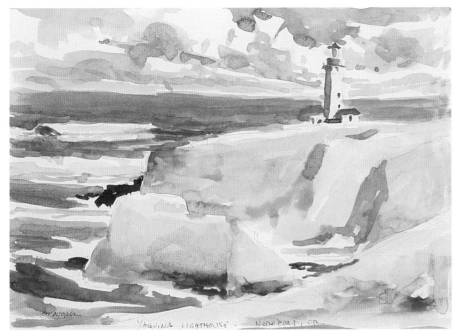

YAQUINA LIGHTHOUSE - NEWPORT, OR

After a Preliminary Sketch, Lay Out the Composition

Using Ivory Black and a no. 8 round brush, make a preliminary sketch from the original photographs, working out the composition and value relationships.

Next, clip your watercolor paper to Gator board, using Bulldog clamps to hold the paper at the corners. Prop it up at a 30- to 90-degree angle. Use a lower angle to maintain better control of the flow of the wet paint.

Lightly draw the horizon line, lighthouse and guidelines to indicate landmasses on the paper. Keep details to a minimum, concentrating more on proportion and placement.

2 Paint the Upper Sky and Sea

Pre-wet the sky background and sea with the elephant ear sponge and water. Reserve the lighthouse space as dry paper by painting around it with plain water using the no. 8 round brush. With a midvalue wash of Manganese Blue Nova and French Ultramarine and the 2-inch (51mm) wash brush, paint the sky above the lighthouse. Add more French Ultramarine to darken the wash and paint the background sea from left to right on either side of the lighthouse. Reserve the white breaker as dry paper by painting around it with variations of the darker French Ultramarine and Manganese Blue Nova wash. Use a damp ½-inch (12mm) brush to lift off a reflection under the large white breaker.

Add Alizarin Crimson to French Ultramarine and Manganese Blue Nova for the water to the left of the large foreground rock. Use the side of your 2-inch (51mm) wash brush for a rough texture and soften some edges with a dampened ½-inch (12mm) flat brush. Leave spaces of white paper for foam and breakers. Finish all the remaining ocean areas in the same manner. Allow this to dry.

3 Paint the Landmasses

Pre-wet the grassy foreground area with the elephant ear sponge before painting. With the 2-inch (51mm) wash brush, roughly add Raw Sienna to some of the leftover ocean color to create a low-chroma yellow-green. Follow the values in the preliminary sketch.

Pre-wet the entire middleground landmass under the lighthouse with the elephant ear sponge. Mix thick and thin variations of Burnt Sienna, French Ultramarine and Raw Sienna for warm and cool, light and dark gradations to indicate shadows and textures. With the 1-inch (25mm) Cirrus flat brush, paint the dark cliffs on the far right using various combinations of Burnt Sienna, Raw Sienna, Aureolin and French Ultramarine. With your no. 8 round and mixtures of Winsor Blue (Green Shade), Aureolin, Raw Sienna and Burnt Sienna, paint the shadows on the cliffs, painting over previous washes that have dried. Accent edges with thick, rough strokes or soften with a damp brush as desired. To paint the large foreground rock, pre-wet the rock with the elephant ear sponge. Make sure all adjacent areas are dry so the paint will not bleed into the rock or cause back runs. Mix warm neutrals with Burnt Sienna and

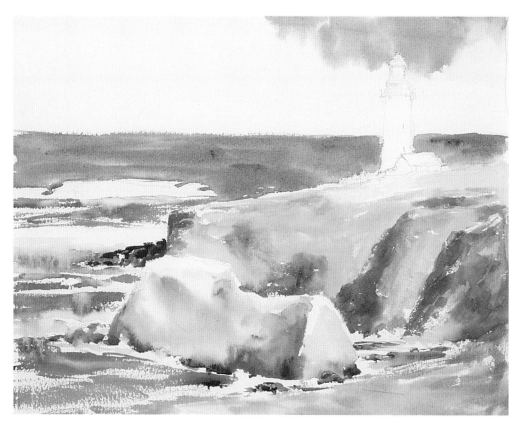

French Ultramarine for the darker shadows and projections. Alternate warm and cool colors, as well as light and dark passages. Soften edges with a damp brush. Keep the top and right side lighter. Intensify the mixture to paint the darkest wet rock behind the large foreground rock. On the left side of the foreground rock, alternate thick paint and water to create a wave-washed look. Seek other areas that could be accented with similar small rocks.

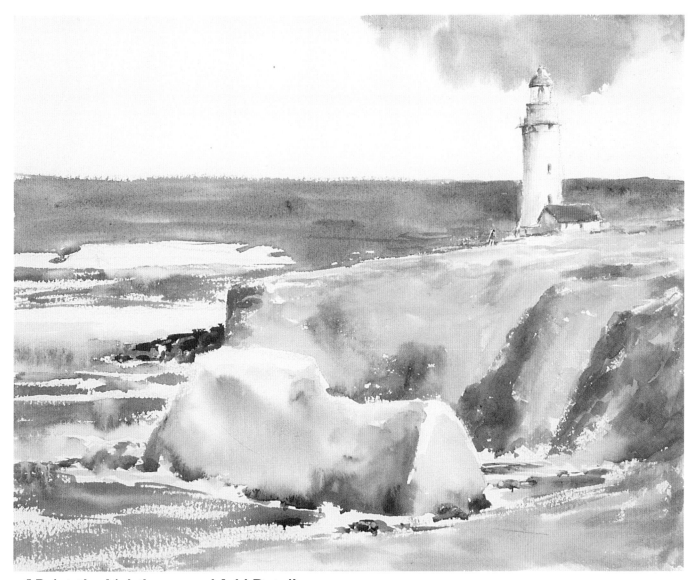

4 Paint the Lighthouse and Add Details

Pre-wet the base of the lighthouse with water using a no. 8 round brush. Load the brush with Manganese Blue Nova and French Ultramarine and stroke it along the length of the left inside edge to give a rounded columnar shape to the base of the lighthouse. Add more Manganese Blue Nova to the brush and paint the left side of the building at the base of the lighthouse.

As these areas dry, make darker accents of French Ultramarine mixed with a little Burnt Sienna under the railing, eaves of the outbuilding and the interior of the lighthouse. Soften the lower edge of the lighthouse.

Underpaint the roof of the lighthouse and outbuilding with Cadmium Orange and add Winsor Red on the left sides wet-into-wet. Introduce plain water on the right side for variation of tone. Use the tip of the no. 8 round brush to keep these details loose.

Underpaint the window shapes on the tower and doorway of the outbuilding with Raw Sienna. Allow to dry. Paint the interior shapes with Burnt Sienna, Manganese Blue Nova or French Ultramarine for variety.

Using the tip of a no. 8 or no. 4 round brush, paint the figure simply as a Winsor Red jacket, small dark head (French Ultramarine plus Burnt Sienna) and white slacks left as white paper, with the background painted on either side of the legs. Use more of the dark green from step 3 under the house and figure to add contrast.

Show reflected light with a light overwash of New Gamboge under the railing and alongside the left side of the lighthouse tower and in the gable end of the outbuilding. Allow to dry.

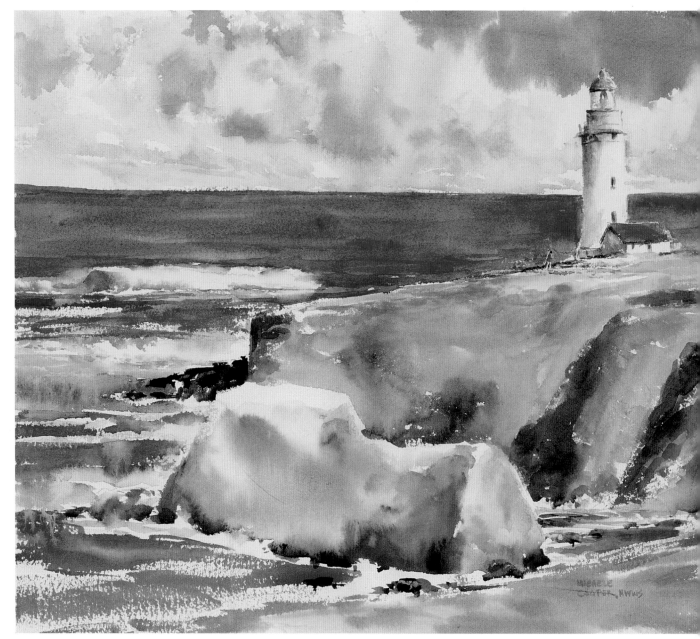

5 Paint the Breakers, Waves and Clouds

Pre-wet the large breaker to the left of the background cliff with the elephant ear sponge. Using the no. 8 round brush, add Manganese Blue Nova at the edges of the breaker to show form and movement and Manganese Blue Nova plus French Ultramarine at the left edge to show the curl. Repeat for the remaining waves and eddies.

Pre-wet the sky area with the elephant ear sponge from the top of the paper to the top edge of the ocean. Mix Manganese Blue Nova with a little French Ultramarine for the soft contours of clouds. Make them smaller at the horizon and larger at the

apex to show perspective. Mix Alizarin Crimson with the previous colors and lower the chroma, if necessary, with a little Raw Sienna and paint the cloud shadows. Save as much white or light paper as possible. Keep it simple so that the sky does not compete with the lighthouse but helps attract the viewer to it as the center of interest. Use the kneaded eraser to eliminate any unwanted pencil marks.

MORNING LIGHT AT YAQUINA HEAD
Michele Cooper
15" x 20" (38cm x 51cm)

Autumn Bridge in Acrylic

BY LINDA TOMPKIN Photographed near Lincoln City, Oregon, during a typical overcast Oregon coast day, the covered bridge featured here brings to mind tranquil days in rural America.

Linda Tompkin has creatively transformed the scene into this lovely acrylic painting, inspired by the rivers and fall settings of the auxiliary reference photos.

REFERENCE PHOTOS

MATERIALS

Surface

Strathmore 500 Series Illustration Board (100% rag, acid-free)

Palette

LIQUITEX HIGH VISCOSITY ACRYLICS: Burnt Sienna, Burnt Umber, Cadmium Red Medium, Cadmium Red Deep Hue, Chromium Oxide Green, Hooker's Green Deep Hue Permanent, Indo Orange Red, Phthalo Blue, Raw Sienna, Raw Umber, Red Oxide, Titanium White, Ultramarine Blue, Yellow Medium Azo, Yellow Oxide

LIQUITEX ACRYLIC GLOSSIES: Maroon

Brushes

2-inch (51mm) brush for applying gesso

No. 1 white synthetic rigger

Nos. 1 and 6 filberts

Nos. 4, 8 and 10 synthetic flats

Nos. 2 and 4 synthetic rounds

Other

1¼-inch (3cm) putty knife (to clean wells)

24-inch (61cm) ruler

6H graphite pencil

Clips

Drafting tape

Golden retarder

John Pike palette

Kneaded eraser

Paper towels

Razor blade (to scrape dry paint off palette)

Spray bottle

Support board

White gesso

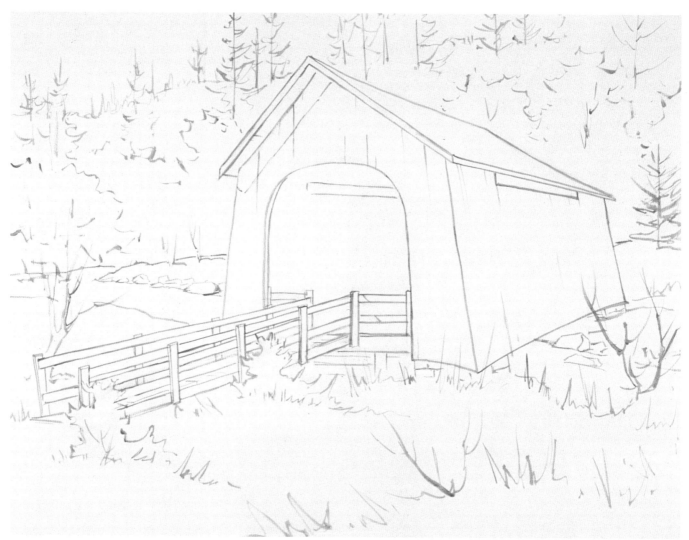

Prepare the Painting Surface and Lay Out the Composition

To prepare your painting surface, cut the illustration board 4 inches (10cm) larger than the image size, allowing 2 inches (5cm) for a border. Apply a thin coat of gesso to seal the paper. Let dry. Using a ruler and 6H graphite pencil, establish the boundaries of the painting. Mask around drawn lines with drafting tape to keep a clean border while painting. Clip your prepared illustration board to a support board.

Next, lay out the composition using a 6H graphite pencil, then overpaint with a mixture of Raw Umber and Raw Sienna. Use a no. 2 synthetic round brush, adding enough water to the mix to facilitate a clean line. When it's dry, remove the original pencil lines with a kneaded eraser.

Helpful Hint

To slow the drying time of the acrylic paint on your palette, add one drop of retarder to each of the colors on your palette and mix it in with the paint. This will not appreciably affect the drying time of the paint when it is applied to your work. Periodically mist the paints on your palette with water to keep them from drying out.

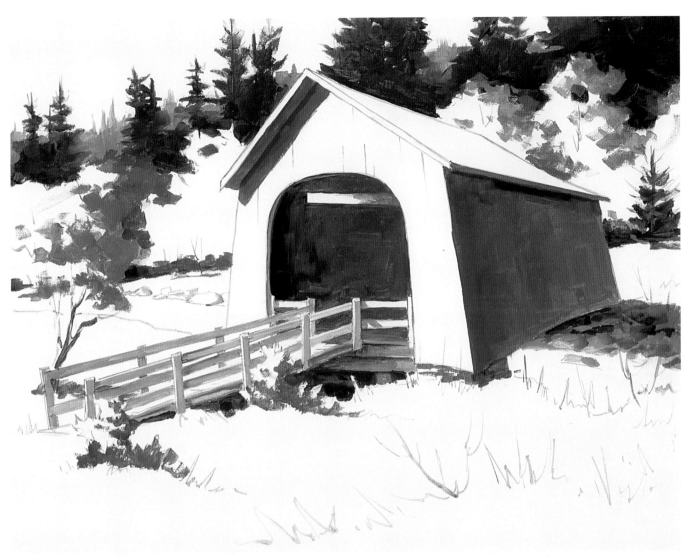

2 Paint the Darks and Shadow Sides of All Objects

Using a no. 10 flat brush, paint the opening of the covered bridge using a mixture of Burnt Umber, Ultramarine Blue, Maroon and Titanium White. Paint the dark areas under the bridge with the same colors. A small amount of water may be added to all mixtures, if desired.

For the dark evergreens in the distance, apply a mixture of Hooker's Green Deep, Ultramarine Blue, Raw Sienna, Yellow Oxide and Titanium White with a no. 8 flat brush. For the lighter trees on the distant hill line, use combinations of Titanium White, Phthalo Blue, Hooker's Green Deep Hue Permanent and Indo Orange Red.

Using a no. 10 flat brush, paint the shadow side of the bridge and the cast shadow under the eave on the front of the bridge, mixing Red Oxide, Cadmium Red Deep Hue, Burnt Umber, Ultramarine Blue and a little Titanium White. Paint the underside of the eave using Ultramarine Blue, Burnt Umber, Maroon and Titanium White.

Paint the handrails with a no. 4 flat brush. Use Titanium White, Burnt Umber, Burnt Sienna and Ultramarine Blue.

Paint the cast shadow from the bridge with a no. 8 flat brush using Burnt Umber, Ultramarine Blue, Titanium White, Raw Sienna and Hooker's Green Deep Hue Permanent. Then add the shadow sides of the rocks on the far side of the river using Titanium White, Burnt Umber and Ultramarine Blue.

Next, paint the shadow side of all the trees and bushes using a no. 8 flat brush. For the red foliage, combine Raw Sienna with Cadmium Red Medium, Maroon and Chromium Oxide Green. Paint the shadow sides of the yellow trees using Raw Sienna, Burnt Sienna, Titanium White and Chromium Oxide Green. Paint the tree behind the footbridge using combinations of Raw Sienna, Chromium Oxide Green and Burnt Sienna. Paint cast shadows from the foreground bushes and the shadows under the distant tree line using combinations of Raw Sienna, Burnt Umber, Ultramarine Blue, Hooker's Green Deep Hue Permanent and Titanium White.

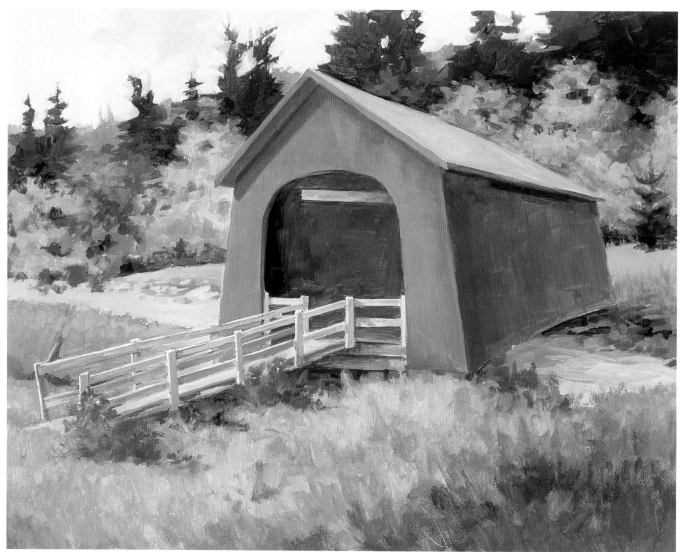

3 Paint the Lights

A Front of the bridge. Use a no. 10 flat brush with combinations of Titanium White, Red Oxide, Cadmium Red Medium and Yellow Oxide. Add a little Burnt Umber to the mixture that goes under the roof.

B Trees. Use a no. 10 flat brush and varying mixtures of Titanium White, Yellow Oxide, Yellow Medium Azo, Raw Sienna and Red Oxide. Try not to overmix your colors. Let the various colors coexist on your brush, and let them fall randomly throughout the foliage areas. For the red sunlit foliage, use Indo Orange Red, Cadmium Red Medium, Yellow Oxide and Titanium White. Use some of the deep evergreen colors from step 2 to create areas within the foliage for the future placement of tree limbs. For the green tree behind the bridge, use Titanium White, Yellow Oxide and Chromium Oxide Green.

C Sunlit bank. Use a no. 8 flat brush with Titanium White, Yellow Oxide, Yellow Medium Azo, Raw Sienna and Chromium Oxide Green. Gradually grade the wash as it approaches the darker rocky areas. Place the light gray rocks on the distant shore with a mixture of Titanium White, Burnt Sienna and Ultramarine Blue.

D Autumn grasses. Use a no. 6 bristle filbert brush, holding the brush midway up the handle and horizontal to your painting surface. With the side of your brush, paint with upward movements from the base of the grass. Start with short strokes in the distance and gradually make the strokes longer as they approach the foreground. Using combinations of Titanium White, Raw Sienna, Yellow Oxide, Red Oxide, Chromium Oxide Green and Hooker's Green Deep Hue Permanent, alternate light and dark values, and warm and cool colors, striving to create texture. Load your brush with a variety of colors and roll the brush as you apply the paint to add variety.

E Water in the stream. Use Titanium White, Ultramarine Blue, Phthalo Blue and Burnt Umber using a no. 8 flat brush.

F Bridge roof. Use Titanium White, Burnt Sienna and Ultramarine Blue. Use Titanium White with a small amount of Raw Sienna to highlight the handrail.

G Sky. Use a no. 8 flat brush and Titanium White, with small amounts of Indo Orange Red and Phthalo Blue.

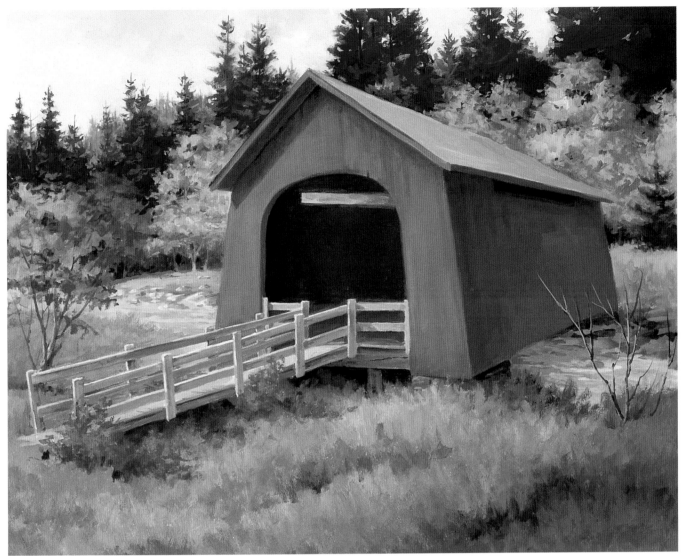

4 Work From Background to Foreground

Except where noted, the same colors used in the first two steps will be used here. Repaint all areas to achieve better coverage, richer color and additional details.

A Sky. Use a no. 10 flat brush to paint the clouds, feathering them into the blue sky. Some of the tree forms will be temporarily lost as you paint the sky.

B Distant tree line. Use a no. 4 round, dragging the paint in an upward motion to indicate tree shapes. For the dark evergreens, use a no. 1 rigger to establish the trunks for some of the trees. From this center point, use the side of a no. 2 round to feather the evergreens into the sky. Paint small areas of the sky into the dark mass to show tree structures.

C Gold and red foliage. Create a lacy effect by painting in small negative shapes. With a no. 2 round, add some tree branches and trunks using the same colors that are in the foliage.

D Grass on the distant shore. Use a no. 8 flat and move down to the rocks, adding more definition to the shapes. Continue by restating the water.

E Another layer on the bridge. Use a no. 10 flat brush. Deepen the value of the underside of the eave on the front of the bridge. Paint the handrails leading to the bridge using a no. 4 flat.

F Grassy areas. Using the no. 1 and no. 6 filberts, create denser color and interesting textures.

G Branches for the bush. Use your rigger with a mixture of Burnt Umber, Ultramarine Blue and Titanium White. When using the rigger, add some water to your mixture so the paint flows off the tip of the brush easily.

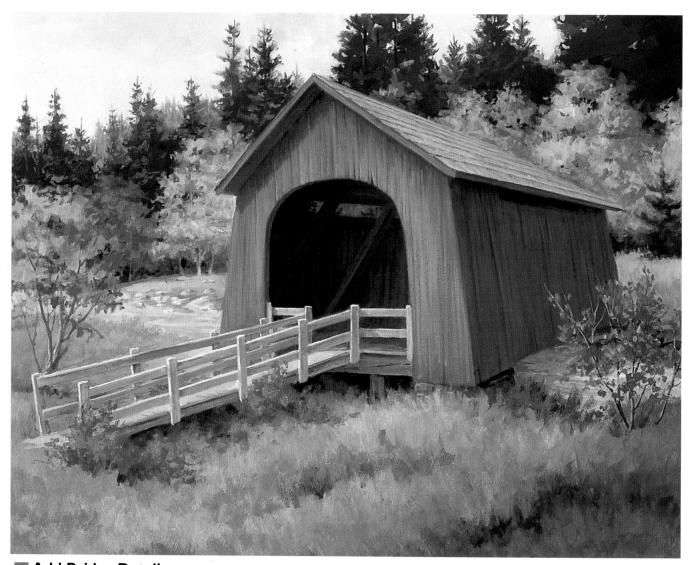

5 Add Bridge Details

A Indicate the boards in the siding. With your rigger, paint the shadow side of the bridge using Burnt Umber, Ultramarine Blue and Titanium White.

B Paint in some of the textures on the front of the bridge. Using Red Oxide, Titanium White and Yellow Oxide and your rigger, suggest boards. Using a no. 4 flat, darken some of the boards as they approach the roof with a thin wash of Burnt Umber.

C Paint the shingles on the bridge roof. Use a no. 2 round and a gray mix of Red Oxide, Ultramarine Blue and Titanium White.

D Paint the internal structure of the bridge. Use a mixture of Burnt Umber, Ultramarine Blue, Maroon and Titanium White,

and a no. 8 flat brush and a no. 4 round. Darken the foliage that shows through the opening in the far side of the interior of the bridge with Hooker's Green Deep Hue Permanent and Raw Sienna.

E Paint the foliage on the bush. Use a no. 2 round and combinations of Yellow Oxide, Indo Orange Red, Cadmium Red Medium, Maroon and Chromium Oxide Green.

F Indicate some lighter branches on the pine trees. Use Titanium White, Hooker's Green Deep Hue Permanent and Ultramarine Blue. Add a few dead trees for interest using your rigger.

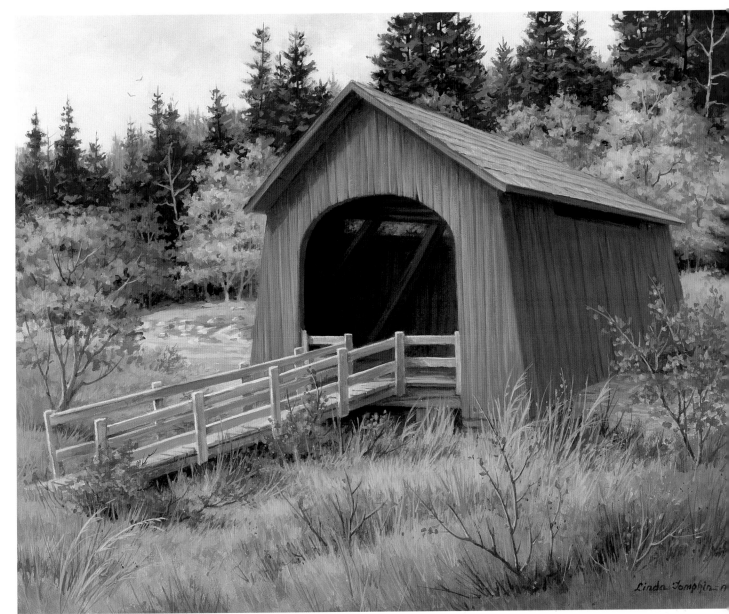

6 Add the Finishing Details

A Continue to refine the distant evergreen area.
With a no. 2 round brush, paint in some lighter areas using Titanium White, Hooker's Green Deep Hue Permanent and Ultramarine Blue. Also, add some darker tree trunks and branches with your rigger.

B Decrease the intensity of some of the foreground red bushes. Use a no. 2 round with a combination of Raw Sienna and Red Oxide.

C Darken the water behind the red bush. Use a no. 4 round brush with less Titanium White in the mixture of Ultramarine Blue and Burnt Umber.

D Add some of the dark branches and grasses. Use a rigger to create these dark shapes out of the darker tones already established, superimposing them over the lighter areas of grass.

E Paint the lighter grass. Bring the tall, light grass out of the light areas already established using Titanium White, Yellow Oxide and Raw Sienna. Start your strokes at the base of the grass. Moving your hand upward, let the paint flow off the brush.

F Warm leaf colors on some foreground branches.
If desired, spatter lights and darks into the foreground grass areas. Using a rigger loaded with very wet pigment, tap your brush against the handle of another dry brush to create the spatters. The closer you hold the brush to the surface, the more control you will have over the spatters.

Starrett Mansion in Mixed Media

BY BARBARA KRANS JENKINS Barbara Krans Jenkins is the definitive detail-oriented artist. She not only researches the visual characteristics of her subjects but also investigates the history, geography and, in this case, construction of her subject.

The result is this amazing ink, watercolor and colored pencil painting of the historic Ann Starrett Mansion in Port Townsend, Washington. By researching the mansion, she was able to add a soaring eagle, common to the region, and a view of Mount Baker.

REFERENCE PHOTOS

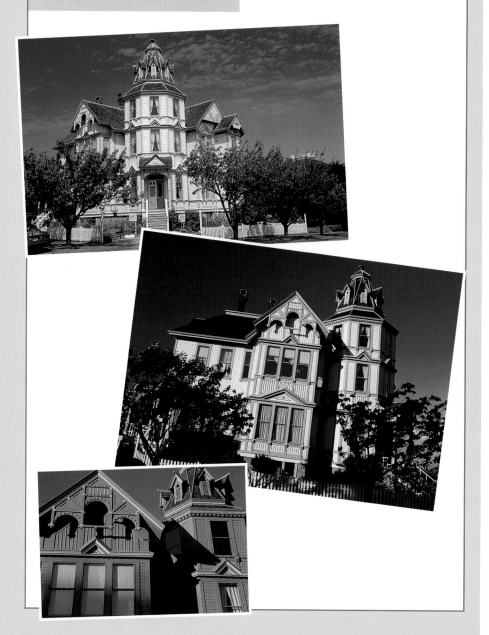

MATERIALS

Surface

Strathmore 500 Series illustration board (100% rag, acid free)

Palette

Colored Pencils
BRUYNZEEL COLORING PENCILS:
Olive Green

DERWENT ARTIST'S COLORED PENCILS:
Mahogany, Spruce Green

DERWENT STUDIO COLORED PENCILS:
Cedar Green

FABER-CASTELL POLYCHROMOS
COLORED PENCILS: Wine Red

PRISMACOLOR COLORED PENCILS:
Apple Green, Black Grape, Blue Slate, Burnt Ochre, Celadon Green, Cream, Dark Umber, French Grey (10%, 20%, 30%, 50%, 70% and 90%), Grass Green, Indigo Blue, Jade Green, Light Umber, Lilac, Marine Green, Mediterranean Blue, Metallic Green, Metallic Tile Blue, Olive Green, Warm Grey 70%, White

Pastels
PRISMACOLOR SEMI HARD NUPASTELS:
305 Spruce Blue

Watercolors
WINSOR & NEWTON ARTISTS'
WATERCOLORS: Neutral Tint, Permanent Sap Green, Prussian Blue

Brushes

1½-inch (38mm) flat

Nos. 6 and 8 rounds

Other

0.51mm Pentel mechanical pencil with 2B graphite lead

Artgum eraser

Black India Koh-I-Noor 3074-F ink

Drafting tape

Krylon workable fixative

Rapidograph Koh-I-Noor mechanical pen

Ruler and T-square

Sakura cordless eraser with white vinyl eraser

Scrap board

1 Lay Out the Composition and Establish Placement

After taping the illustration board to an oversize drawing board, establish the horizon line and perpendicular compositional centerline with a mechanical pencil. Plot vanishing points approximately 21 inches (53cm) right and 19 inches (48cm) left of the centerline, which will continue off the drawing surface. Then, lightly draw the house with a mechanical pencil, taking care that all the shapes are in correct perspective. (Note: The camera always distorts perspective.)

2 Draw the Subject in Ink

With a Koh-I-Noor (6 × 0 mm) pen and black India ink, draw the building and suggest some landscaping contours in freehand over the pencil guide.

Crosshatching & Stippling

Crosshatching is a technique of drawing straight or curved lines of different lengths that cross each other to build a darker area. *Stippling* is a technique of making repetitive dots with the tool point. The closer together the dots are, the more dense or dark the effect.

3 Establish Pen and Ink Values

Using crosshatching and stippling techniques with the pen, establish values and textures in the house and setting. When dry, erase the pencil underdrawing.

4 Apply Color Foundation Using Watercolor

Mix a pool of sky color with Winsor & Newton Prussian Blue and Neutral Tint. Generously wet the board in the sky areas using clean water and a flat brush. Using a no. 8 round brush, apply the pigment from the pool in varying concentrations, along with washes of individual colors so it is darker at the top.

Mix a pool of house base color from Winsor & Newton Permanent Sap Green, Neutral Tint and Prussian Blue, and apply in varying concentrations using nos. 6 and 8 round brushes.

Vary the house base pool color and paint in the landscaping base colors. Allow this to dry.

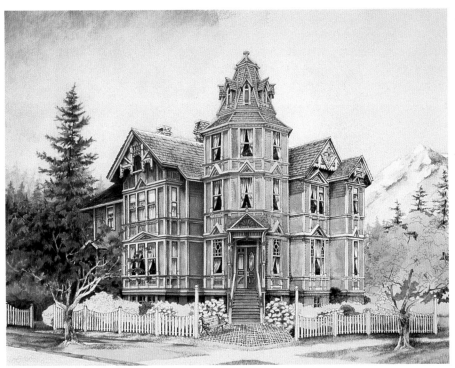

Layering & Burnishing

Layering is a light application of colors that allows the paper surface to show through. Burnishing is achieved by pressing down hard and working in a circular motion to pick up the previously layered colors and blend them into a new color.

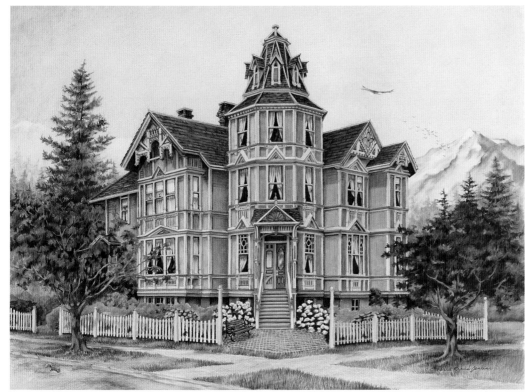

STARRETT MANSION,
PORT TOWNSEND,
WASHINGTON

Barbara Krans Jenkins

12" × 15½" (30cm × 39cm)

5 Colored Pencil Finish

Layer and burnish colors over the watercolor base. Use the scrap board as a hand rest to keep skin oils off the surface. Working from top to bottom, side to side, begin to lay in colors. When finished, spray the completed piece with three light layers of fixative.

A Sky. Use a mixture of all the blues, Black Grape, Wine Red and French Greys, burnishing with White and French Grey 10%.

B Background. For the distant trees and atmosphere, work with layers of all the greens, Metallic Tile Blue, Indigo Blue and French Grey 20%, 30% and 50%.

C Foreground. Start the foreground trees with Apple Green, Olive Green, Marine Green, Celadon Green, Mediterranean Blue and Metallic Tile Blue. Finish the trees with Wine Red, Mahogany, all browns and French Grey 30% and 50%. Burnish with Light Umber, Black Grape, Mahogany, White and French Grey 10% and 20%.

D Middle ground. Layer with Metallic Tile Blue, Mediterranean Blue, Spruce Green and Olive Green, then burnish with French Grey 20%.

E Fence. Burnish with French Grey 10% (in areas getting more light) and 30% (in shaded areas).

F Shrubs. Layer in the shrubs behind the fence with Metallic Tile Blue, Cedar Green and Spruce Green. Burnish with French Grey 20%. For the house shrubs, layer with all of the greens, Metallic Tile Blue, 305 Spruce Blue and Lilac, and burnish with French Grey 10% and White.

G House and base. Use Jade Green, Celadon Green and Metallic Green for the base color. Burnish with White and French Grey 10% and 20%.

H House and trim. Burnish the primary trim color with French Grey 10% and 20% and White. Layer in the secondary house trim and bench colors with a light layer of Metallic Tile Blue and a heavier layer of Spruce Green. Burnish with White and French Grey 10%.

I Accent trim. Use Mahogany and French Grey 20%.

J Window sashes. For the window sashes, use Black Grape and Wine Red. Burnish with French Grey 20%. Use Cream, White and French Grey 10%, 30% and 50% for the shades and drapes. Burnish the openings with French Grey 90%, Warm Grey 70% and Black Grape.

K Roof. Use Black Grape, Warm Grey 70% and all the browns and French Greys.

L Brick walk. Use Mahogany, Black Grape, Burnt Ochre, Dark Umber and all the French Greys for the brick walk and the chimneys.

M Mountains. Use Blue Slate, Black Grape, Metallic Tile Blue and Lilac. Burnish with White and French Grey 10%, 30% and 50%.

N Grass. Use Grass Green, Olive Green and Spruce Green, then burnish with White and French Grey 10% and 30%.

O Animals. For the eagles, birds and squirrels, use all the browns, Warm Grey 70% and French Grey 30%. Use an electric eraser to remove sky pigment and expose the paper surface for the heads and tails of the eagles, then add the birds.

7 REFLECTIVE and TEXTURED SURFACES

One of the most difficult challenges any painter faces is the accurate depiction of reflective or textured surfaces. Whether attempting to create the reflections on a body of water, a piece of metal or a glass object, you'll need to pay close attention to the relationship between your subject and the light source. Adding texture to the objects in your paintings also requires an understanding of light and shadow. The best way to approach painting such surfaces is to closely examine the subject at hand. Taking reference photos provides you with ample time to study the nature of your subject's surface, ultimately ensuring better accuracy in your paintings.

Choosing the right lens is particularly important when photographing reflective or textured surfaces. Reflections are best photographed with telephoto zoom lenses with focal lengths of 100mm or greater, as you'll need to stand a considerable distance from your subject. Conversely, textures usually require the use of a macro lens designed for close-up work and capturing details. These lenses are generally available in two fixed focal lengths: a 50mm standard focal length and a 100mm short telephoto length. Always make sure you choose the appropriate lens for the task at hand before you begin taking pictures.

In this chapter you'll practice creating a myriad of surfaces. You'll paint the sparkling reflective surface of the ocean as well as the sleek and smooth texture of a porcelain pitcher. You'll also have the chance to create the natural textures of bark and wood. Work through the following demonstrations, then find other reflective and textured surfaces to paint to further develop your skills. With practice and patience, you'll learn to portray surfaces of all kinds.

Seattle Reflections in Mixed Media

BY BEVERLY FOTHERINGHAM On a clear December day, Gary Greene was out shooting material for another book, *Artist's Photo Reference: Boats & Nautical Scenes*, when he came across this scene at a local marina. Not only did he find a perfect subject for this book, depicting reflections and the texture of the water, but he also knew who should paint it: Beverly Fotheringham. Having seen her work at a local gallery several months prior, Gary knew she would create a stunning work.

REFERENCE PHOTO

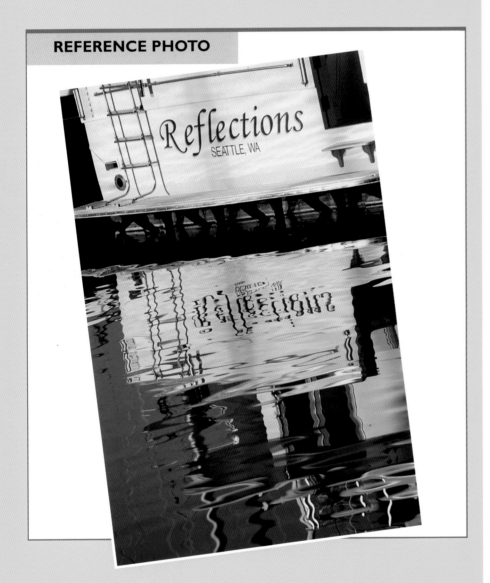

MATERIALS

Surface

260-lb. (550gsm) cold-press watercolor paper

Palette

Colored Pencils
PRISMACOLOR COLORED PENCILS: Light Cerulean Blue, Light Umber, Parma Violet, Periwinkle, Sienna Brown, Terra Cotta, Tuscan Red, Warm Grey 50%

Watercolor Pencils
DERWENT WATERCOLOR PENCILS: Blue Grey

Watercolors
DANIEL SMITH EXTRA FINE WATERCOLORS: Carbazole Violet, Cobalt Blue, Indanthrone Blue, Manganese Blue Hue, Napthamide Maroon, Phthalo Blue, Quinacridone Burnt Orange, Quinacridone Burnt Scarlet, Quinacridone Coral, Quinacridone Gold, Sepia, Ultramarine Blue

Brushes

Nos. 0, 2, 4, 6 and 8 synthetic rounds

No. 1 flat hog bristle

Other

2-inch-wide (5cm) transparent tape

Airbrush and compressor

Ballpoint pen

Gator board

Graphite paper

Green low-tack tape

H pencil

Liquid frisket

Opaque projector

Paper towels

Shampoo

Tracing paper

Waterproof Black India ink

White plastic eraser

Winsor & Newton Bleed-proof White

Draw the Layout

Photocopy the original photograph to use as a value study and from which to project the image onto the tracing paper. Once you have determined the overall size of your image, tape the watercolor paper to the Gator board using the 2-inch-wide (5cm) transparent tape. Be careful to retain a border on all sides.

Project the photocopied image onto the tracing paper using the opaque projector. Using an H pencil, draw the image onto the tracing paper.

Position the tracing paper on top of the watercolor paper using the green low-tack tape to hold it in place. Be careful to align the image within the work space you have predetermined.

Use the graphite paper to transfer the image from the tracing paper onto the watercolor paper. Use the ballpoint pen to trace over the pencil lines and transfer the image.

Remove the tracing paper. Smooth out any lines that need adjusting. Use the white plastic eraser to eliminate any smudges or unwanted lines.

2 Fill in the Darkest Areas With Black India Ink

Outline the darkest areas with black India ink using a no. 0 brush. Fill these areas in with a no. 4 or no. 8, depending on the size of the area.

Protect the areas you want to keep white—like the rippled vertical lines in the water and the highlighted spots on the stern—with liquid frisket. Begin by dipping the no. 1 flat hog bristle brush in the shampoo (this will protect your brush from damage and makes cleaning the brush much easier). Be sure to completely rinse out your brush when finished with this step.

It is essential that the black India ink and the liquid frisket be allowed to dry thoroughly before beginning any further steps. Never use a hair dryer to force dry the liquid frisket.

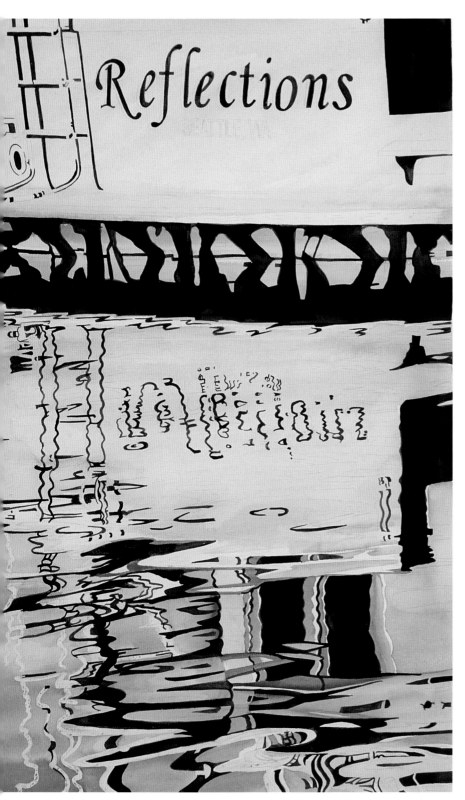

3 Paint the Underlying Washes

Wet the surface of your work area with clear water to begin the process of layering overall washes using Manganese Blue Hue, Indanthrone Blue, Phthalo Blue and Ultramarine Blue. Start at the bottom with the darkest blue—Indanthrone Blue—and work from the darkest to the lightest hues using a no. 12 brush. Working wet-into-wet allows you to blend the entire range of blues with a series of soft, parallel strokes. The result is a mirror-like quality of the water's surface.

Paint very light wet washes onto the stern of the boat. Use the Quinacridone Burnt Orange, Quinacridone Burnt Scarlet, Quinacridone Gold, Carbazole Violet and Cobalt Blue. Apply these colors to the wet surface and blend them into a very thin glaze of color. Paint the reflection of the boat with matching thin glazes, working wet-into-wet.

After the washes are thoroughly dry, use the no. 6 brush to bring the first layer of color into the lower third of the painting with Quinacridone Gold, Quinacridone Burnt Orange, Quinacridone Burnt Scarlet, Cobalt Blue and Quinacridone Coral.

4 Paint the Second Wash Layers and Preliminary Detail

To create various shades of brown in the boat's reflection, combine the Quinacridone Burnt Orange with the Carbazole Violet. The ripples are actually very small graded washes. Blend the color into a hard-edged oval with a no. 4 brush, then touch a wet no. 6 brush to the center of the oval to dilute the pigment.

With a no. 2 round brush, add detail to the ladder and the swimmer's deck by layering Cobalt Blue, Indanthrone Blue, Carbazole Violet and Quinacridone Burnt Orange into the shadowed area under the stern of the boat. Use the airbrush to darken the blue water with a combination of Indanthrone Blue, Carbazole Violet and Cobalt Blue.

After this is complete, return to the reflections on the water. Add more color with a no. 2 brush, concentrating initially on the reddish highlights using Quinacridone Coral and Quinacridone Burnt Scarlet.

For the darker portion of the painting—the ripples in the lower right—add layers of color using the full range of blues and violets from the palette with the no. 4 and no. 6 round brushes. This results in a richness of color impossible to create without layering multiple hues over each other. Use a thin glaze of Cobalt Blue, Carbazole Violet and Indanthrone Blue over the Quinacridone Gold, Quinacridone Burnt Orange and Quinacridone Burnt Scarlet.

Next, add reddish accent color to the boat's reflection using Quinacridone Coral with a no. 0 brush.

Look at the reference photo and you'll see that the word *Reflections* has a shadow to give the word relief. To paint this, lay in hard-edged color along the lettering using a no. 0 brush. Dip the no. 2 brush in clear water and stroke the brush parallel to the lettering to create a faded wash. The colors used include Quinacridone Gold, Cobalt Blue, Carbazole Violet, Quinacridone Burnt Orange and Quinacridone Burnt Scarlet.

Using a no. 2 brush, paint in the words SEATTLE, WA on the

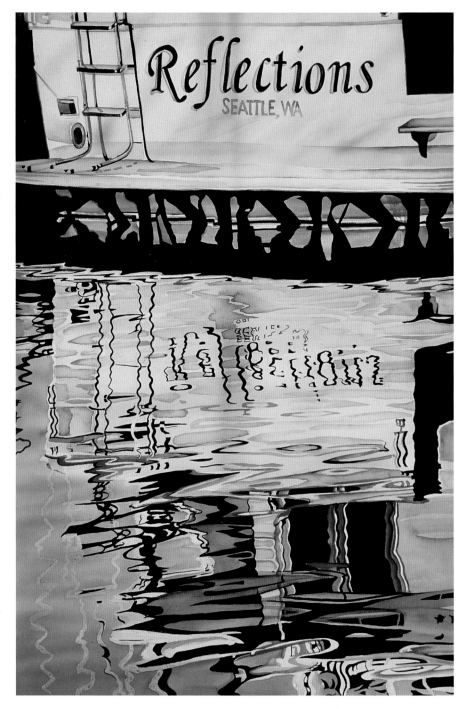

stern using a mixture of Quinacridone Burnt Scarlet, Indanthrone Blue and Napthamide Maroon. Blend the paint into a graded wash, the lighter shades at the bottom of the letters, the darker shades at the top.

Mix Carbazole Violet and Quinacridone Burnt Scarlet into a very diluted solution with clear water for use in the airbrush. Using the airbrush, apply a very light glaze over the central vertical region of the painting (through the *flec* and *SEATT* lettering down into the reflection of the vessel).

5 Add the Final Details

Remove the frisket that has been protecting the white areas. Now paint these areas with a combination of Indanthrone Blue and Napthamide Maroon, with just a touch of Quinacridone Burnt Orange.

Lay in the dark gray areas hidden in shadow under the swimmer's platform of the boat using a no. 4 brush. Use colors darker than you want—for instance Carbazole Violet, Cobalt Blue, Indanthrone Blue and Naphthamide Maroon—to layer the ripples toward the bottom of the painting. Then remove much of the pigment with a stroke of clear water. Detail the swimmer's deck using Carbazole Violet, Cobalt Blue, Quinacridone Burnt Orange, Quinacridone Burnt Scarlet and Sepia. With a no. 4 brush, create a hard line blended to a graded wash.

At this stage, bring in the colored pencils to detail the black, inked-in areas. Beginning in the upper right corner of the painting, apply Derwent Blue Grey and the Prismacolor Periwinkle and Parma Violet pencils to lighten the details of this shadowed area. The addition of color softens the solid black areas.

Use the Prismacolor Parma Violet and Sienna Brown to render the detail on the step bracket. For the area under the swimmer's platform, use Prismacolor Sienna Brown, Terra Cotta, Tuscan Red, Warm Grey 50%, Light Cerulean Blue and Light Umber pencils. Repeat these color combinations in the reflections.

In the photo, more of the boat is revealed in the reflection. Use all of the colored pencils and the watercolor pencils listed in the materials list to create the reflection of the cabin and the superstructure. Blend each individual area into combinations of color that fade from dark to light.

To create the bright highlights, use the Winsor & Newton Bleed-proof White in small dots and areas throughout the water surface, and in the center few inches of the line that stretches across the stern of the boat.

To finish the painting, use a no. 1 flat hog bristle brush dampened with clear water to remove pigment in selected locations, such as the stern of the boat. Scrub out the color and blot up the moisture using paper towels. This reductive technique provides a very realistic sheen to the reflective surfaces.

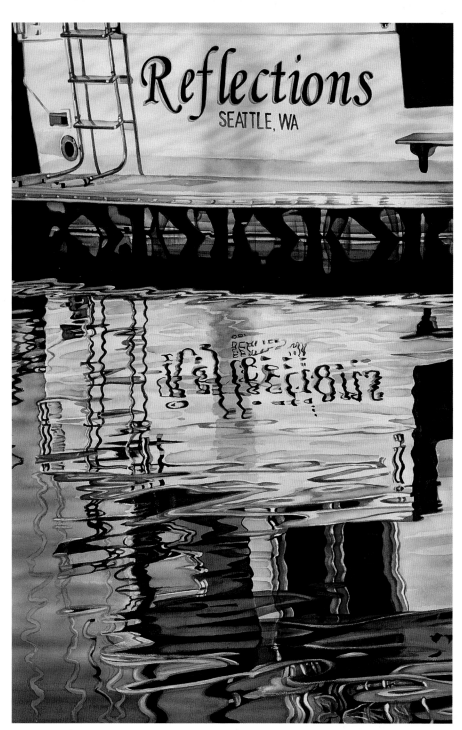

SEATTLE REFLECTIONS
Beverly Fotheringham
25" × 17" (64cm × 43cm)

Memories in Mixed Media

BY PIA MESSINA One of Pia's favorite places for shooting reference photos is the historic old town of Port Townsend, Washington. On a recent visit, she took a tour of the Rothschild House, one of the many faithfully restored homes.

Taking advantage of the soft natural light, she placed her camera on a tripod and photographed this "found" still life, among several other prime reference photos. With careful cropping and the omission of some unnecessary details (such as the busy wallpaper), talented artist Pia Messina used several mediums to turn the scene into an exciting impressionistic artwork.

REFERENCE PHOTO

MATERIALS

Surface

24 × 18-inches (61cm × 46cm) 140-lb. (300gsm) Arches watercolor paper

24 × 18-inches (61cm × 46cm) 100% rag drafting paper

24 × 18-inches (61cm × 46cm) graphite transfer paper

Palette

Colored Pencils
CARAN D'ACHE PABLO COLORED PENCILS: Burnt Sienna, Dark Green, Indigo Blue, Purplish Red, Ruby Red

PRISMACOLOR COLORED PENCILS: White

Watercolors
HOLBEIN ARTISTS' WATERCOLORS: Jaune Brilliant no. 2

WINSOR & NEWTON ARTISTS' WATERCOLORS: Alizarin Crimson, Burnt Sienna, Cadmium Red, Cobalt Blue, French Ultramarine, Indigo, Permanent Rose, Raw Sienna, Winsor Green

Brushes

2-inch (51mm) Japanese hake

Nos. 4 and 16 rounds

Other

4 bulldog clips

Elephant ear sponge

Gator board cut 1 inch (3cm) larger all around the watercolor paper

Golden gesso (white)

Golden gel (gloss)

HB graphite pencil

Paper towels

Tombo ABT N25 black pen/brush

Draw the Layout

Photocopy the reference photo. Draw a grid on the photocopy with the Prismacolor White colored pencil. With the HB graphite pencil, draw a grid on the drafting paper proportional to the one on the photocopy. Use the grids to compare as you draw an enlarged image of the subject on the drafting paper.

Lay the graphite transfer paper on the watercolor paper, then lay the drafting paper on top. Go over the image on the drafting paper with the graphite pencil, pressing lightly so the image is duplicated on the watercolor paper.

2 Underpaint the Middle Values

Clip the watercolor paper to the Gator board with bulldog clips. Tilt the board at a 30-degree angle. Wet the paper a few times with the elephant ear sponge to remove the paper's protective sizing. Let dry.

Lay down a coat of white gesso with random strokes to emphasize texture. Let dry.

Lay a wash of Cobalt Blue with a touch of Burnt Sienna on all the middle value areas using the hake brush. Be careful to save the highlighted areas. Let dry. Paint a thin wash of Golden gel diluted 50 percent with water and allow to dry. The wash of Golden gel will make the paper a little slippery, so corrections will be easier to make.

3 Add Darker Values

Lay a wash of Cobalt Blue and Burnt Sienna on the background areas, the pitcher's side and handle, and the mirror. Using the same wash with a little Indigo added, darken the contour of all the objects' bases and the rims with a no. 16 round brush. Paint the front area of the marble top with Permanent Rose and Raw Sienna. Leave the reflecting areas on the pitcher and glass white. Paint the shadowed areas on the marble top Permanent Rose, Raw Sienna and French Ultramarine. Wet the wood on the side of the dresser lightly with the hake brush, then paint it with Permanent Rose, Raw Sienna, French Ultramarine and Indigo. With a mixture of French Ultramarine, Burnt Sienna and Alizarin Crimson, paint the mirror stand. Let dry.

Paint the two flowers: one Cadmium Red, the other Permanent Rose. Paint a flower on the pitcher with Alizarin Crimson, Winsor Green and Raw Sienna. Paint the drawer knobs and cabinets. Let everything dry.

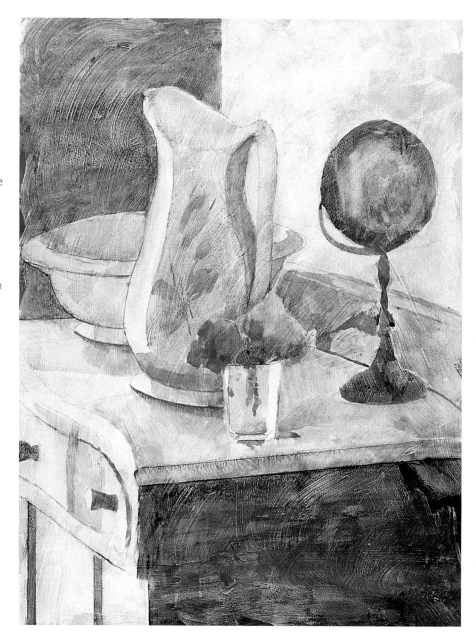

4 Add Details

Paint a wash of Jaune Brilliant no. 2 on the lighter portion of the wall and do the same on the front of the dresser. Let dry.

Color dark areas of both flowers with Alizarin Crimson. To emphasize the rose stems between the flowers, use the Dark Green colored pencil. Accent the lighter leaves with Raw Sienna watercolor.

On the mirror, detail the reflections of the pitcher handle and some red from the flowers with Burnt Sienna, Purplish Red and Ruby Red colored pencils. Add texture to the marble in the back with Indigo Blue. When everything is completely dry, outline all the shapes with the black pen to convey a feeling of the human touch.

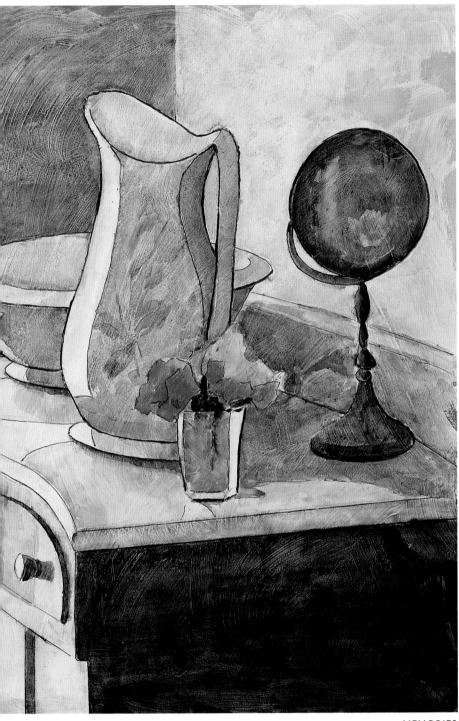

MEMORIES
Pia Messina
24" × 18" (61cm × 46cm)

Final Resting in Oil

BY LIANA BENNETT In this great painting by Liana Bennett lies a tale of two national parks: The image of the burled tree trunk was snapped in Olympic National Park, and the mountain lupine, in Rainier National Park, both in Washington.

The burled trunk presents a fascinating texture study, but its surroundings are banal. To liven the scene, Liana decided to add the lupine from the other reference photo. She cut and pasted and used the cloning tool in Photoshop. Although the process was a bit time-consuming, the resulting reference photo is a considerable improvement over the original.

MATERIALS

Surface

18 × 24-inch (46cm × 61cm) Fredrix canvas panel

Palette

WINSOR & NEWTON GRIFFIN ALKYDS (FAST-DRYING OIL PAINTS): Burnt Sienna, Cadmium Red Light, Cadmium Yellow Deep, Cadmium Yellow Light, French Ultramarine, Permanent Alizarin Crimson, Phthalo Blue, Titanium White

Brushes

⅛-inch (3mm) badger flat

2-inch (51mm) housepainting brush (for applying gesso)

Nos. 2, 6 and 8 natural bristle filberts

No. 4 sable round

Other

Daniel Smith Venetian Red Acrylic Gesso

Krylon Kamar spray varnish

Odorless Turpenoid

Palette mixing knife

Paper towels

Stick of white chalk

Winsor & Newton Liquin for oil and alkyd

REFERENCE PHOTOS

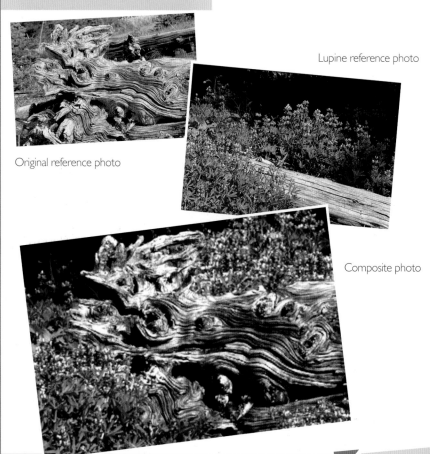

Lupine reference photo

Original reference photo

Composite photo

Helpful Hints for Using Alkyds

- Store alkyds in a cold place, such as a refrigerator or freezer.
- Any medium that is used for standard oils can be used with alkyds, but media such as linseed oil will retard drying time.
- To accelerate drying time, place your painting in a warm area.

Sketch the Layout

Use a standard house paintbrush to apply a single coat of red gesso to the canvas panel. Let dry.

Sketch a few preliminary drawings before chalking the final layout on the gessoed canvas. Keep the lines and shapes loose and abstract.

2 Block in Shapes

Once this is complete, prepare your paints. Mix French Ultramarine and Burnt Sienna to create a black that easily changes into a warm or cool color.

Block in various shapes and values using Liquin and Odorless Turpenoid to thin and lighten the color.

In addition to the black mix, you will need to create a purple mixture and a white mixture. For the purple, combine Permanent Alizarin Crimson, French Ultramarine and a touch of Cadmium Yellow Deep. Make the white mix, consisting mostly of Titanium White with light touches of French Ultramarine, Permanent Alizarin Crimson and Cadmium Yellow Deep.

3 Paint the Background, Define the Wood

Using your no. 8 filbert brush and the black mix, add just enough Cadmium Yellow Light to make a deep green. Add Titanium White and more Cadmium Yellow Light to suggest leaves and stems.

Next, use the purple mixture with a touch of Titanium White under the flower areas. Add more Titanium White to enhance the light on the flowers.

For the darkest shapes and lines in the wood, use the no. 4 round brush and the black mix. Be sure to find the "movement" in the wood. Spread your paint thickly for dark shapes.

Using the same brush and the white mix, paint the lightest areas of the wood. Add touches of purple mix to create middle to light values in the wood. Now the painting has values ranging from darkest to lightest, and you can compare all the other color values to these high contrasting hues.

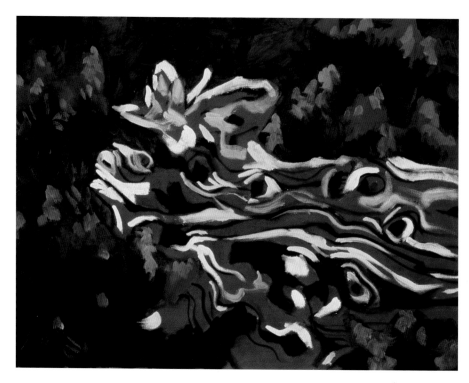

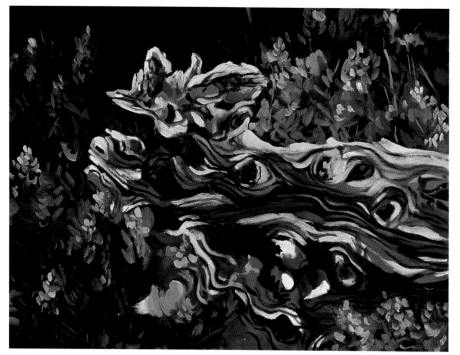

4 Detail the Wood, Background Flowers and Leaves

To add fullness to the flowers, pick a brush that matches the strokes you need. Use the purple mixture to paint the flowers, adding Titanium White, Permanent Alizarin Crimson or French Ultramarine to change the hue to pink or blue. This will add variety and depth to the flowers.

For the leaves in the background, use the black mix as the base. You can add more Cadmium Yellow Light, Titanium White, Phthalo Blue or French Ultramarine as necessary to give several green hues to the leaves, but be sure to leave some dark hues to create depth.

Look for warm areas on the wood, using Burnt Sienna and a no. 2 round brush to note these areas. Next, to tone down and lighten the purple mix, add the white mix. Place this color between the dark lines. It's OK if some blending occurs. Add more detail to the wood with the ⅛-inch (3mm) badger flat and black paint mix. Adjust black shapes in the wood if necessary.

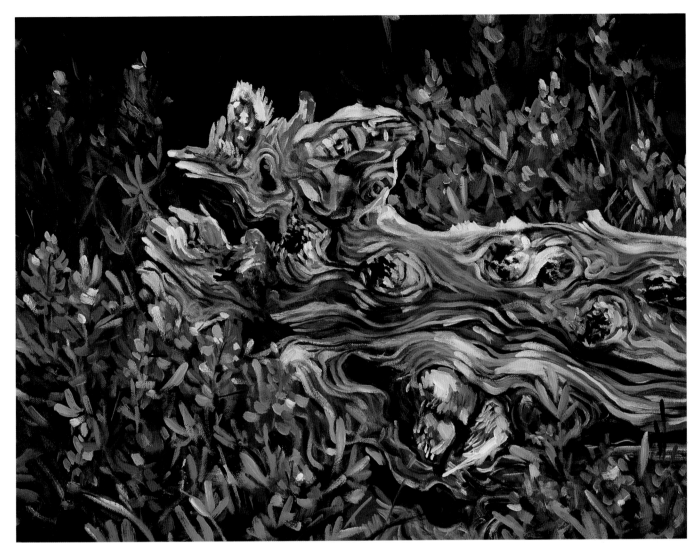

5 Add the Finishing Touches

Starting in the area behind the wood, use the purple mix to add smaller shapes and lighter values to the flowers with the ⅛-inch (3mm) badger flat or the no. 4 round brush. Keep the stronger lights on top and vary the hues to create a more natural look. Use more French Ultramarine, Permanent Alizarin Crimson or Titanium White as necessary.

To highlight the leaves, combine Cadmium Yellow Light and Titanium White with the black mix. Change the hue of the black mix by adding Cadmium Yellow Light, Cadmium Red Light, Phthalo Blue or Titanium White to add variety to the greens for the leaves and stems.

Before finishing the wood, mix together two new colors— blue-gray (mix Titanium White with the black mix) and soft gray (add Titanium White and a touch of Cadmium Yellow Deep with

the purple mix). Add touches of Burnt Sienna or Cadmium Red Light to the white mix to create a wide range of colors in which to finish your wood.

Paint with a detail brush to add small areas of detail, such as the protruding nubs of wood. Blend some areas and leave others sharp to add extra dimension.

Wait 24 hours for everything to dry. After your painting is dry, apply two thin coats of Krylon Kamar spray varnish in a well-ventilated room.

FINAL RESTING
Liana Bennett
18" × 24" (46mm × 61mm)

The White Doorknob in Acrylic

BY STEVE WHITNEY With the use of acrylic molding paste, Steve Whitney created a very lifelike bas-relief of the stone in the composite reference photo below. If you run your fingers over the painting, you would swear it is the real thing.

He came upon the stonework while searching sites for reference photos in Tucson, Arizona, a few years ago. When he took the photo, Steve realized that regardless of how the image was used, he would have to lighten or eliminate the dark shadows around the deeply recessed door, and that the door, even though it had a weather-beaten look, could be replaced with something more appealing. Three years and many doors later, he came across the perfect door, part of an old garage in Mendocino, California.

To create the reference photo in Photoshop, Steve flopped the stonework horizontally because he felt it would make a better composition. Then he relocated the doorknob by cutting and pasting it in place and cloning areas around it to hide any seams. He also re-moved the glare on the door jamb by adjusting the output levels and cloning darker areas over the highlight. With a few adjustments, the two altered images came together for the final composition.

MATERIALS

Surface

Crescent cold-press watercolor board

Palette

DANIEL SMITH ULTIMATE ACRYLICS:
Quinacridone Gold, Quinacridone Sienna

GOLDEN FLUID ACRYLICS: Dioxazine
Purple, Hansa Yellow Light, Payne's Gray,
Titanium White, Transparent Yellow Iron
Oxide

GOLDEN HEAVY BODY ARTIST ACRYLICS:
Cadmium Red Light, Cadmium Yellow Light,
Cerulean Blue Chromium, Titanium White,
Ultramarine Blue, Ultramarine Violet

Brushes

⅝-inch (16mm) bright

⅞-inch (22mm) flat

No. 4 round

Other

1-inch (25mm) putty knife

2B graphite pencil

Clean kitchen sponge

Golden Acrylic Gesso

Golden Acrylic Molding Paste

Hair dryer

Kneaded eraser

Masterson Sta-Wet palette, butcher tray or
sheet of safety glass

Plastic or canvas tarp or newspaper

SimAir original frisket film, matte finish

Small craft or utility knife

Small natural sponge

Spray bottle with setting for fine mist

Spray fixative

Straightedge

Thick, absorbent paper towels

REFERENCE PHOTOS

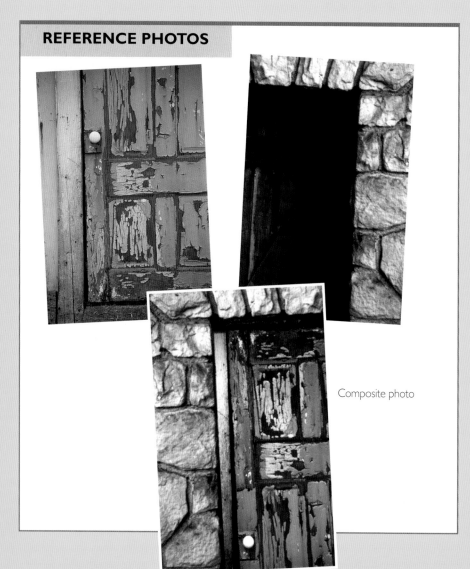

Composite photo

1 Draw the Subject

Lay out the painting with a 2B graphite pencil. Use a straightedge to draw the long straight lines of the door frame. Sketch the stones and boards freehand. Use something round, like the bottom of a Golden Fluid Acrylic bottle, to trace the shape of the door knob. When you are done with the drawing, use the kneaded eraser to clean up smudges. Spray the finished drawing with fixative and allow it to dry before continuing.

2 Build up the Stone Wall and Mask the Door

Use your putty knife to apply a layer of acrylic molding paste between 1/16 inch (2mm) and 1/8 inch (3mm) thick to the shapes of the stones. Try to follow the edges of the stones, but don't worry about being too precise. A small palette knife is useful for getting the paste into tight corners. Use the putty knife to scrape back unwanted molding paste from the mortar channels between the stones. Finish building each stone by lightly troweling the shape with the flat of the putty knife blade. Take care not to overwork the surface. Set the painting aside and allow the molding paste to dry completely.

When the molding paste has hardened, mask the doorway portion of the painting with frisket film. A small craft knife works well for cutting the film. Overlapping sheets of film is fine.

After applying the frisket film, turn the painting over and apply two coats of gesso to the back of the watercolor board to minimize warping. Allow it to dry completely.

3 Underpaint the Stone Wall

Spread a tarp or newspapers on the floor and lay the painting face up in the middle. The tarp should be large enough to protect the floor from accidental spattering. Make sure all the bottles of fluid acrylics listed in the materials list are within easy reach, with their small, flip-up caps open and ready to go. Fill your spray bottle and water container with clean water and have them close at hand, along with a damp sponge and plenty of paper towels.

Use your spray bottle to liberally mist the unmasked stone wall. Squeeze various combinations of all the fluid acrylic colors onto all the stones, allowing different colors to mingle. You can roughly follow the color scheme shown in the photograph to the right, or make your own. It is not necessary to entirely cover the stones. Thin lines of paint will do the job.

Immediately spray the paint with water, so that it begins to spread freely. Use your kitchen sponge to help move paint around, to remove paint and to add texture. Use dry paper towels for the same purpose. The goal is to create thin, general patterns of textured color. You will add the finishing touches later. Spray as needed to keep the paint wet and workable. Add more paint if you like and continue spraying, sponging, wiping off and adding more paint until you are satisfied.

Use your hair dryer to completely dry the rock area. Put away your fluid acrylics. The rest of the painting will be done with Golden Heavy Body Artist Acrylics and Daniel Smith Ultimate Acrylics.

4 Underpaint the Door

For the door panels, create four color mixtures—dark reddish brown (Quinacridone Sienna and a little Ultramarine Blue), light reddish brown (the dark reddish brown mix and Titanium White), muted blue-green (Cerulean Blue Chromium, Cadmium Yellow Light, Titanium White and a touch of Cadmium Red Light), and creamy yellow (Cadmium Yellow Light, Titanium White and a touch of Ultramarine Violet).

Paint the rectangular door panels boldly and loosely with the mixtures above. Use your ⅞-inch (22mm) flat brush for the large areas and your no. 4 round brush for the dark, narrow crevices bordering the panels. Indicate the basic color patterns in the door but don't worry about specific details at this point.

Paint the door frame with your ⅝-inch (16mm) flat brush. Paint the horizontal part of the door frame with the dark reddish brown mixture. Paint the vertical part of the door frame with a mixture of Ultramarine Violet, Titanium White and a touch of Quinacridone Gold.

Paint the brass plate around the doorknob with a mixture of Quinacridone Gold and a touch of Ultramarine Violet. For the lighter portion of the brass plate, lighten this mixture with a little Titanium White.

At this stage, the only white paper showing should be the doorknob.

5 Refine the Stones and Crevices

For the stone detailing you'll need to mix up a pale violet (Titanium White with a little Ultramarine Violet and even less Cadmium Yellow Light), pale gold (Titanium White with a little Cadmium Yellow Light and even less Ultramarine Violet), dark reddish brown (Quinacridone Sienna and a little Ultramarine Blue) and dark gray-green (Ultramarine Blue, Quinacridone Gold, a little Ultramarine Violet and a touch of Titanium White). Apply the colors sparingly with a small natural sponge to make the stones darker in some places and lighter in others. Don't make your dark areas too dark, and take care to let the underpainting peek through. The goal is a thin, mottled effect, characteristic of granite.

For the mortar channels between the stones, mix Quinacridone Gold, Quinacridone Sienna and a touch of Ultramarine Blue to create a dark ochre. Using your no. 4 round brush, apply this paint to the narrow lines of mortar between the stones. Use dark reddish brown to indicate shadows along the edges of the stones.

Add a little Quinacridone Sienna to Ultramarine Blue to create a cool, near-black for the crevices. If the mixture appears too blue, add a little Cadmium Red Light to warm it. Apply this mixture with the no. 4 round to the darkest areas in the crevices between the stones, in the door frame and in the door proper. Drag thin lines of this color over the horizontal part of the door frame to create the effect of wood grain.

Create the reflective shine on the upright part of the door frame by applying pale gold (see mixture above) with the wadded corner of a dry paper towel. Daub color thickly to the place where the reflection is strongest, then push the paint upward and downward along the door frame to create smooth transitions. After the reflection dries, use a paper towel to rub a thin layer of Ultramarine Violet over the outer edges of the reflection, as needed, to make the transition gradual. Also working with a towel, rub a thin coat of Quinacridone Gold over the remainder of the upright to reduce the intensity of the violet.

Mix a thick, creamy white by adding a touch of Cadmium Yellow Light to Titanium White. Use your no. 4 round brush to paint the entire doorknob. When the white is dry, paint a thin crescent of Cerulean Blue Chromium along the bottom of the doorknob and a hint of color to the brass plate.

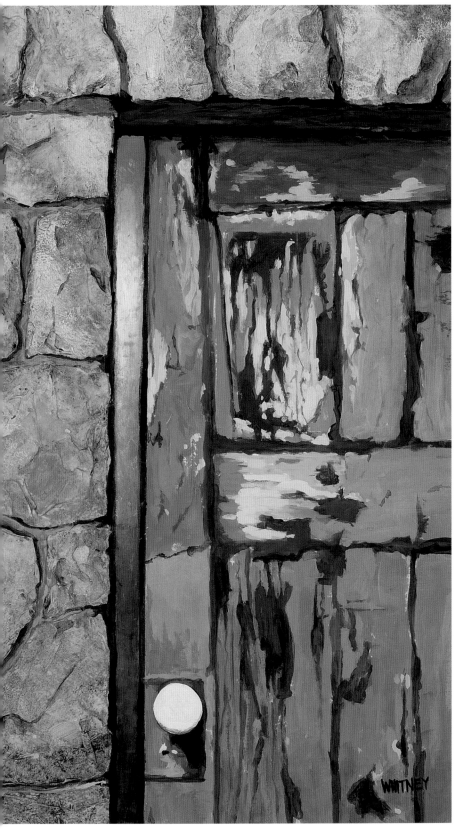

6 Add the Final Touches

Use a natural sponge to adjust the colors in the stones, applying one or more of the color mixtures used in the previous step for this area.

Use your no. 4 round brush to restate or modify the mortar channels between the stones, reinforce the shadow lines along the edges of the stones, introduce additional shadow lines along ridges and crevices within the stones, and darken the crevices along the door frame.

Add a tiny touch of Cadmium Yellow Light to a small pile of Cerulean Blue Chromium with your no. 4 round brush. Add enough Titanium White to create a pale blue-green. Keep the mixture thick. Use your no. 4 round brush to add a few small touches of this color to various spots on the door panels. Also add thick notes of muted blue-green and creamy yellow (see the mixtures in step 4) to already existing areas of those colors to indicate less weathered areas of paint.

THE WHITE DOORKNOB
Steve Whitney
27 ½" × 18" (70cm × 46cm)

Arcs, Radii and Rectangles in Colored Pencil

BY GARY GREENE Gift shops—so-called tourist traps in particular—are excellent sources for reference photos. During a recent business trip, Gary Greene could not help but notice such an establishment on the main highway of the town he was staying in. After passing by it several times, he decided to stop in and see what he could find.

It turned out to be a virtual treasure trove. Gary found, among other interesting items, clay pots, serapes, weather-beaten wood artifacts and several old wagon wheels in varying states of erosion. One of his favorites is the image you see here. Unfortunately, there was a tree nearby casting dappled shadows on the scene, something Gary did not want to include in his painting.

Gary wanted to see what the image would look like without the shadows, so he scanned the photo and opened it in Photoshop, where he used the rubber stamp and cloning tools to remove the shadows cast by the tree. He also changed the composition by flipping the wagon wheel's hub from the right bottom corner to the left bottom corner.

MATERIALS

Surface

300 lb. (640gsm) cold-press watercolor paper

Palette

FABER-CASTELL ALBRECHT DÜRER WATERCOLOR PENCILS: Burnt Ochre, Dark Cadmium Yellow, Dark Chrome Yellow, Ivory, Light Flesh, Terracotta, Van Dyck Brown, Warm Grey II, Warm Grey III

FABER-CASTELL POLYCHROMOS COLORED PENCILS: Burnt Ochre, Burnt Sienna, Dark Sepia, Terracotta, Van Dyck Brown, Warm Grey I, II, III, V, VI

PRISMACOLOR COLORED PENCILS: Dark Umber, Light Umber, Pumpkin Orange, Sienna Brown, Terra Cotta, Tuscan Red, Warm Grey 90%

Brushes

Nos. 8 and 10 rounds

Other

2B graphite pencil

Compass with beam extension and 2B graphite lead

Cotton balls

Cotton swabs

Electric pencil sharpener

Kneaded eraser

Koh-I-Noor imbibed eraser

Metal straightedge

Paper towels

Plastic circle template

REFERENCE PHOTOS

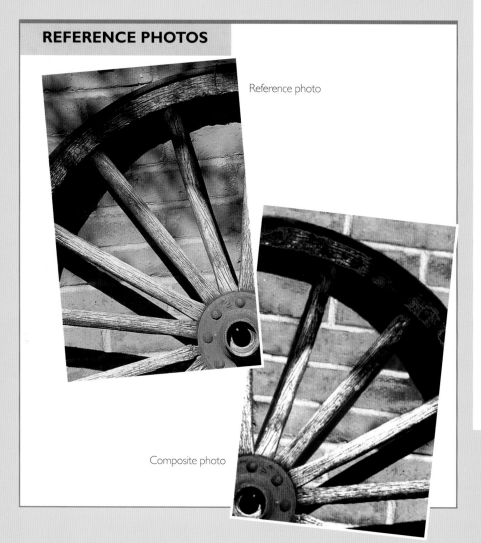

Reference photo

Composite photo

Prepare the Layout

First, roughly lay the painting out with a 2B graphite pencil, then make a tighter layout over this with a pencil, straightedge, compass with beam extension and circle templates to correct photographic distortion. Lay the painting out a third time with Albrecht Dürer Dark Chrome Yellow and Warm Grey lines drawn next to the graphite lines. Remove the graphite lines with a kneaded eraser, leaving light colored pencil lines.

2 Underpaint With Water-Soluble Colored Pencils

Underpainting colors the paper with minimal impact on the paper's tooth, which in turn allows various textures to be created. Water-soluble colored pencils, like the Albrecht Dürer pencils used in this step, will produce a mottled look in the underpainting which will help enhance textures. To maintain a consistent coverage of pigment, keep pencils well-sharpened.

Begin with the wood spokes and wheel, lightly layering Light Flesh and Ivory lengthwise along the spokes and wheel. Carefully wipe with a cotton ball to remove some of the pigment, producing a lighter underpainting. Next, dissolve the pigment with water, using a no. 10 round brush and the same lengthwise stroke used to lay the color down. Once this area is dry, move on to the mortar.

For the sunlit mortar, use Warm Grey II, layering the area unevenly with circular strokes. Apply water with a no. 8 round watercolor brush; this will create lighter and darker areas in the mortar. After the sunlit mortar is dry, lay in the shadowed areas of mortar with Warm Grey III. Use a no. 8 round brush and clean water to blend the shadowed mortar areas. Allow this to dry.

For the bricks, use a circular stroke to apply Dark Cadmium Yellow to the entire brick, both sunlit and shadowed, and wet this with a no. 10 round brush. Wait for the bricks to dry and layer Burnt Ochre over the Dark Cadmium Yellow in the shadowed areas. Use the no. 10 round brush to wet this area and allow it to dry before moving on to paint the rusted areas of the wheel.

Apply Terracotta with a circular stroke to the thin layer of rusted metal on the outer rim of the wheel and to the two bolts by either side of each spoke. Wet this area with a no. 10 round brush. For the rusted hub in the center of the wheel, use Van Dyck Brown and Burnt Ochre and wet the area with a no. 8

round brush. Once the hub is dry, paint certain areas of the inner rim with Warm Grey II, as shown. After wetting the area and allowing it to dry, layer the remaining portions of the inner rim with Terracotta.

3 Create the Wood Texture

Now that the underpainting is complete, use Poly-chromos and Prismacolor "dry" colored pencils for the remainder of the project. When using oil-based colored pencils and keep a needle-sharp point on them at all times to help create a realistic wood texture. Constant sharpening with a quality electric pencil sharpener is a must. Soft, wax-based colored pencils simply cannot hold a sharp point without either breaking or quickly wearing down.

Lay out the largest, deepest cracks and dark areas with Dark Sepia and vary the thickness, shape and size of each. After layering the cracks with Dark Sepia and Van Dyck Brown, apply another coat of Dark Sepia until the paper surface is completely covered.

Draw surface cracks and lighter areas with Burnt Sienna with Van Dyck Brown to depict deeper weathering. To give the cracks dimensionality, leave a thin gap free of color to the left of each large crack on the spokes and on the bottom of the cracks on the wheel. Draw various horizontal strokes with Burnt Sienna, Van Dyck Brown and Dark Sepia for the larger dark, weathered areas.

4 Lay in Bricks and Mortar

For sunlit brick areas, color the deeper crevasses with Dark Sepia and Sienna Brown. Randomly apply Burnt Ochre and Terracotta, leaving some areas of the underpainting free of additional color. Blend and soften the pigment over the entire brick with a cotton swab. Lighten random areas with a kneaded eraser.

Where the wheel's shadows are cast onto the bricks, apply Dark Sepia over darker underpainted areas. Smooth the color with a cotton swab and randomly reapply Dark Sepia.

Use the same process for the sunlit areas of mortar; apply Polychromos Warm Grey III, II and I, leaving the underpainting free of additional color in some areas, then soften the pigment with a cotton swab. With Warm Grey VI, draw cracks between the bricks and mortar and the shadows cast by the bricks.

For the shadowed mortar areas, layer Warm Grey V over the darker underpainted areas in the wheel's shadow. Smooth the color with a cotton swab and reapply Warm Grey V randomly. Repeat until the desired effect is achieved.

5 Create the Rust

Layer the darkest values on the hub, rivets and inside the wheel with Warm Grey 90% and Dark Umber. For the secondary shadow on the side of the wheel, use Dark Umber. Lightly color layers of Terra Cotta (Prisma-color), Tuscan Red, Pumpkin Orange, Light Umber, and Terracotta (Polychromos) over the rusted areas, including the shadows. Use Warm Grey II and III to color in the white areas in the inner rim of the hub. Repeat this process until most of the paper surface is covered, but allow some of the underpainting to show through to give the appearance of rust.

ARCS, RADII AND RECTANGLES
Gary Greene
23½" × 15¾" (60cm × 40cm)

Everything Hinges On... in Colored Pencil

BY GARY GREENE Artists who attempt colored pencil are often frustrated by their results. Their biggest mistakes are trying to apply all of the pigment at one time and using a dull point. The textures in this painting were created by gradually adding the pigment to the white and round boards with layers of fine lines and with evenly applied layers of color. Using rough watercolor paper further enhanced the rough texture of the wood.

This image is a portion of a weathered garage door discovered in Port Townsend, Washington. Quite often it's the details that most people miss that make exciting subjects.

MATERIALS

Surface

Arches 300-lb. (640gsm) rough watercolor paper

Palette

Oil-based Colored Pencils
CARAN D'ACHE PABLO COLORED PENCILS: Brownish Beige

FABER-CASTELL POLYCHROMOS COLORED PENCILS: Black; Cold Grey I, II, IV, V and VI; Dark Sepia; Warm Grey V; White

Water-soluble Colored Pencils
CARAN D'ACHE SUPRACOLOR II WATERCOLOR PENCILS: Brownish Beige

DERWENT WATERCOLOR PENCILS: Blue Grey

FABER-CASTELL ALBRECHT DÜRER WATERCOLOR PENCILS: Burnt Ochre; Cinnamon; Cold Grey I, II and III; Ivory; Light Flesh; Venetian Red

Wax-based Colored Pencils
DERWENT STUDIO COLORED PENCILS: Blue Gray

PRISMACOLOR COLORED PENCILS: Cloud Blue, Dark Umber, Pumpkin Orange, Sienna Brown, Yellowed Orange

Brushes

No. 14 flat
Nos. 4 and 8 rounds

Other

2B graphite pencil
Cotton balls
Cotton swabs
Electric eraser with Koh-I-Noor imbibed eraser strips
Kneaded eraser
Krylon workable fixative
Lyra Splender pencil (a pigment-free colored pencil for blending)
Paper towels
Small circle template (optional)
X-Acto knife with a no. 16 blade

REFERENCE PHOTO

Lay Out the Composition

Lay out the painting with a 2B graphite pencil (follow the sketch shown). When the composition is finalized, retrace next to the graphite lines using Cold Grey II and Venetian Red water-soluble colored pencils. Lightly erase all graphite lines with a kneaded eraser so only the colored pencil lines remain.

Helpful Hint

Keep pencil points extremely sharp at all times, and apply pigment and water in the same direction as the object's length.

2 Underpaint the Basic Elements With Water-Soluble Colored Pencils

A Flat white boards. Apply Cold Grey I, leaving the highlight on the right edge free of pigment. Apply water with a nearly dry no. 14 flat brush. Dry with a hair dryer or allow to air dry. Apply Cold Grey III and Blue Grey to shadow areas. Apply water with a nearly dry no. 14 flat brush. Again, dry with a hair dryer or allow it to air dry.

B Round white boards. For all boards, draw nail heads approximately 3/16 inch (5mm) in diameter with Cold Grey II and a circle template. Leave the circles free of pigment. Apply Cold Grey I, II and III. Lightly wipe with a dry cotton ball. Apply water with a nearly dry no. 14 flat brush. Dry with a hair dryer or allow it to air dry.

C Two-by-fours. Apply Brownish Beige. Leave the highlights, nail heads and white areas free of pigment. Wipe with a cotton ball. Use a cotton swab in tighter areas. Apply water with a nearly dry no. 14 flat brush. Apply Cold Grey I to the white area. Wipe this with a cotton swab and apply water with a medium-dry no. 8 round brush. Dry all with a hair dryer or allow to air dry.

D Hasp. Apply Venetian Red and Cinnamon. Leave the highlight areas free of pigment. Wipe with a dry cotton swab. Apply water with a nearly dry no. 14 flat brush. Use a no. 4 round brush in tighter areas. Dry with a hair dryer or allow to air dry.

E Hinge. Apply Burnt Ochre, Light Flesh and Ivory. Apply water with a no. 4 round brush. Dry with a hair dryer or allow to air dry.

3 Paint the White Boards

All pencils used to finish the rest of the painting are either wax- or oil-based.

A Illuminated areas. Lightly apply Cloud Blue to the white wood surfaces, leaving the right edges free of pigment for highlight. Apply a heavier application of pigment to the opposite edge, as shown. Wipe with a dry cotton ball. Carefully apply thin grain lines with Cold Grey IV, overlapping lines for darker values.

B Shadowed areas. Lightly apply Black and Cold Grey VI (darkest values only), Blue Gray and Cold Grey IV and V to shadow areas. Lightly remove excess pigment with a dry no. 14 flat brush. Carefully apply thin wood grain lines with Cold Grey V or VI, or Black (darkest values only).

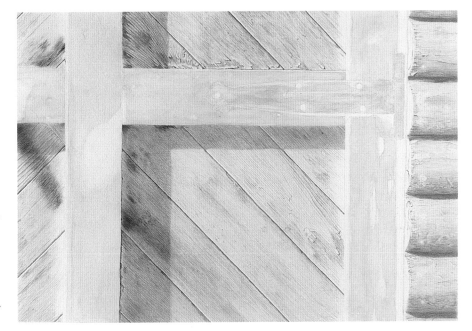

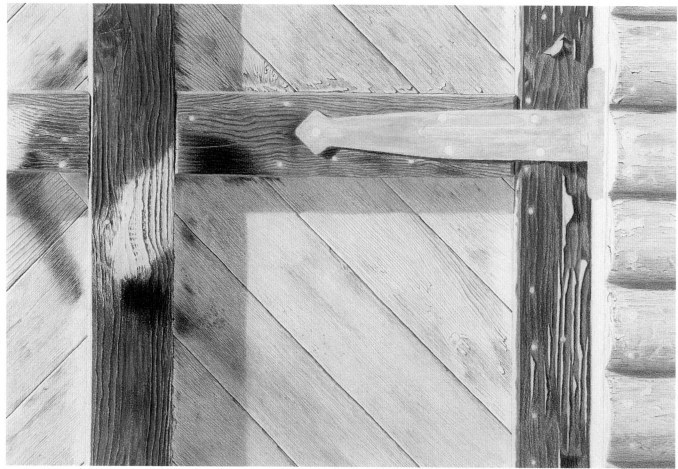

4 Paint the Two-by-Fours

A Blue paint. Lightly apply Cold Grey VI to cast shadows in areas with blue paint. Lightly apply Blue Gray over shadows. Use slightly more pressure on the darker side of raised areas. Leave the lighter side of raised areas and the peeling paint highlights on the left vertical two-by-four free of pigment. Lightly scrub blue areas with a cotton swab, including the lighter side of raised areas. Do not scrub shadows. Repeat applications of Cold Grey VI and Blue Gray, as above, until a majority of the paper surface is covered. Burnish (blend) blue areas with a Splender pencil. Do not burnish highlights. Repeat applications of Cold Grey VI and Blue Gray, as mentioned above. Lightly scrape random areas of blue paint with the flat edge of a no. 16 X-Acto knife blade. Touch up with Blue Gray. Very lightly apply Cloud Blue and Cold Grey I to highlight areas of peeling paint, then lightly burnish with White. Apply Cold Grey II to the upper edge of the horizontal two-by-four. Burnish with a Splender pencil. Apply Cold Grey IV to the lower edge of the horizontal two-by-four, then burnish with a Splender pencil. Apply Blue Gray to the highlighted edges of the vertical two-by-fours. Burnish with White. Repeat until the paper surface is covered.

B Bare wood. Lightly apply Warm Grey V and Dark Sepia to the shadow areas of bare wood. Lightly apply several layers of Dark Sepia and Brownish Beige to bare wood areas until most of the paper surface is covered. Do not apply pigment to lighter areas for the first few layers. Lightly burnish with a Splender pencil. Randomly apply Brownish Beige over blue paint.

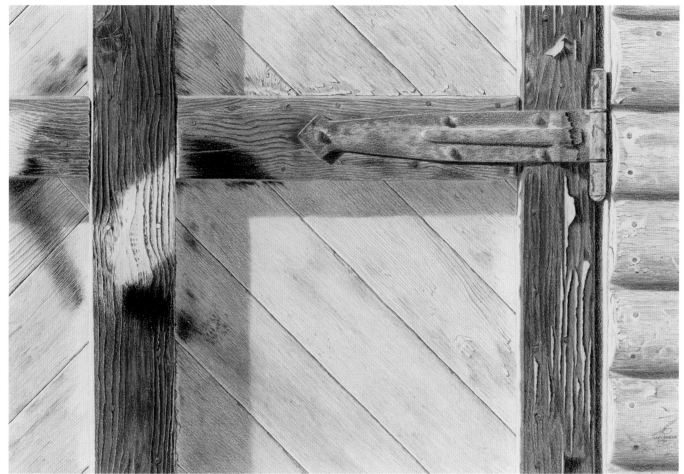

5 Hinge It All Together and Add the Finishing Touches

A Hasp. Layer the shadows with various combinations of Cold Grey VI and Dark Umber. Layer with various combinations of Sienna Brown, Dark Umber and Pumpkin Orange. Leave the underpainted rivet and highlight areas free of pigment. Layer the highlighted back portion of the hasp with Yellowed Orange. Layer highlights on the front and top edges with Cold Grey I. Layer rivets with gradations of Dark Umber, Burnt Umber and Pumpkin Orange. Layer the front edge with Cold Grey II and the top edge with Cold Grey I.

B Hinge. Layer a secondary shadow on the cylinder with Cold Grey V and IV. Layer Sienna Brown and Dark Umber as shown, leaving portions of underpainting to show through. Burnish dark gaps between the hasps with Cold Grey VI.

EVERYTHING HINGES ON...
Gary Greene
15½" × 23" (39cm × 58cm)

C Nail heads. Lightly layer nail heads with Dark Sepia and Dark Umber. Draw a line on the shadow edge of one-third of the nail heads with Cold Grey VI (blue and white areas) or Dark Umber (bare wood areas). Lightly layer small areas around some nail heads with Dark Umber.

D Final touches. Layer a vertical shadow between the two-by-four and round wood with Cold Grey VI, V and Blue Gray, repeating the layering until most of the paper surface is covered. Adjust the values with appropriate colors. Lightly apply four to five coats of fixative. Allow it to dry after each coat.

Artist Biographies

NORMA AUER ADAMS

Norma graduated from Stanford University with a BA in art. While living in Manhattan and Boston, Norma began painting urban landscapes, where flowers assumed a major role in her art. Her work has appeared in many publications, including *The Best of Flower Painting* (Kathryn Kipp, North Light, 1997). Her paintings have received numerous awards and have been shown in exhibits and museums, including the Southern Allegheny Museum of Art in Pennsylvania.

KALON BAUGHAN

Kalon received a BFA from Albion College. He has painted professionally since then, returning to Albion College as its Artist in Residence from 1992 to 1994. Kalon has been a featured artist at numerous shows, including the Pacific Rim Wildlife Art Show. He has received many awards and honors, including several Best of Show, Judges' Excellence and People's Choice Awards. Kalon was a Featured Artist for the Rocky Mountain Elk Foundation in 2002 and is the author of *Painting the Faces of Wildlife Step by Step* (North Light Books, 2001).

LIANA BENNETT

Liana's art career began at a young age. In high school she illustrated workbooks and painted backdrops for plays, all while selling several of her paintings on the side. Liana's paintings and multimedia work have received both national and regional honors and awards. She has been a teacher and demonstrating artist for 30 years and continues to find all aspects of the art world challenging and exciting. Since 1984, Liana has been teaching at the Arts Umbrella in Bothell, Washington, which she helped found.

MARK BOYLE

Mark studied design and illustration at the Burnley School of Art in 1982 and has since worked as a graphic designer. His awards include eleven paintings juried into the Arts for the Parks competition, five of which have won medallions, including the 1999 Yellowstone National Park Purchase award. His work is published in North Light Books' *The Best of Wildlife Art*. Mark has been a member of the Puget Sound Group of Northwest Painters, the Northwest Pastel Society and the Northwest Watercolor Society. His artwork is included in the collections of the Leigh Yawkey Woodson Art Museum and Yellowstone National Park.

PEGGY BRAEUTIGAM

Working in pastels since 1985, Peggy's work has been accepted into many art competitions, including the International Association of Pastel Societies Second Biennial Convention Exhibit. Her awards include an Award of Merit in the Northwest Pastel Society, and her paintings have been published in several issues of *The Artist's Magazine*. A charter member of the Northwest Pastel Society, Peggy served as its president from 1992 to 1997. She is also a signature member of the Pastel Painters' Society of Cape Cod and a member of the pastel societies of Oregon, Colorado and New Mexico.

JUNE CAREY

Although June has had no formal training, she has been painting in oils since she was a child. Her landscapes and seascapes have been included in Arts for the Parks six times from 1994 to 2000, and she was its Region II Winner in 1997 and 1998. She has exhibited at Mystic International (hosted by the Maritime Gallery at Mystic Seaport) each year since 1995. She was a featured artist in 1999, and in 2000, she won its Stobart Award. In 1998 she won the California Art Club's Gold Medal in the marine category. She is a member of the American Society of Marine Artists, the California Art Club and Oil Painters of America.

MICHELE COOPER

A noted teacher and painter, Michele has worked in numerous media, including pastel, oil, acrylic and watercolor, and has studied privately with several nationally renowned artists. She has had several books privately published and produced a series of watercolor lessons on video. Her work has received many honors, including the Northwest Watercolor Society Annual Award and the Puget Sound Painters Award for excellence in landscape painting. Michele is a signature member of the Northwest Watercolor Society and Women Painters of Washington.

BEVERLY FOTHERINGHAM

Beverly Fotheringham has concentrated on painting in the watercolor media since 1997 and has earned distinction as a signature member of both the National Watercolor Society and the Northwest Watercolor Society. She has won numerous awards for her work in juried shows throughout the United States. Beverly received formal training at the Art Center College of Design in Los Angeles and a BA degree in fine arts from California State University Fullerton.

GARY GREENE

In addition to being an accomplished photographer, Gary is a talented fine artist, graphic designer, author and instructor. Specializing in outdoor photography, his works have been published by the National Geographic Society, Hallmark, Petersen's *Photographic* magazine and *Popular Photography* to name a few. His paintings and photographs have won numerous awards, both nationally and internationally. Gary is also the author of several North Light Books, including *Creating Texture in Colored Pencil* (1996) and *Creating Radiant Flowers in Colored Pencil* (2001).

SANDRA JACKOBOICE

Sandy completed a BA in art at Aquinas College. She then worked as Art Program Director at the Franciscan Life Process Center in Lowell, Michigan. There she developed, organized and directed an artist-in-residence program for ten years. Sandy is a signature member of The Pastel Society of America and a member of the Artist's Alliance and the Grand Valley Artists. She is cofounder and former president of the Great Lakes Pastel Society, a member of the International Association of Pastel Societies. Her work has been exhibited both nationally and internationally. More information about Sandy and her work is available at www.skjackoboice.com.

BARBARA KRANS JENKINS

Barbara earned a BS in education from Kent State University and studied graphic design at Akron University. She taught and freelanced for twenty-five years, designing logos, doing home portraits and illustrating for magazines, calendars and cards. Her work has been honored in many shows, such as the Botanicals National Exhibition, and has appeared in several books, including *The Best of Flower Painting* (North Light Books, 1997). Barbara is a member of the Colored Pencil Society of America, the Akron Society of Artists and the Ohio Realist Group.

CAROLYN E. LEWIS

Carolyn works as director for the Lawrence Churski Gallery and teaches landscape painting at the Cuyahoga Valley Art Center. From 1996 through 1998 she was president of the Akron Society of Artists (Ohio), and she received honorable mention in the top six out of 9,000 entries for *The Artist's Magazine* 1998 National Landscape Competition. Carolyn is a signature member of several organizations, including the Akron Society of Artists and Oil Painters of America. She is also a member of Portrait Society of America and the American Society of Classical Realists.

NANCY PFISTER LYTLE

Nancy, who died February 17, 2005, after a long battle with breast cancer, won numerous awards for her art. She worked mostly in acrylics but also in watercolor and mixed media. In addition to being a working artist, she had been a technical illustrator and an editor for North Light Books. Nancy's work hangs in public and private collections across the U.S. and abroad. Her painting "Northern Bound on the Underground Railroad" received statewide attention in Ohio during an exhibit on the Underground Railroad in southwestern Ohio. Two other notable works of Nancy's reside in Clinton County, Ohio: one, a painting of the Clinton County courthouse dome, hangs in the judge's chambers there; and "Quarantine," showing a mother and her child with polio, is owned by Clinton Memorial Hospital.

PIA MESSINA

Pia was born in Turin, Italy, at a time when a career in art was considered unsuitable for a woman. After raising two sons, she moved to the United States with her husband and attended the National Academy of Design. She achieved life membership in the Art Student League and signature membership in the New Jersey Watercolor Society. Pia moved to the West Coast in 1989 and gained signature membership in several organizations including the Northwest Watercolor Society and the National Watercolor Society.

SHERRY C. NELSON

Sherry has been painting and teaching wildlife art for over twenty-five years and has settled into birds as a specialty. She has been active in the Society of Decorative Painters since its inception, serving as president and receiving the Master Decorative Artist Award (the highest level of certification) in 1976. Sherry also received the Silver Palette Award in 1987 and has produced sixteen instructional publications for wildlife painters of all skill levels.

ROSS NICOLL

Ross has been an artist for most of his life. After serving an engineering apprenticeship, Ross became a technical illustrator. Although he is mostly self-taught, he exhibits professionally in national and international venues. He is represented by the Kirkland gallery and has exhibited at Seattle's Frye Art Museum. He continues to build on the knowledge he has acquired on his own, taking classes with Seattle artists Chuck Webster and Jess Cauthorn.

TED PANKOWSKI

After only a few years of painting experience, Ted Pankowski decided to transform his lifelong love of painting into a profession. A self-taught artist, Ted continues to attend workshops given by nationally renowned painters such as Matt Smith and Ned Mueller. His work has received wide recognition and numerous awards. In addition to his success as a painter, Ted was invited to teach at the Arts Umbrella in Bothell, Washington, a 15-year-old community resource for aspiring new artists.

SUEELLEN ROSS

Sueellen's work has appeared in many shows including Birds in Art at the Leigh Yawkey Woodson Art Museum. She was the Region I Winner at the Arts for the Parks competition in 1991. Her book, *Paint Radiant Realism in Watercolor, Ink and Colored Pencil* (North Light Books), was published in 1999. Her work also appears in other North Light Books, including *Painting Birds Step by Step* (by Bart Rulon, 1996). Articles about Sueellen's work have appeared in *The Artist's Magazine, Southwest Art Magazine* and *American Artist Magazine*. Her artwork is in the permanent collection of the Leigh Yawkey Woodson Art Museum.

BART RULON

Bart received a BA from the University of Kentucky and has been a professional artist ever since. His work has been displayed in many exhibits, museums and galleries across the globe and has won him many honors, including the Rocky Mountain Elk Foundation Featured Artist of 2001 and the Audubon Alliance Artist of the Year Award in 1998. His paintings are part of the permanent collection of the Leigh Yawkey Woodson Art Museum. Bart is the author and illustrator of numerous North Light Books, including *Painting Birds Step by Step* (1996) and *Artist's Photo Reference: Songbirds* (2004).

DIANNA SHYNE

Dianna has been painting for over 20 years. Her work has received many national awards, including the Grumbacher Gold Medallion. Dianna's paintings are included in numerous collections, including the permanent collection of the Wiregrass Museum. In 2001, Dianna began teaching at the University of Washington Women's Center and became president of the Northwest Watercolor Society. She has also given demonstrations of acrylic painting techniques at the Seattle and Bellevue Art Museums.

MARY SWEET

Mary received both a BA and MA in art from Stanford University and her work has been accepted in juried shows across the United States since the 1960s. Her awards include first, second and third place respectively at the New Mexico State Fair in 1997, 1998 and 1999, and the Lena Newcastle Award at the American Watercolor Society's 121st Annual exhibition. Mary is a signature member of the New Mexico Watercolor Society and the Western Federation of Watercolor Societies.

LINDA TOMPKIN

Linda has been painting for more than twenty years and works primarily in acrylics and oils. Articles about her work have appeared in *The Artist's Magazine.* She's also published in *The Best of Watercolor series* (Rockport Publishers). Her paintings have been included in many competitions, including those of the American Watercolor Society and the National Society of Painters in Casein and Acrylic. Linda is a signature member of several societies, among them the American Watercolor Society, the National Watercolor Society and the Ohio Watercolor Society.

LARRY WESTON

Larry has been painting since the first grade. He began teaching while in the military, conducting oil painting classes for other servicemen. After his discharge, Larry studied commercial art. He also completed the Famous Artists School's Commercial Art, Illustration and Design course and the Famous Artists School's Fine Art and Painting course. Larry worked as a commercial artist and art director for several major companies before resigning in 1982 to pursue fine art full-time. He is a signature member of the Southwestern Watercolor Society and an associate member of the National Watercolor Society.

STEVE WHITNEY

An award-winning painter in oil, acrylic and watercolor, Steve has had paintings in all three media juried into national shows. He is a juried associate member of Oil Painters of America and of the Puget Sound Group of Northwest Painters. He is a signature member of both the Montana Watercolor Society and the Northwest Watercolor Society. Steve's studio is just outside Woodinville, Washington, and is represented by Kaewyn Gallery in Bothell, Washington.

FRANK E. ZUCCARELLI

Frank attended the Newark School of Fine and Industrial Arts, where he later went on to teach pictorial illustration and painting. He also received a BA from Kean University. He has exhibited internationally and has conducted workshops in the United States and China. He has received numerous awards, including the Pastel Society of America 1998 President's Award and the Bruce Crane Salmagundi Club Award 2000. Frank has written several articles for *The Artist's Magazine* and *American Artist magazine.* His work has also appeared in several books, including *The Best of Oil Painting* (Rockport Publishers, 1996) and *Pastel Interpretations* (North Light Books, 1993).

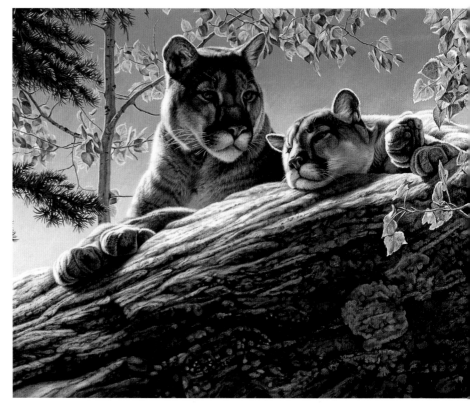

CONTENTMENT
Kalon Baughan
16" × 24" (41cm × 61cm)

Index